London Apartments

London Apartments

 teNeues

Editor:
Paco Asensio

Editorial coordination and text:
Ana Cristina G. Cañizares

English copyediting:
Juliet King

German translation:
Haike Falkenberg / Inken Wolthaus

French translation:
Michel Ficerai

Art direction:
Mireia Casanovas Soley

Graphic design / Layout:
Pilar Cano, Soti Masbagà

Photo editing:
Marta Casado

Published in the US and Canada by
teNeues Publishing Company
16 West 22nd Street, New York, N.Y. 10010, USA
Tel.: 001-212-627-9090, Fax: 001-212-627-9511

Published in Germany, Austria and Switzerland by
teNeues Verlag GmbH + Co KG
Am Selder 37, 47906 Kempen, Germany
Tel.: +49-(0)2152-916-0, Fax: +49-(0)2152-916-111

Published in UK and Ireland by
teNeues Publishing UK Ltd.
77 The London Fruit & Wool Exchange,
Brushfield Street, London EI 6EP, UK
Tel.: +44-(0)20-7655-0999, Fax: +44-(0)20-7655-0888

www.teneues.com

Editorial project:

© 2001 **LOFT** publications
Domènec 9, 2-2
08012 Barcelona. Spain
Tel.: +34 93 218 30 99
Fax: +34 93 237 00 60

e-mail: loft@loftpublications.com
www.loftpublications.com

Pinted by:
Gràfiques Ibèria, S.A.
Barcelona, España

September 2001

Die Deutsche Bibliothek - CIP-Einheitsaufnahme
Win Titeldatensatz für diese Publikation ist bei
der Deutschen Bibliothek erhältlich.

When most people think of London's residential landscape, they picture period buildings with private courtyards and rows of Victorian houses fringed by luscious English gardens. England's capital city is renowned for its traditional architecture and picturesque qualities. Yet many people do not realize that behind some of the typical facades are spectacular homes that enjoy the latest in contemporary architecture and design.

LONDON APARTMENTS is an important collection of residential projects that demonstrate the innovative talent of the country's most respected architects and designers.

From industrial lofts in London's gritty outskirts to cozy apartments next to its trendy markets, all the projects feature detailed designs and planning geared towards the needs and wants of their residents.

A dwelling is as artistic as it is necessary, and a determined lifestyle dictates how people create their surroundings. The styles and solutions offered here reflect the changing needs and demands of the city dweller within one of the most contemporary and cosmopolitan cities of the world.

Altbauten mit privaten Innenhöfen und Reihen viktorianischer Einfamilienhäuser gesäumt von üppigen englischen Gärten – daran denken viele, wenn sie sich die Wohnlandschaft der britischen Hauptstadt vorstellen. Von der traditionellen Architektur und dem pittoresken Charakter der Stadt in die Irre geführt, wird den Besuchern oft nicht klar, dass hinter vielen dieser typischen Fassaden spektakuläre Wohnungen liegen, die das Neuste in zeitgenössischer Architektur und Design vorstellen.

LONDON APARTMENTS ist eine umfassende Sammlung verschiedener Wohnungsentwürfe, die das innovative Talent der angesehensten Architekten und Designer unter Beweis stellen.

Von industriellen Lofts in Londons unpolierten Außenbezirken bis zu gemütlichen Apartments gleich neben den beliebtesten Märkten - alle Projekte zeichnen sich durch ein detailliertes Design und eine nach den Bedürfnissen und Wünschen ihrer glücklichen Bewohner ausgerichteten Planung aus.

Eine Wohnung ist heute genau so sehr Kunstobjekt wie Notwendigkeit, und ein klar definierter Lifestyle schreibt vor, wie die Menschen ihre persönliche Umgebung gestalten. Die hier vorgestellten Einrichtungsstile und Lösungen spiegeln die Bedürfnisse und Ansprüche der Stadtbewohner in einer der aktuellsten und kosmopolitischsten Städte der Welt wider.

Édifices d'époque aux cours privées, rangées de résidences Victoriennes ornées de délicieux jardins à l'anglaise – la première pensée venant à l'esprit en songeant au paysage résidentiel de la capitale anglaise. Abusés par l'architecture traditionnelle et le pittoresque de la ville, les gens réalisent peu souvent que ces façades classiques cachent des lieux captivants, à la pointe du design et de l'architecture contemporains.

LONDON APARTMENTS est un recueil essentiel des projets résidentiels représentatifs du talent novateur des architectes et designers les plus respectés du pays.

Des lofts industriels des banlieues dures aux appartements douillets proches des marchés à la mode, ces projets affichent tous design et planification minutieux à l'écoute des besoins et volontés de leurs heureux occupants.

De nécessité le foyer est devenu un art, un style de vie particulier dictant les formes selon lesquelles chacun décide de créer son environnement. Les styles et solutions présentés ici reflètent les besoins et exigences changeants des citadins, en l'occurrence au cœur de l'une des villes les plus modernes et cosmopolites du monde.

London Apartments

Knightsbridge Penthouse
Yakeley Associates

Photos: © **Chris Gascoigne / VIEW** Completion date: **2001** diana@yakeley.com

This luxurious apartment takes full advantage of its panoramic views with floor-to-ceiling silicon glazing and an uncluttered, elegant interior. Along with the client's growing art collection, the penthouse features a variety of natural materials and tones, including American black walnut flooring and pivoting doors; a pale cream limestone reception and stairs; wenge wood bookcases; and mirrored slump glass in the bar and master bathroom. A timber deck with a glass balustrade and stainless steel handrail surrounds the living area downstairs. The master bedroom is located on the upper level and has a masculine air, with walls lined in taupe Ultrasuede, red silk curtains, and a leather bed.

Dieses luxuriöse Penthouse nutzt durch die Komplettverglasung und die elegante Einrichtung alle Vorteile seiner Panoramablicke. Neben der Kunstsammlung des Eigentümers dekorieren Naturmaterialien und -töne die Wohnung: Fußböden und Schiebetüren aus amerikanischer schwarzer Walnuss, Empfang und Treppe aus cremefarbenem Kalkstein, Bücherregale aus Wengeholz sowie Spiegel in der Bar und dem Schlafzimmer. Ein Holzdeck mit Glasbalustrade und einem Handlauf aus Edelstahl zieht sich außen am Wohnraum entlang. Das Hauptschlafzimmer liegt in der Etage darüber: mit in taupe Ultrasuede abgesetzten Wänden, roten Seidenvorhängen und einem Lederbett.

Cet appartement luxueux jouit pleinement de ses points de vue panoramiques grâce à des baies vitrées, et un intérieur élégant et dépouillé. Conjointement à la collection d'œuvres d'art du client, le penthouse présente une gamme de matériaux et de tons, comprenant portes et parquets de noyer noir, réception et escaliers en combe couleur crème, bibliothèque en wengé, chambre principale et bar en verre miroir coulé. Une rambarde de bois, dotée d'une balustrade en verre et d'une main courante en acier, entoure l'aire de séjour. Au niveau supérieur la chambre principale est masculine, avec des murs tendus d'Ultra suède gris clair, des rideaux de soie rouge et un lit en cuir.

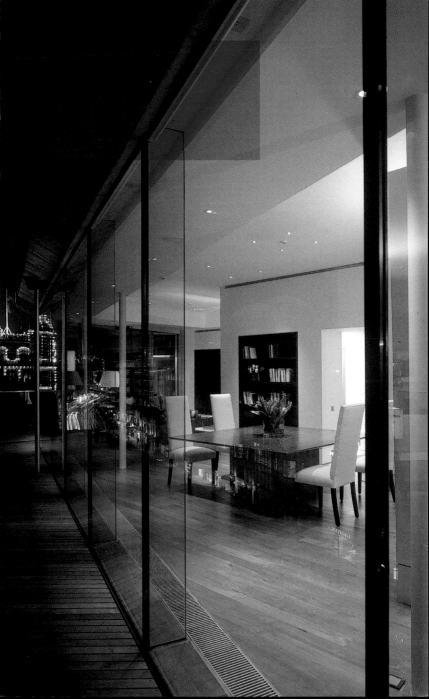

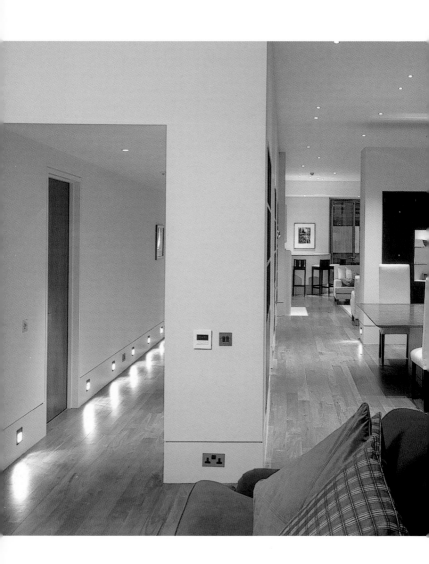

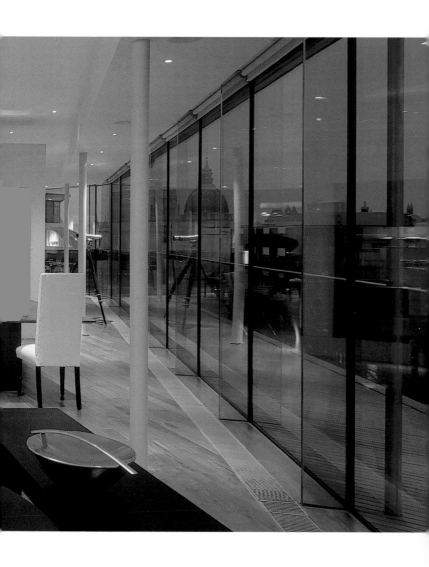

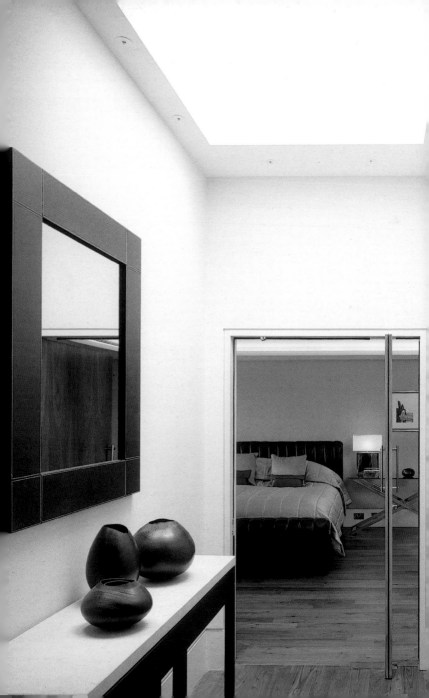

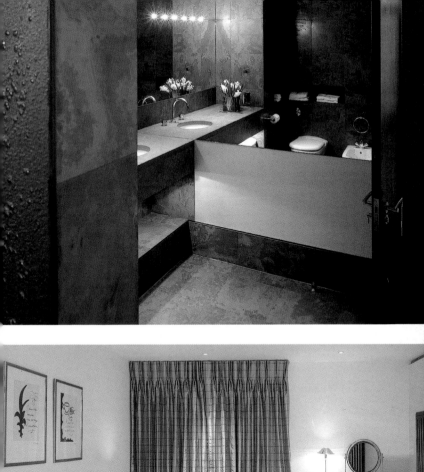

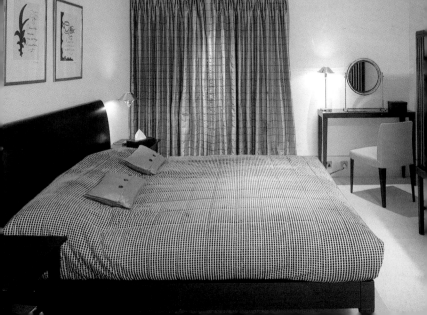

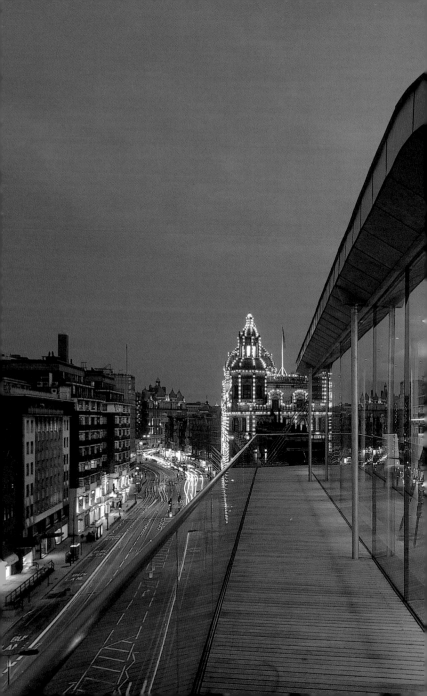

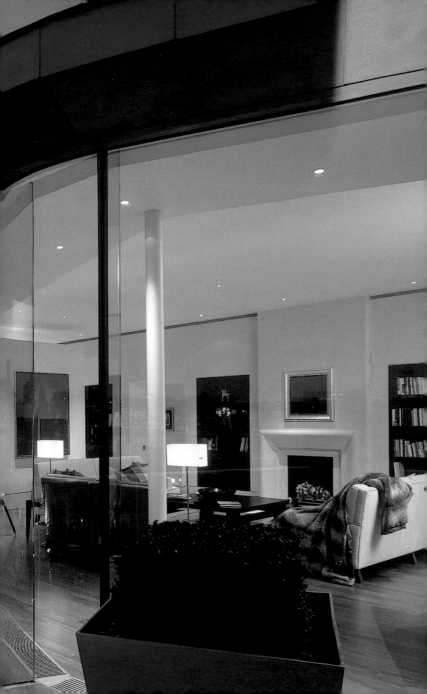

Rosoman Street
Felicity Bell

Photos: © **Chris Tubbs** Completion date: **1998** studio@felicitybell.com

Designed as a studio and home for interior designers Felicity Bell and Christian Papa, the common problem of combining these two functions and still maintaining intimacy was easily solved in this case with folding translucent screens. On one side, the space is dedicated to work and living, while the other side contains a bathroom and master bedroom. Screens near the entrance make it possible to block off a meeting room, studio, or guestroom. Another screen makes it possible to conceal the bathroom in the entrance hall, which is connected to the master bedroom. The interesting kitchen features Australian jarrah wood surfaces and a lustrous gray rubber floor.

In dieser Atelierwohnung für die Innenarchitekten Felicity Bell und Christian Papa wurde das Problem der Kombination verschiedener Raumfunktionen unter Berücksichtigung der Privatsphäre einfach durch faltbare Paravents gelöst. Der Raum auf der einen Seite wird zum Arbeiten und Leben genutzt, Schlafzimmer und Bad liegen auf der anderen Seite. Wandschirme im Eingangsbereich lassen sich zu einem Besprechungsraum, Arbeits- oder Gästezimmer arrangieren. Außerdem kann man das an das Schlafzimmer angrenzende Bad hinter einem Paravent im Eingang verstecken. In der interessanten Küche fallen die australischen Jarrah-Holzoberflächen sowie der glänzende graue Kunststoffboden auf.

Pour concevoir cet atelier/logement, associant ces deux fonctionnalités en conservant l'intimité, les architectes d'intérieur Felicity Bell et Christian Papa ont eu recours à des cloisons translucides dépliables. Un côté de l'espace est consacré au travail et au séjour, l'autre comprend une salle de bain et une chambre principale. Des cloisons près de l'entrée permettent de créer une salle de réunion, un atelier ou une chambre d'hôte. Une autre séparation dissimule la salle de bain dans le hall d'entrée, jouxtant la chambre principale. Une cuisine intéressante met en évidence des surfaces en bois de Jarrah et un sol plastique gris étincelant.

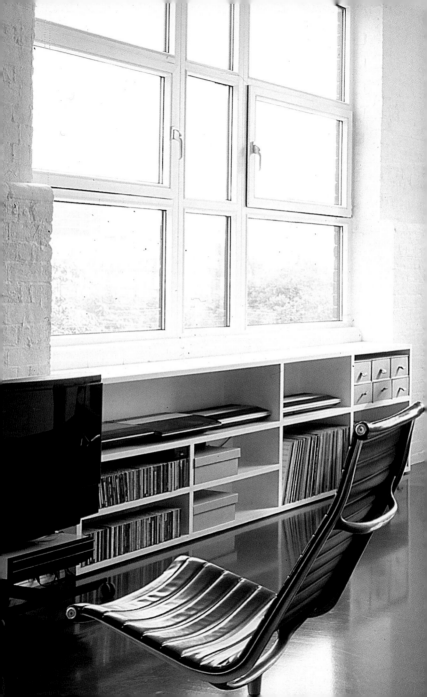

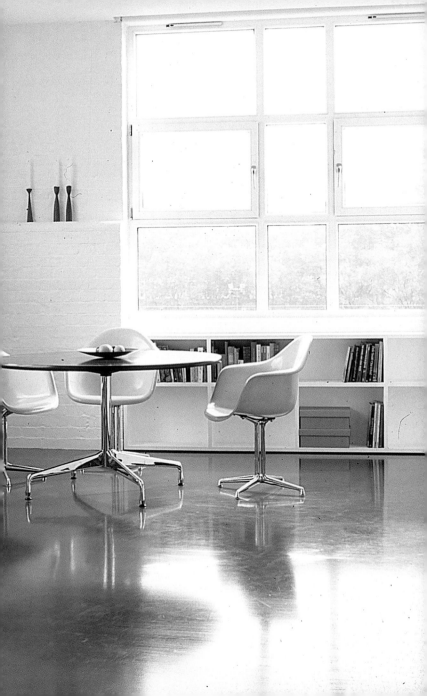

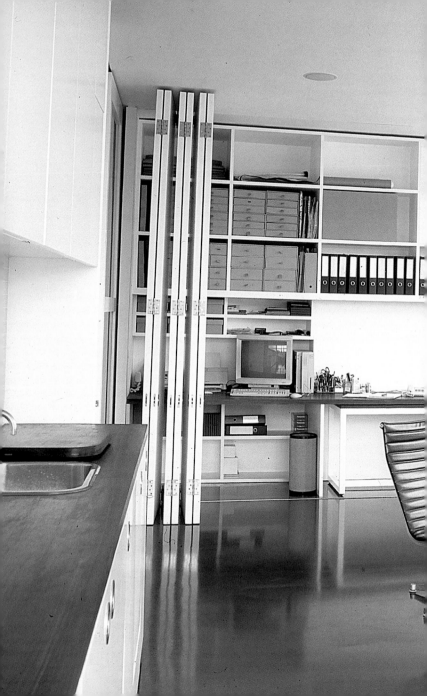

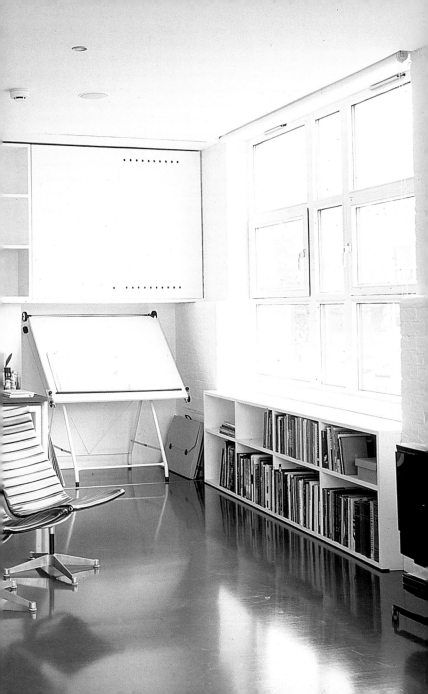

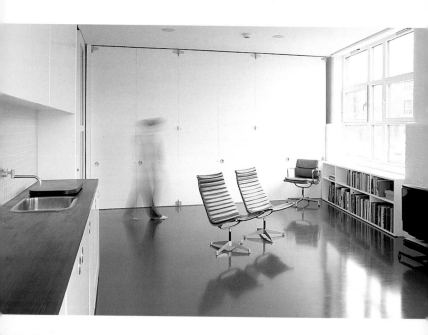

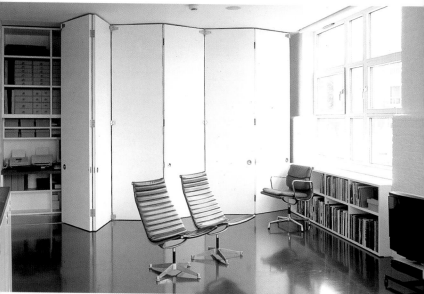

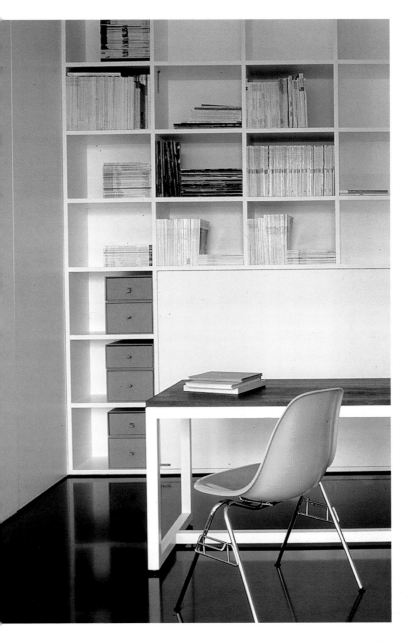

Pimlico Loft
Farshid Moussavi and Alejandro Zaera

Photos: © **Valerie Bennett** Completion date: **1998**

The dimensions and space of this L-shaped loft in Pimlico were taken advantage to a maximum. The 16-foot ceilings were used to construct a mezzanine floor that runs the length of the loft, accommodating a library/office visible from the main level and a bedroom and bathroom that are sectioned off with sliding panels. The linear qualities of the architecture are offset by the unusually curved nature of the furniture. The project presents uniform colors and materials, including ceilings, walls, and sliding doors in white; wide solid oak tiles; a sandstone bathroom; and matte black hinged doors. Indirect lighting illuminates the space, and the two-story main wall is used wisely as a gallery space.

Der Schnitt und Raum dieses L-förmigen Loft in Pimlico werden optimal genutzt. Dank der fast fünf Meter hohen Decke konnte über die gesamte Länge ein Zwischengeschoss eingezogen werden, in dem sich Bibliothek und Büro offen, sowie Bad und Schlafzimmer durch Schiebewände abgetrennt, befinden. Die abgerundeten Formen der Möbel gleichen die Geradlinigkeit der Architektur aus. Farben und Materialien sind homogen, dazu gehören die Decken, Wände und Schiebetüren in weiß, breite solide Eichendielen, ein Sandstein-Bad und mattschwarze Türen. Die Beleuchtung ist indirekt und die doppelt raumhohe Seitenwand wird sinnvoll als Galerie genutzt.

L'espace et les dimensions de ce loft de Pimlico en forme de L ont été grandement mises à contribution. Grâce aux plafonds à cinq mètres, une mezzanine parcourt la longueur du loft, et accueille une chambre et une salle de bain séparées par des cloisons coulissates, et un bureau/bibliothèque visible depuis le niveau principal. La nature linéaire de l'architecture est balancée par un mobilier aux formes curvilignes. Le projet propose couleurs et matériaux uniformes: plafond, murs et portes coulissantes en blanc, parquet carrelé de chêne brut, salle de bain en grès, portes noires mates suspendues. Un éclairage indirect illumine l'espace, le mur principal de deux étages servant ingénieusement de lieu d'exposition.

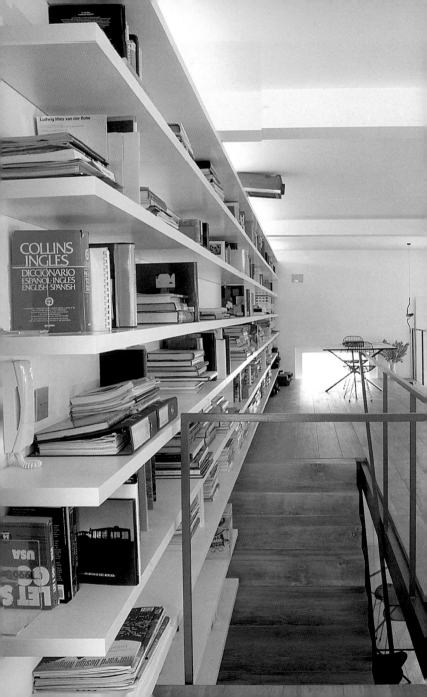

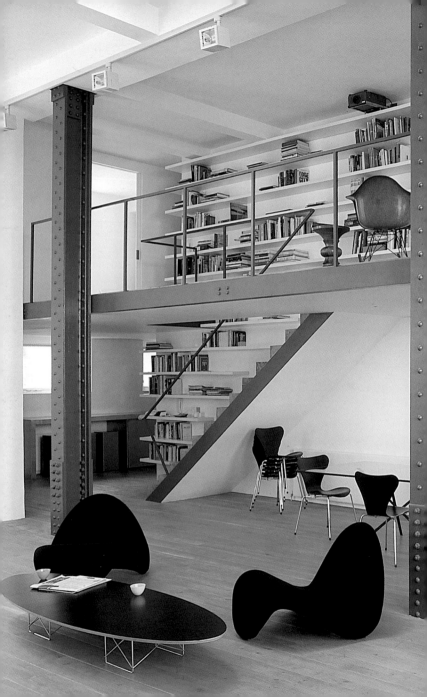

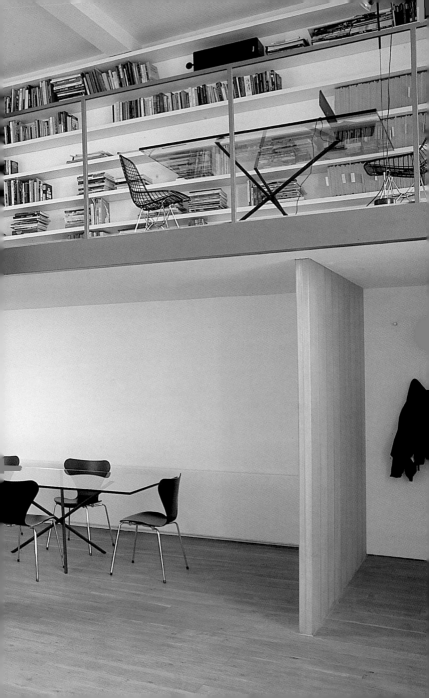

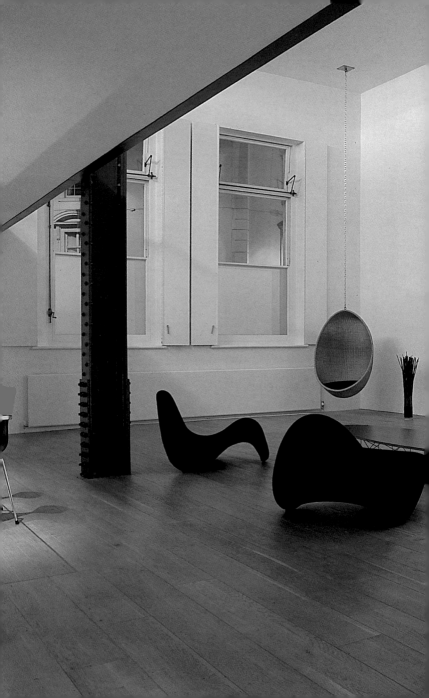

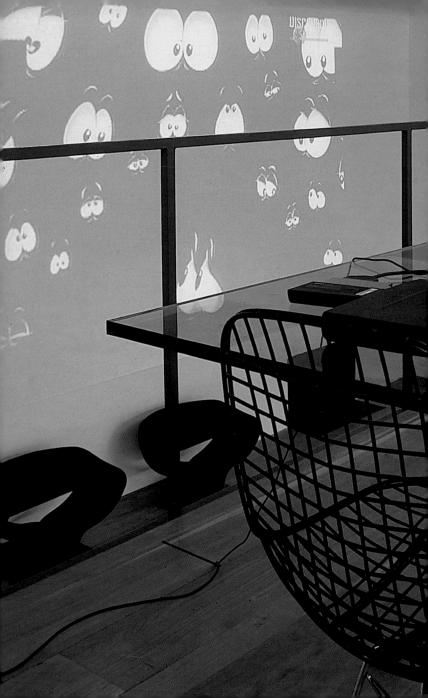

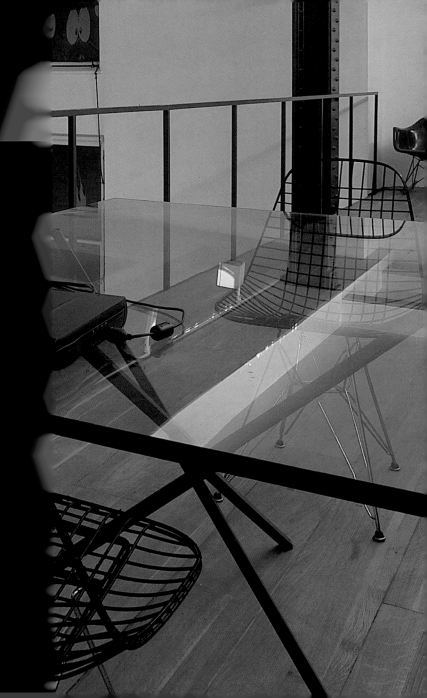

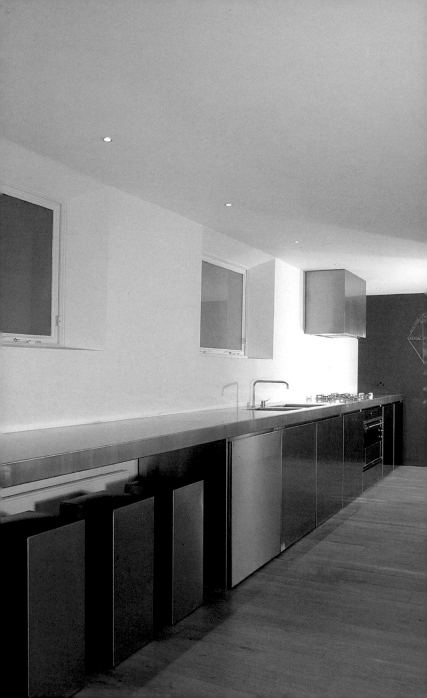

Wapping Loft
Neil Choudhury

Photos: © **Jordi Miralles** Completion date: **2001 choudhury@zoom.co.uk**

A medley of shapes, textures and materials define the character of this space. Wood floors merge into tile, wooden beams stretch across the ceiling, and wine colored pillars run down the length of the living room. Brickwork along most of the walls and a jagged stone tabletop are some elements that create a rough aspect, while smooth and curved white walls do the opposite. Carefully chosen light fixtures illuminate the rooms distinctly, shedding light on precise objects or in a general fashion. The bedroom is wrapped in brick walls and a rounded structure houses the bathroom. The kitchen incoporates a breakfast counter and elevated onto a dais, shares the same space as the large living area.

Eine Mischung aus Formen, Oberflächen und Materialien macht den Charakter dieses Apartments aus. Holzböden gehen in Fliesen über, Holzbalken spannen sich über die Decke und bordeauxrote Säulen reihen sich über die gesamte Länge des Wohnzimmers auf. Sichtbares Ziegelmauerwerk an fast allen Wänden und eine gezackte Tischplatte aus Stein vermitteln einen rauen Eindruck, im Gegensatz zu den geschwungenen weißen Wänden. Sorgfältig ausgewählte Lampen beleuchten jeden Raum unterschiedlich, sie streuen Licht auf konkrete Objekte oder allgemein in den Raum. Zur Küche, die auf einem Podest steht und sich einen Raum mit dem Wohnzimmer teilt, gehört auch eine Esstheke.

Un pot-pourri de formes, textures et matériaux définit la nature de cet espace. Les parquets se mêlent au carrelage, les poutres en bois s'étendent tout au long du plafond, et des piliers lie de vin parcourent l'ensemble du séjour. Les murs en maçonnerie et une table en pierre aux arêtes saillantes figurent parmi les éléments créant un aspect rugueux. Leur action s'équilibre avec celle des murs blancs, lisses et curvilignes. Un éclairage choisi avec soin illumine distinctement les chambres, insistant sur certains objets, ou de manière générale. La chambre s'enveloppe de murs de briques, une structure arrondie accueillant la salle de bain. La cuisine est surélevée pour partager le même espace que l'aire de séjour.

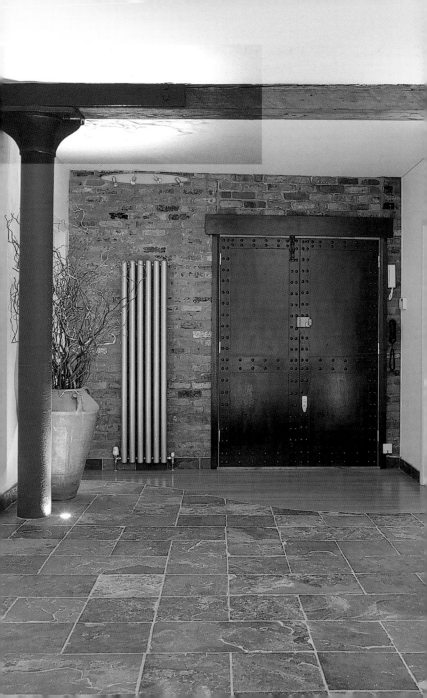

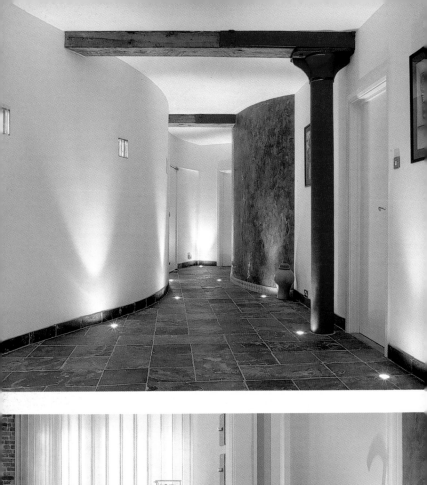

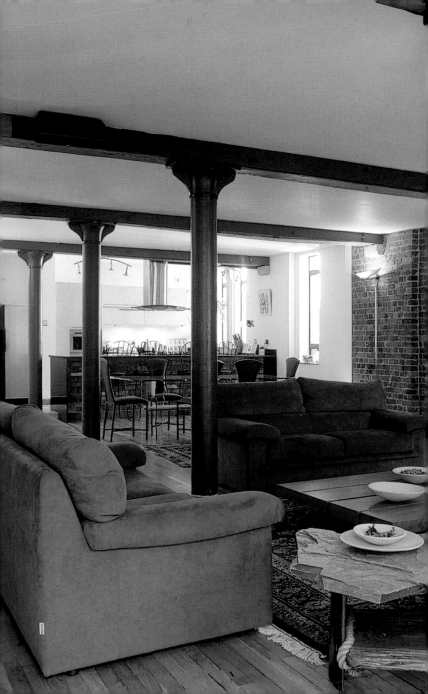

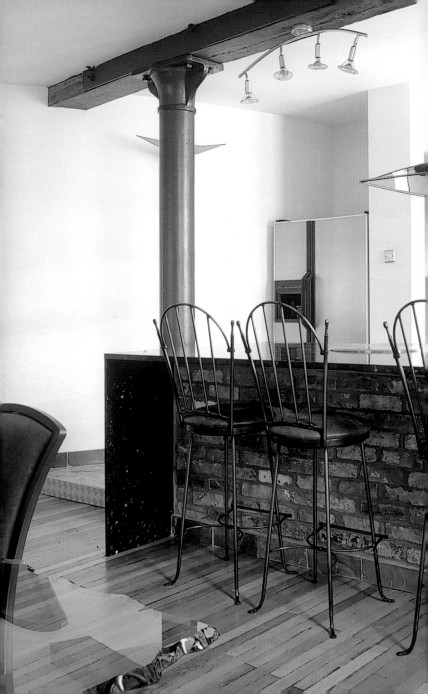

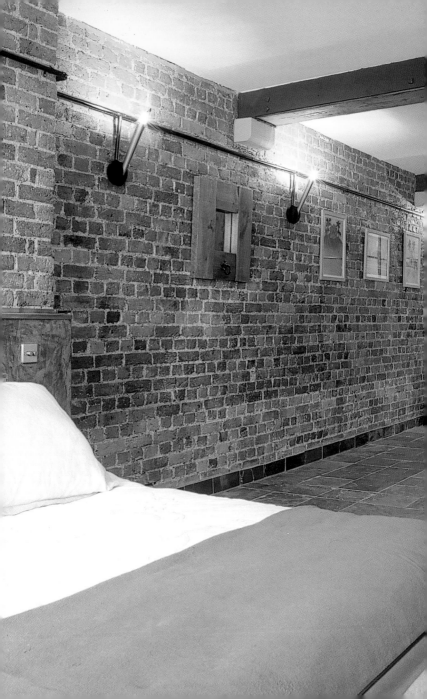

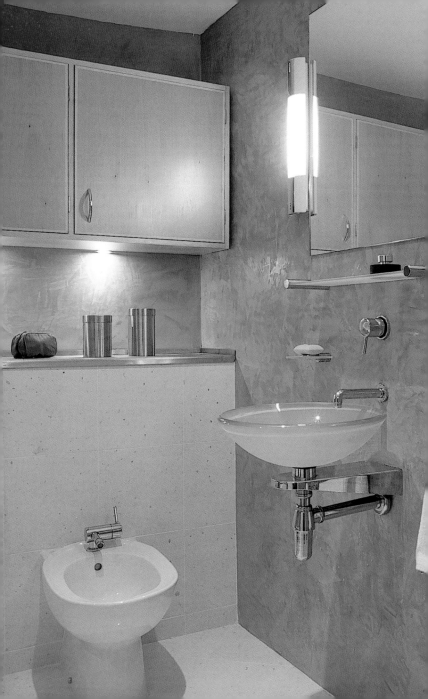

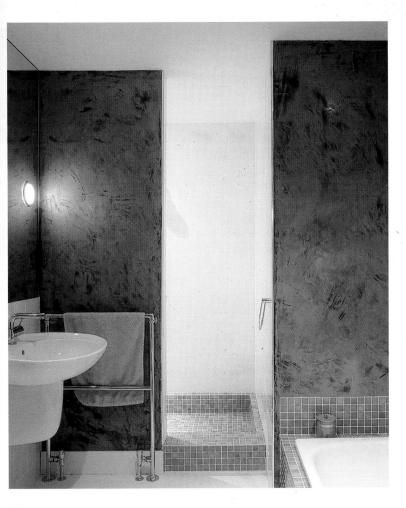

The bathrooms are finished in cool colors and painted in uneven brushstrokes. Lighting is important and design is simple, with the necessary storage built along the walls.

Die Badezimmer wurden in kühlen Farben und ungleichmäßigen Pinselstrichen ausgeführt. Die Beleuchtung ist wichtig und das Design einfach; Stauraum gibt es entlang der Wände.

Des traits de pinceaux irréguliers, dans des tons sereins, habillent les salles de bain. L'éclairage est conséquent, le design simple et les rangements s'intègrent dans les murs.

Apartment on the Thames
Claudio Silvestrin

Photos: **Claudio Silvestrin** Completion date: **1997** c.silvestrin@claudiosilvestrin.com

This apartment's design is austere and sober. The space is best characterized by elements that stand out visually yet are functional. The translucent screen dividing the bedrooms from the daytime areas is subtly curved, reflecting movement on both sides and softening the straight lines that dominate the space. Technological details are hidden behind cupboards, partitions, and floors to retain the purity of the design. Long wooden tables and benches complement the minimalist accessories, which include floor lamps, a vase with flowers, a candle, and a frame resting on the Tuscan Serena stone floor. White stylized walls flank the floor-to-ceiling windows that show panoramic views of the flowing Thames River.

Das Design dieses Apartments ist nüchtern und streng. Auffällige, funktionelle Elemente charakterisieren den Raum am besten. Der semi-transparente Wandschirm, der die beiden Schlafzimmer vom Wohnraum trennt, ist leicht gebogen: er lässt Bewegungen auf beiden Seiten wahrnehmen und mildert die geraden Linien, die den Raum dominieren. Technik ist hinter Regalen, Wänden und in den Böden versteckt, um die Reinheit des Designs nicht zu beeinträchtigen. Lange Holztische und -bänke runden die minimalistische Einrichtung ab, zu der Stehlampen, eine Vase mit Blumen, eine Kerze und ein Bilderrahmen auf dem Boden aus toskanischem Serena-Stein gehören. Deckenhohe Fenster bieten Blick auf die vorbeifließende Themse.

Le design de cet appartement est sobre et austère. L'espace est mis en valeur par des éléments visuels forts et fonctionnels. L'écran translucide séparant les chambres des aires de séjour est subtilement courbé, reflétant le mouvement de chaque côté et adoucissant les lignes droites dominant le lieu. Les détails technologiques se cachent derrière des placards, des cloisons et le sol, afin de maintenir la pureté du design. Les éléments de décor minimalistes, lampadaires, vase de fleurs, bougie et cadre reposant sur un sol en pietra serena de Toscane sont complétés par de longs bancs et tables en bois. Des murs blancs stylisés encadrent les baies vitrées, proposant une vue panoramique du cours de la Tamise.

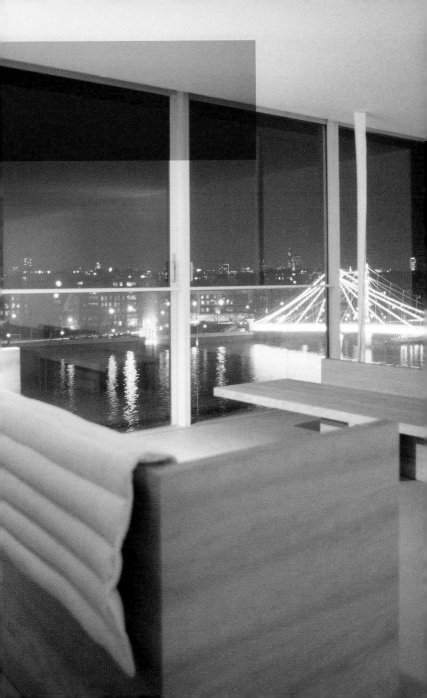

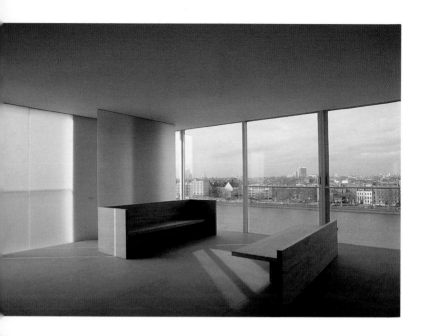

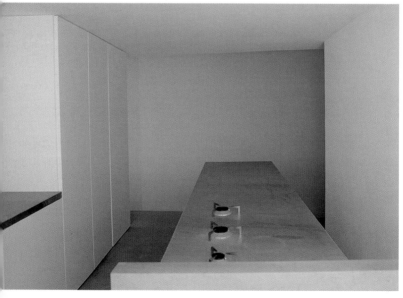

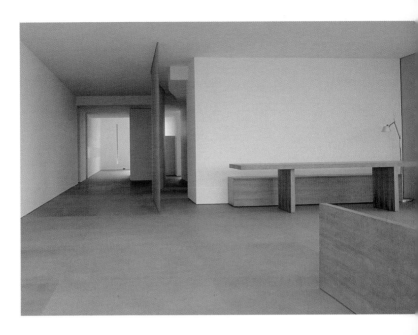

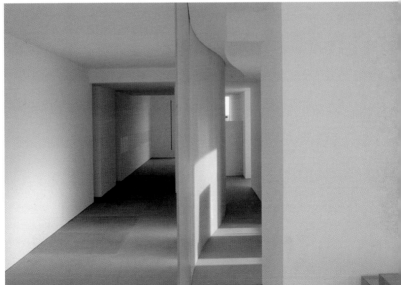

Loft in London's Soho
Knott Architects

Photos: © Jefferson Smith, © Laurent Kalfala, © Knott architects Completion date: 1997
www.knottarchitects.com

Loft owners often underestimate the potential of an open space, spoiling the area by dividing it into traditional rooms. In this case, the clients asked architects to fit two bedrooms, two bathrooms, a kitchen, and living room into a large plot inside a refurbished building in Soho. Wood, steel, and glass partitions were erected against plastered white walls, and the rooms act as pieces of furniture that are detached from the ceilings and party walls. Spotlights are scattered evenly along the ceilings and built into the floors and small cavities inside the walls. The selected materials and techniques emphasize a visual relationship between elements, salvaging the loft's spatial qualities and putting them to good use.

Häufig unterschätzen die Besitzer von Lofts das Potenzial dieser offenen Räume und zerstören ihren Reiz, indem sie sie in normale Zimmer aufteilen. Hier gab der Bauherr den Auftrag, zwei Schlafzimmer, zwei Bäder, eine Küche und ein Wohnzimmer in dem 120 m2 großen Grundriss eines sanierten Gebäudes in Soho unterzubringen. Raumteiler aus Holz, Stahl und Glas stoßen an die verputzten weißen Wände; die Räume wirken wie Möbel, die von Decke und Wänden abgesetzt sind. Strahler sind über die Decken verteilt und im Boden und in Wandnischen eingebaut. Die eingesetzten Materialien und Arbeitsweisen verstärken die optische Verbindung zwischen den Elementen, retten die Geräumigkeit des Lofts und ermöglichen eine sinnvolle Nutzung.

Les propriétaires de loft sous-estiment le potentiel d'un espace ouvert, gâché par le morcellement en pièces traditionnelles. Ici, les clients ont demandé aux architectes d'intégrer 2 chambres, 2 salles de bain, une cuisine et un séjour dans un lot de 120 m2, au sein d'un immeuble rénové de Soho. Des cloisons en bois, en acier et en verre ont été érigées contre les murs de plâtre blanc, les pièces, séparées des plafonds de soutien, s'intégrant à l'ameublement. Des spots sont dispersés régulièrement le long des plafonds, sertis dans le sol et dans des alvéoles murales. Les matériaux et les techniques choisis ont rehaussé le rapport visuel entre les éléments, préservant et mettant à profit la nature spatiale du loft.

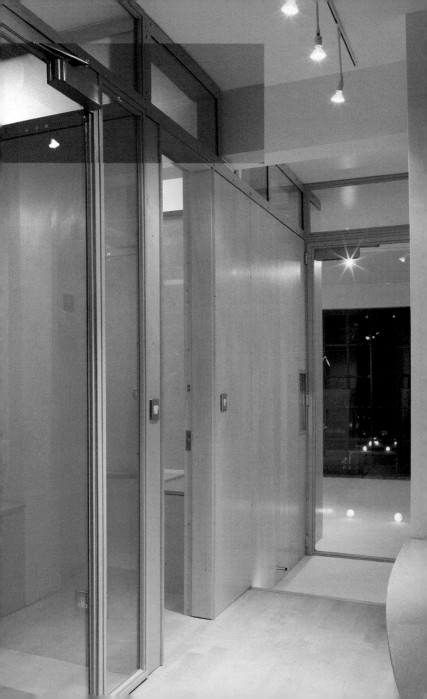

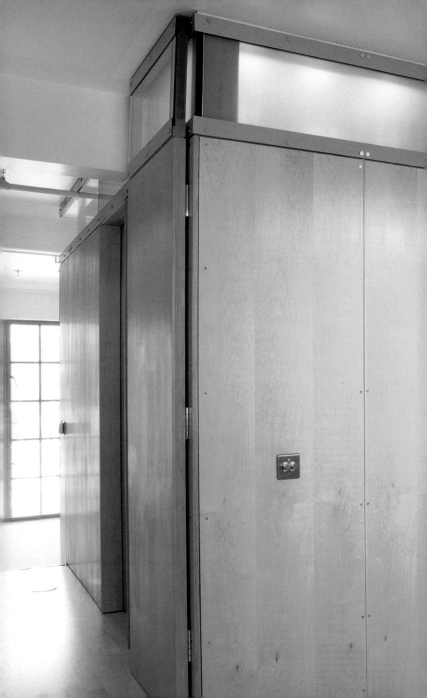

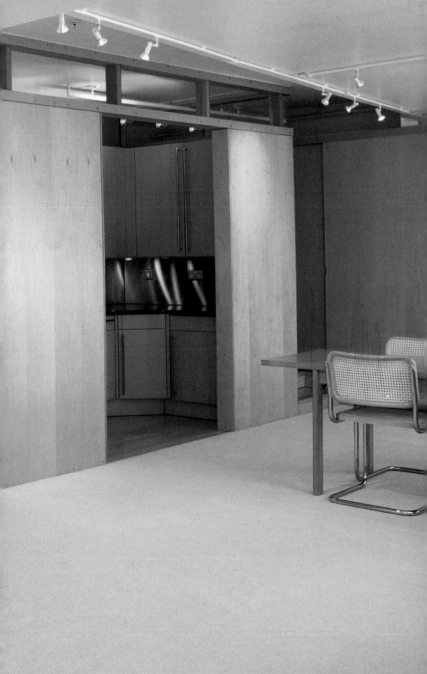

School Conversion
Brian Ma Siy Architects

Photos: © **Jordi Miralles** Completion date: **1996** brian@masiy.demon.co.uk

Home to the architect, this space was originally the ground floor of a school building. The architect left the classrooms intact and painted them white to maximise light. In the center, a 3.5 by 1-meter stainless steel kitchen table acts as worktop for numerous activities. A minimum amount of furniture allows the space to turn into a dojo for karate practice, a playroom, or a lounge area. Architectural features include the Bulthaup kitchen in stainless steel and cobalt blue, the finished steel open-tread stair, and full-height bookshelves accessed from the stairs. filling in the gaps are colorful lights, a block of 20 watercolors, and the six year old's airplanes and train sets scattered throughout the house.

Der Architekt selbst wohnt hier, im ehemaligen Erdgeschoss eines Schulgebäudes. Er ließ die Klassenräume intakt und strich sie weiß, um größtmögliche Helligkeit zu erzielen. Im Zentrum steht ein Allzweckmöbel: die 3,5 x 1 Meter große Küchenarbeitsfläche aus Edelstahl. Dank der minimalen Möblierung kann der Raum in ein Karate-Dojo, ein Spielzimmer oder in eine Lounge verwandelt werden. Zu den gestalterischen Elementen gehören die Bulthaup Küche in Edelstahl und Kobaltblau, die Stahltreppe nur aus Trittstufen und die raumhohen Bücherregale, die über die Treppe erreichbar sind. Das Ganze wird durch eine farbenfrohe Beleuchtung, 20 Aquarelle und die herumliegenden Spielsachen eines Sechsjährigen belebt.

Domicile de l'architecte, cet espace était à l'origine le rez-de-chaussée d'une école. Le créateur a peint en blanc les salles de classes, laissées intactes, pour magnifier la lumière. Au centre, une longue table de cuisine en acier inox offre un plan de travail pour diverses activités. Meublé avec parcimonie, l'espace peut se transformer en dojo pour des entraînements de karaté, en salle de jeu ou en salon. L'ensemble architectural est complété par une cuisine Bulthaup bleu cobalt en acier inox, un escalier en acier poli aux marches ajourées, et des étagères accessibles depuis l'escalier. Des lumières colorées, un ensemble de 20 aquarelles et des jouets d'enfant éparpillés dans toute la maison comblent les espaces.

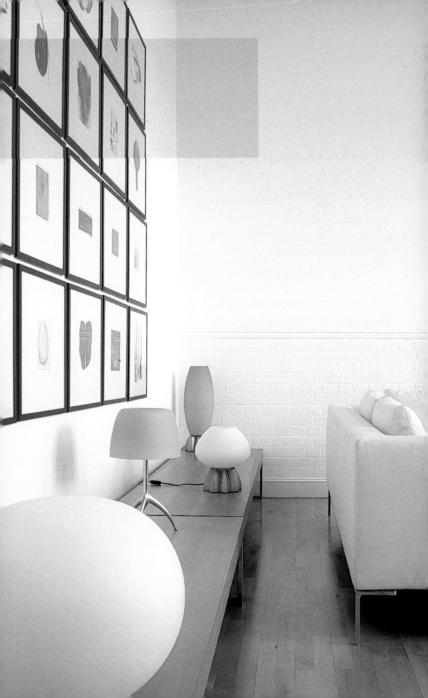

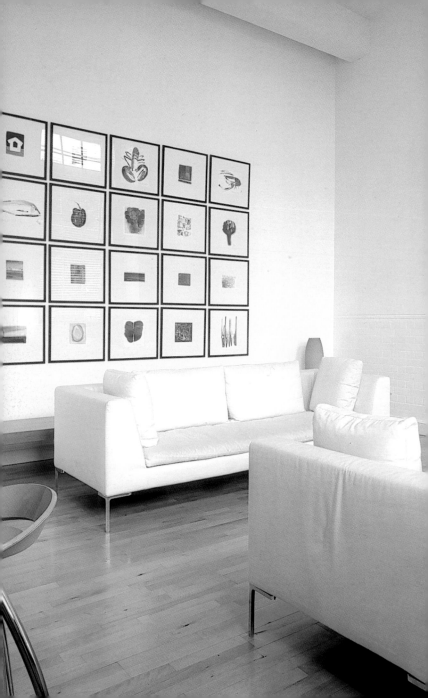

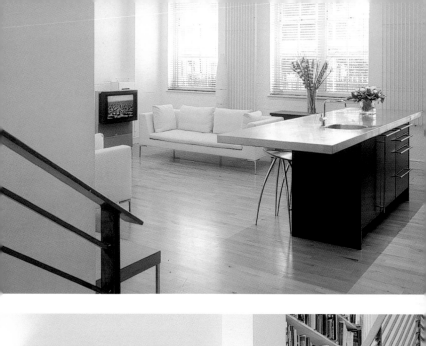

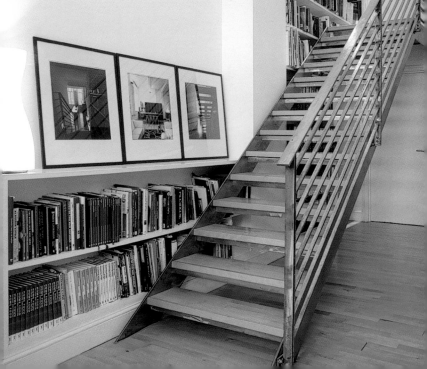

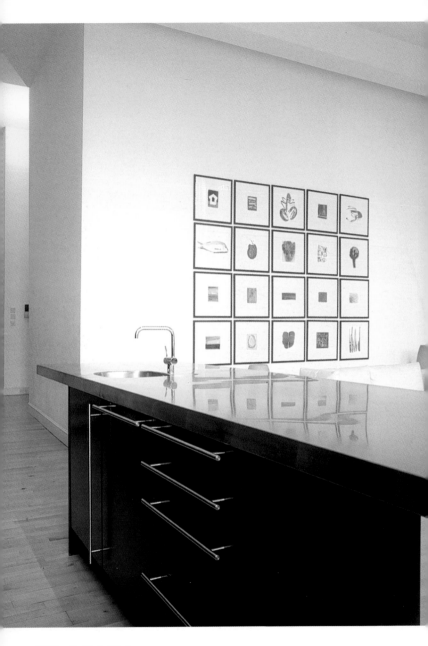

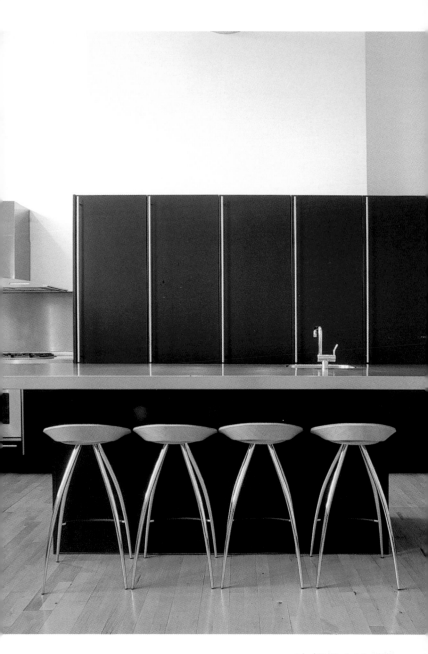

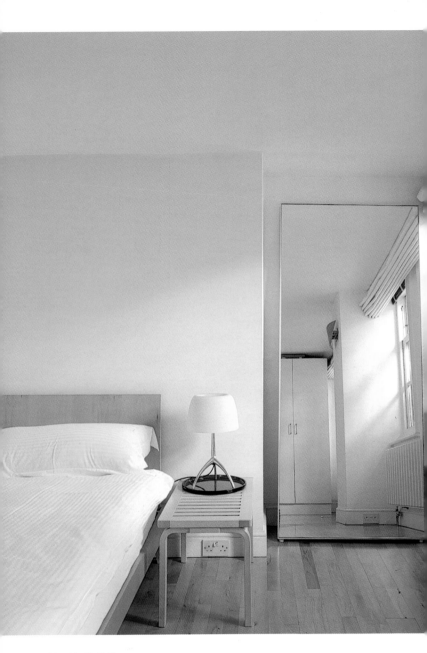

Penthouses in Wardour Street
CZWG Architects

Photos: © **Chris Gascoigne / View** Completion date: **1996**

These spectacular Richmond penthouses seem to have germinated from the existing architecture. The exposed steel framework appears to sprout from the red brick below. Inside, curved ceilings, wood interiors, sliding translucent screens, and original light fixtures create a warm ambience that counterbalances the cool, paved, steel-boned terraces that face east/west on the fifth floor and north/south on the sixth. Created from raw loft spaces characterized by industrial materials, the project's complexity increases and becomes more expressive as the floors rise. The project enjoys wide rooftop vistas and forms part of the scenery; its curved silhouette enriching the vast London skyline.

Dieses atemberaubende Richmond-Penthouse scheint direkt aus dem Bestand hervorgegangen zu sein: das sichtbare Stahlfachwerk sprießt förmlich aus dem roten Ziegel. Innen sorgen gewölbte Decken, Holz, semi-transparente Schiebe-Wandschirme und originelle Lampen für eine warme Atmosphäre, die ein Gegengewicht zu den kühlen, gepflasterten Terrassen mit Stahlgeländern bilden. Ausgehend von den rohen, durch industrielle Materialien geprägten Loft-Räumen, gewinnt das Projekt mit steigender Höhe an Komplexität und Ausdrucksstärke. Vom Dach hat man weite Ausblicke, und die kurvenförmige Silhouette bereichert die Londoner Skyline.

Ces spectaculaires penthouses de Richmond donnent l'impression d'avoir germé de l'architecture existante. La charpente en acier apparent semble pousser hors de la brique rouge. Au-dedans, plafonds courbes, intérieurs en bois, écrans coulissants translucides et éclairages originaux engendrent une ambiance chaleureuse, contrepoids des terrasses d'acier froides et carrelées orientées est/ouest au cinquième, et nord/sud au sixième. Né d'espaces bruts caractérisés par des matériaux industriels, la complexité du projet augmente et devient plus expressive comme les niveaux s'élèvent. Jouissant de perspectives dégagées, intégré dans le paysage, le projet enrichi l'horizon londonien de sa silhouette curviligne.

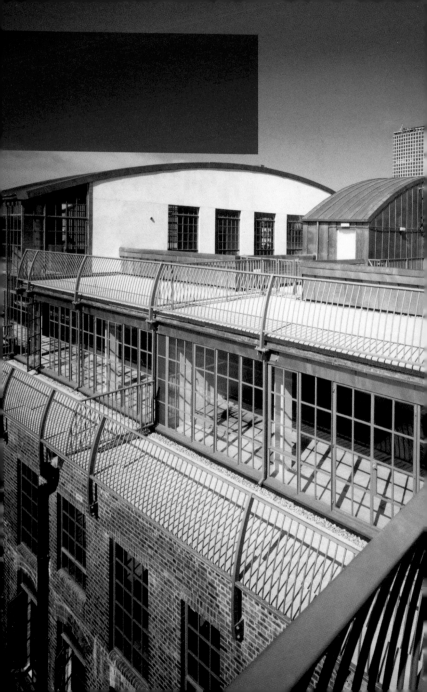

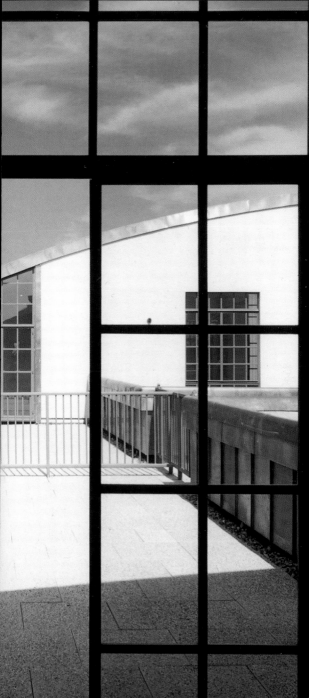

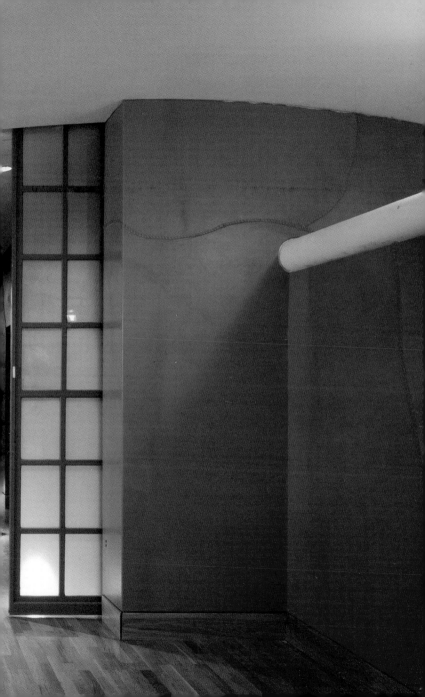

Lee House
Derek Wylie

Photos: © **Nick Cane,** © **Mainstream,** © **Derek Wylie** Completion date: **1996** info@studio-dwa.co.uk

Discovered by the architect on an abandoned site of a former four-story shop front and a two-story silversmith's workshop in the back, the two lower levels were made into a working and living space for himself and his family. Using 250 square meters of floor space, he constructed a basement, ground floor, and second floor with original brick walls, modern lighting, and boarded oak floors. Staircases suggest the physical separation of different living areas, yet still allow for spatial continuity, which exists throughout the house. Colorful tones, precise details, and natural light relax the robust structure. The limestone floor in the back makes for an intimate and charming courtyard.

Der Architekt entdeckte dieses verlassene Gebäude mit vierstöckiger Geschäftsfassade und einer zweistöckigen Schmiede im Hinterhaus und baute die unteren beiden Etagen als Wohnung und Büro für seine Familie und sich um. Auf 250 m² Grundfläche gestaltete er Keller, Erdgeschoss und erste Etage mit Original-Ziegelwänden, moderner Beleuchtung und Eichendielen. Treppen lassen die räumliche Trennung der verschiedenen Wohnbereiche vermuten, unterbrechen jedoch die Kontinuität nicht. Bunte Farben, akkurate Details und natürliches Licht entspannen die robuste Struktur. Durch den Kalksteinboden wirkt der Hinterhof zurückgezogen und behaglich.

Découverte d'un architecte sur le site abandonné d'un ancien magasin à quatre étages et d'une orfèvrerie de deux étages sur son arrière, les deux niveaux inférieurs hébergent des espaces de vie et de travail pour sa famille. Sur 250 m² d'espace au sol, il a construit un sous-sol, un rez-de-chaussée et un second niveau dotés de murs de briques originaux, d'éclairage moderne et de planchers en chêne. Les escaliers suggèrent une séparation physique de différents espaces de vie, mais permettent une continuité spatiale, dans l'ensemble de la maison. Tons colorés, lumière naturelle et détails pacifient la structure massive. Le sol en combe donne un ton intime et charmant à l'arrière-cour.

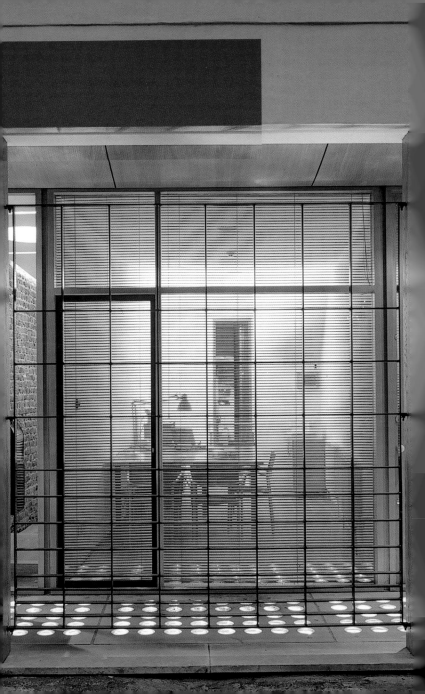

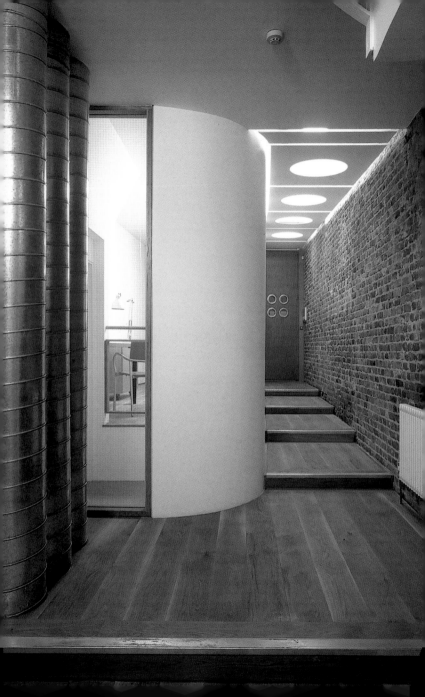

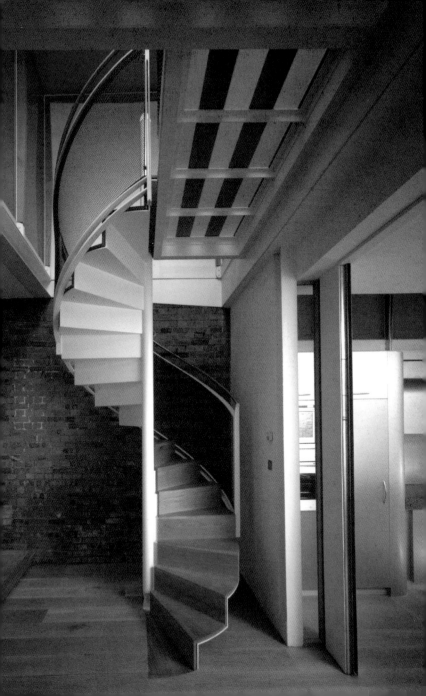

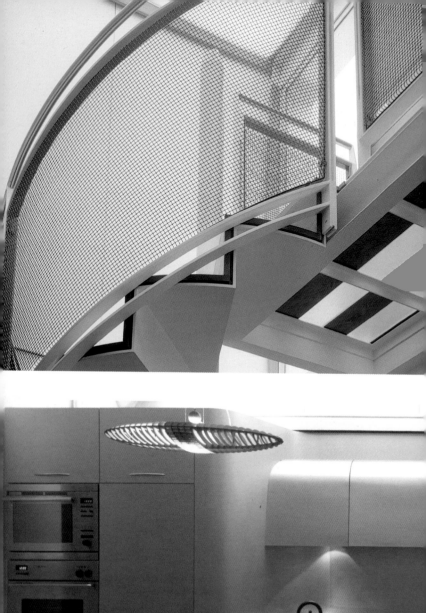
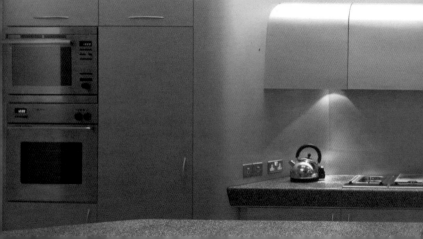

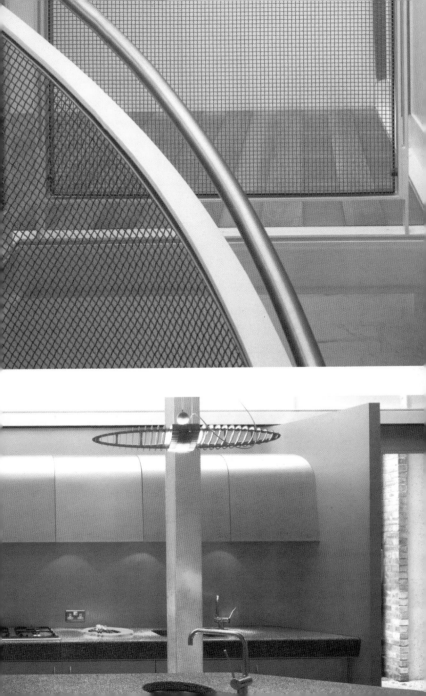

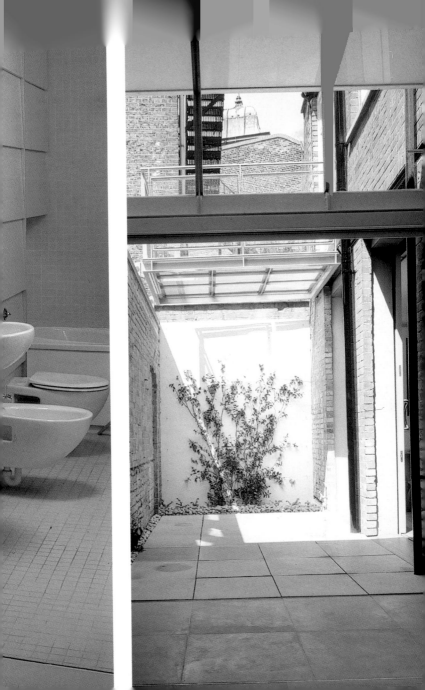

Apartment for a designer
David Edgell

Photos: © **Andrew Wood / The interior archive** Completion date: **1995**

This unconventional setting is an old Victorian-style gramophone factory that menswear designer David Edgell turned into his own personal living and working space, taking advantage of high ceilings and natural light. Due to Britain's strict fire regulations, Edgell was forced to add partitions to the open space, but detaching them from the ceiling and floor created shadow lines that highlighted their independence. Thanks to Edgell's passion for furniture, the interior is a mixture of styles. A stainless steel kitchen, industrial light fixtures, Art Nouveau armchairs, and 20th century chairs in red plastic and pastel colors are set against warm parquet and light colored walls.

Der Modedesigner David Edgell hat dieses unkonventionelle Szenario, eine alte Grammophon-Fabrik viktorianischen Stils, in seine Privatwohnung mit Atelier umgebaut, um in den Genuss der hohen Decken und des natürlichen Lichts zu kommen. Aufgrund der strengen britischen Brandschutzvorschriften musste er Trennwände einziehen, Schatten-kanten am Decken- und Bodenanschluss heben jedoch deren Autonomie hervor. Der Stilmix der Einrichtung ist Ergebnis der Leidenschaft Edgells für Möbel. Eine Edelstahlküche, Fabriklampen, Jugendstilsessel und Plastikstühle des 20. Jahrhunderts in rot und pastell kontrastieren mit dem warmen Parkett und den zart getönten Wänden.

Un décor peu conventionnel: une ancienne fabrique de phonographes de style victorien, transformée en cadre de travail et de vie par le créateur de mode David Edgell, en s'appuyant sur la lumière naturelle et les hauts plafonds. En raison de normes anti-incendie, Edgell dut ajouter des cloisons à l'espace ouvert. Séparées du sol et du plafond elles créent des lignes d'ombre, soulignant leur indépendance. L'intérieur mêle différents styles, grâce à la passion de Edgell pour l'ameublement. Cuisine en acier inox, éclairage industriel, fauteuils Art Nouveau, chaises contemporaines rouges et pastel offrent un contraste avec un parquet chaleureux et des murs colorés.

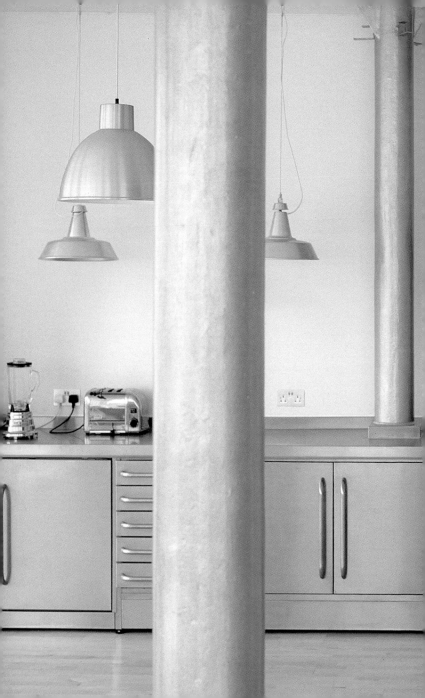

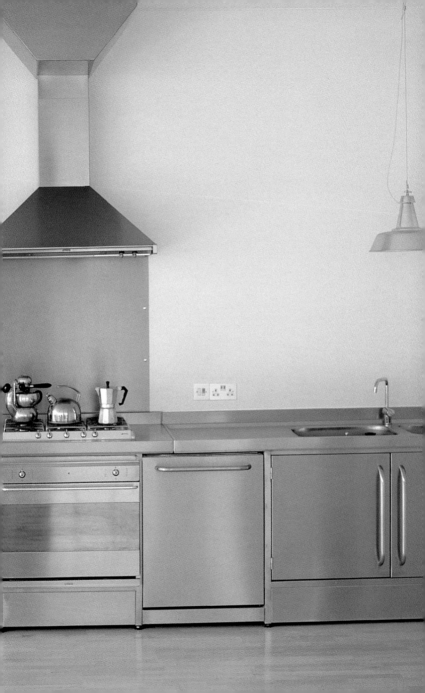

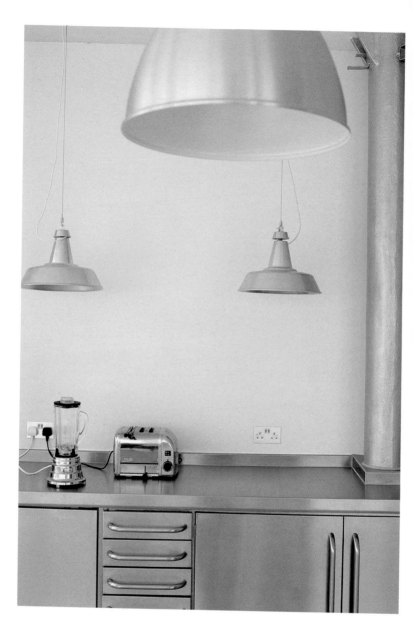

92 David Edgell

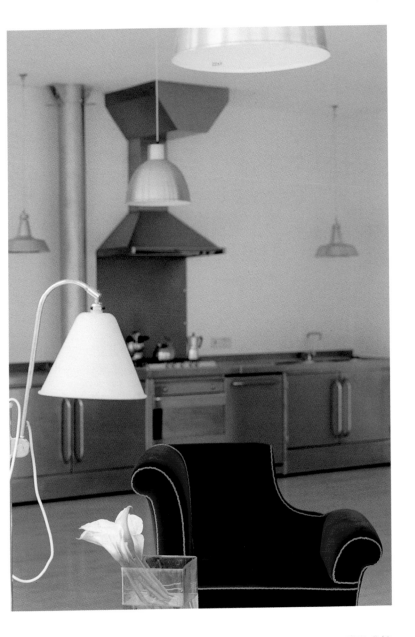

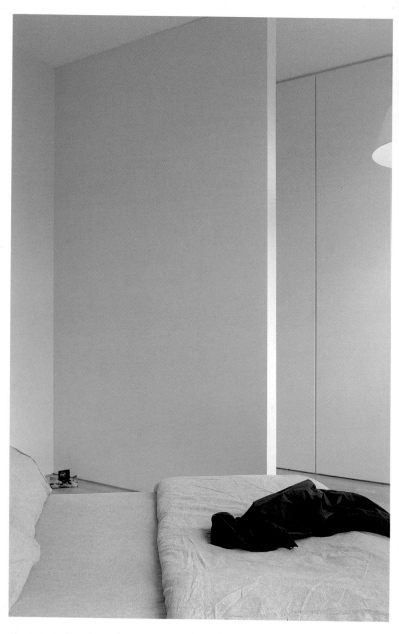

94 David Edgell

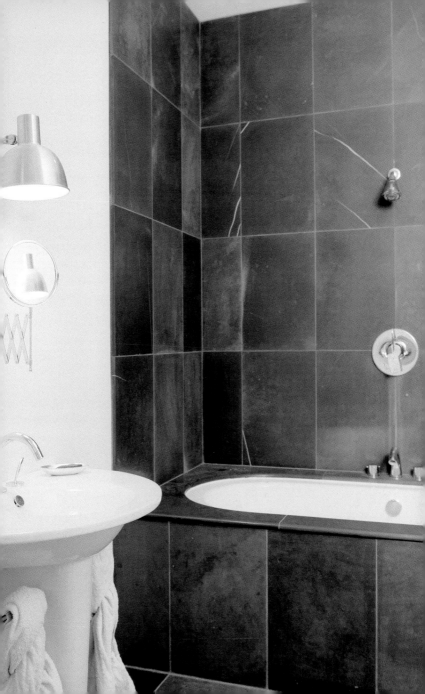

Photos: © **José King / View** Completion date: **1997** architect@noble-assoc.co.uk

On the top floor of a new purpose-built 1990's apartment building, a previously cluttered layout was redesigned into a spacious two-bedroom flat. Partially sheltered by a mansard roof, the space contains two bathrooms, a living room, and a kitchen. The large rectangular living area is enhanced by a skylight, a mirrored wall on one side, and huge window panels running the length of the exterior wall. Full-height doors fold away into pockets of timber paneling between a continuous, leveled ceiling and Afromosia timber floors. Special features include a recessed track between the walls and ceiling that serves as a picture rail and a stone bathtub with Japanese proportions in the master bathroom.

Die oberste ungeordnete Etage eines 1990 fertiggestellten Wohnblocks wurde in eine geräumige Zwei-Zimmerwohnung umgestaltet. Ein Teil der Wohnung liegt unter einem Mansardendach; sie umfasst zwei Bäder, Wohnzimmer und Küche. Der große, rechteckige Wohnraum wird durch ein Oberlicht und eine verspiegelte Wand auf der einen Seite sowie durch riesige Fensterscheiben über die gesamte Länge der Außenfassade noch vergrößert. Raumhohe Türen falten sich in Taschen aus Holzpaneelen unter einer durchgehenden ebenen Decke und über den Holzböden aus Afromosia. Zu den Besonderheiten gehören eine Schattenkante am Deckenanschluss, die als Bilderleiste dient und eine beeindruckende Steinbadewanne im größten Badezimmer.

Au dernier étage d'un immeuble d'appartements, datant des années 90, cet agencement encombré a été remodelé en un lieu spacieux de deux chambres. Partiellement couvert par un toit mansardé, l'espace loge deux salles de bain, un séjour et une cuisine. La vaste aire de séjour est mise en valeur par une lucarne, un mur de miroir d'un côté, et de grands panneaux vitrés le long du mur extérieur. Des portes de pleine hauteur se replient dans des logements en panneaux de bois, entre un plafond nivelé et des parquets en afromosia. Un rail en renfoncement servant de présentoir et, dans la chambre principale, une baignoire en pierre aux proportions japonaises constituent des caractéristiques spéciales.

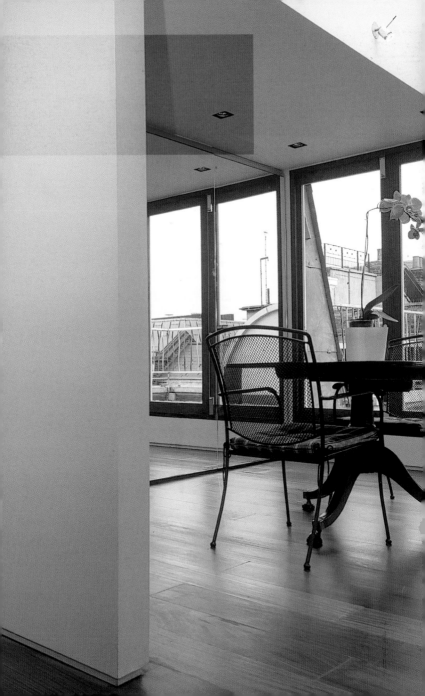

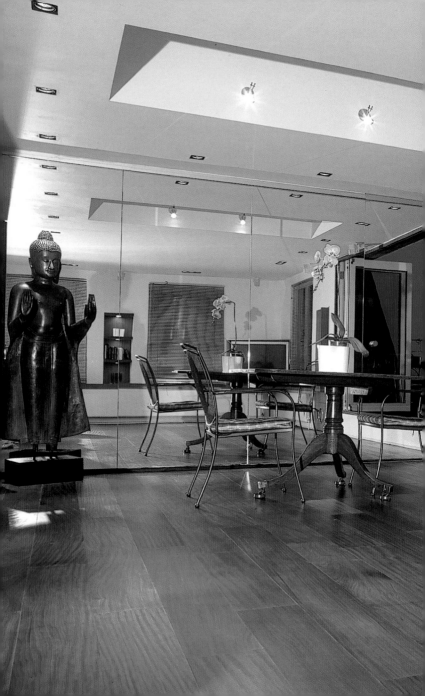

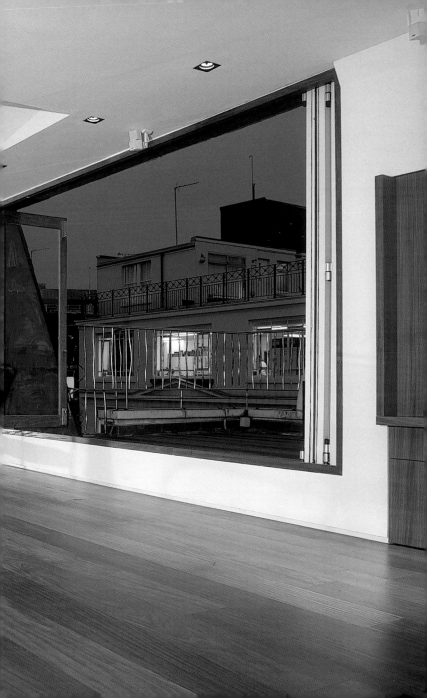

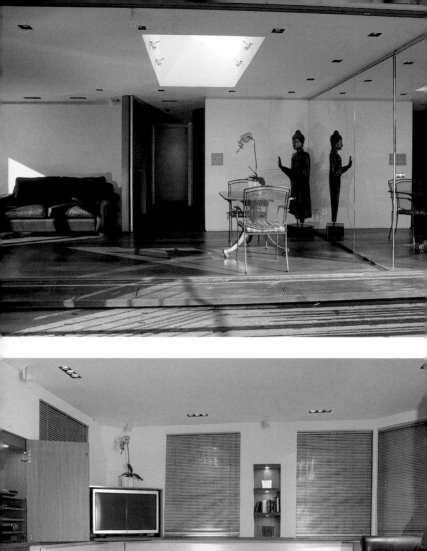

Photos:© **Chris Gascoigne / View,** © **Lifschutz** Completion date: **1998** mail@lifschutzdavidson.com

This five-floor apartment building, formerly the Gas Corporation Research Centre and named after the artist who created the murals for its facade, is located smack in the center of 1,080,000 square feet of light industry, offices, stores, and indoor spaces for common use. The architect doubled the interior ceiling heights, preserved the broad windows, and built outside balconies that are supported by metallic cables anchored to the roof. Numerous materials and cheerful colors adorn the white walls, and every ray of light afforded by London's skies fills the fresh and modern interiors. This project is a victorious attempt at converting an industrial building into a residential community.

Dieses fünfstöckige Wohnhaus, ursprünglich das Forschungszentrum des Gaswerkes und nach dem Künstler benannt, der die Fresken an der Fassade gestaltet hat, liegt mitten in zehn Quadratkilometer Industriegebiet, Büros, Läden und überdachten Gemeinschaftsräumen. Die Architekten verdoppelten die Deckenhöhe, erhielten die breiten Fenster und bauten Balkone an, die an im Dach verankerten Metalldrähten hängen. Zahlreiche Materialien und leuchtende Farben schmücken das Weiß der Wände und jeder Lichtstrahl vom Londoner Himmel belebt die frischen, modernen Räume. Dieser Entwurf ist ein überzeugendes Beispiel für den Umbau eines Industriegebäudes in ein Mehrfamilienhaus.

Baptisé d'après l'auteur des fresques de sa façade, cet immeuble de cinq étages, anciennement Centre de Recherche de la Compagnie du Gaz, est situé juste au cœur de 100 000 m² d'industrie légère, de bureaux, de boutiques et d'espaces publics intérieurs. L'architecte a doublé les hauteurs de plafond, préservant les baies vitrées, et construit des balcons extérieurs, soutenus par des câbles métalliques arrimés au toit. Les murs blancs étant parés de matériaux nombreux, et de couleurs vives, le moindre rayon de lumière offert par le ciel londonien remplit les intérieurs neufs et modernes. C'est un essai réussi de conversion d'immeuble industriel en communauté résidentielle.

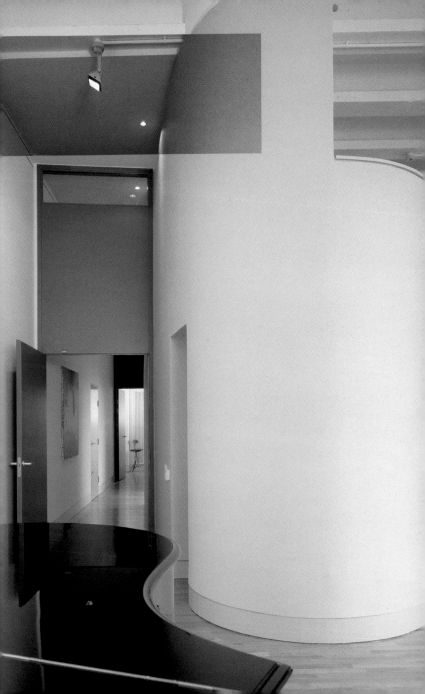

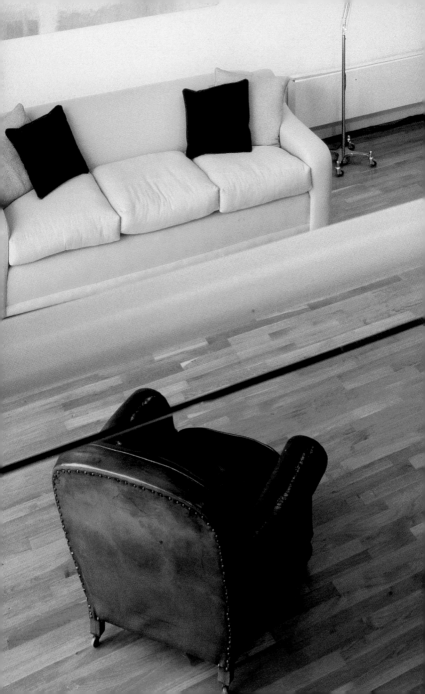

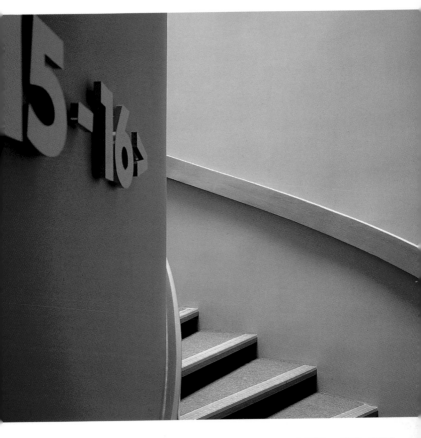

A curved stairwell provides access to the
corridors along which the apartments are
found. The new roof anchored balconies allow
a fluid connection from the outside in, where
light penetrates through large windows.

Ein ovale Treppe erschließt die Flure, an
denen sich die Apartments anreihen. Die
neuen im Dach verankerten Balkone bilden
fließende Übergänge nach draußen und
Tageslicht scheint durch große Fenster.

Une cage d'escalier courbe offre un accès aux
couloirs où se trouvent les appartements.Les
balcons situés sur le nouveau toit fluidifient
la communication vers l'intérieur, la lumière
s'engouffrant à travers de grandes fenêtres.

Thomson / BleeResidence

Rivington Street Studio

Photos: © **Sarah Blee** Completion date: **2000** rss@rssa.co.uk

Built as an addition to an existing family house, this project aimed to build a structure linked to the adjoining house that would contain four bedrooms and extra living space. The ground floor accommodates a large, L-shaped living room that opens onto a long timber deck through huge sliding and pivoting doors. The second floor, in a similar shape, contains a spacious kitchen/dining/living area. Two ample bedrooms are located on the top floor and divided by a screen wall made of dark-stained timber. The windows have varying dimensions according to their orientation and function. Walls are pristine white, spaces are generous, ceilings are high, and light is abundant in this classically modern home.

Dieser Anbau an ein bestehendes Einfamilienhaus sollte mit dem Haupthaus verbunden werden und vier Schlafzimmern und zusätzlicher Wohnfläche Platz bieten. Im Erdgeschossbefindet sich ein großer L-förmiger Raum, der sich über große Fenstertüren auf eine holzbelegte Terrasse öffnet. Das obere Geschoß gleicher Struktur nimmt einen weiten Koch-/Ess/Wohnbereich auf. Zwei großzügige Schlafzimmer liegen in der obersten Etage, sie sind durch eine Wand aus dunkelgefärbtem Holz getrennt. Die Fenstergröße variiert je nach Orientierung und Funktion. Die Wände in diesem klassisch-modernen Zuhause sind makellos weiß, die Räume groß, die Decken hoch und das Licht reichlich.

Extension d'une demeure de famille, ce projet tendait à créer une structure reliée à la maison attenante, et comprenant 4 chambres ainsi qu'un séjour supplémentaire. Le rez-de-chaussée reçoit un grand séjour en forme de L qui s'ouvre, par de larges portes pivotantes-coulissantes, sur une longue passerelle en bois. Le second étage, de forme similaire, contient une aire cuisine/repas/séjour spacieuse. Situées au dernier étage, deux belles chambres sont séparées par une séparation en lambris teintés de sombre. Les fenêtres sont modulables selon leur orientation et leur utilisation. Les murs d'un blanc virginal, les espaces généreux, les hauts plafonds et une lumière abondante caractérisent cette demeure moderne classique.

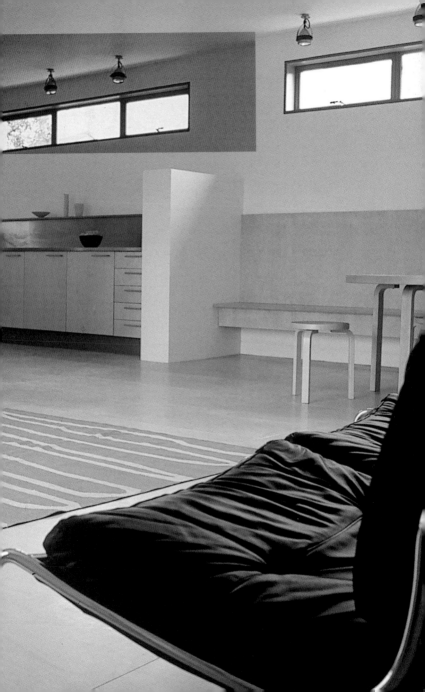

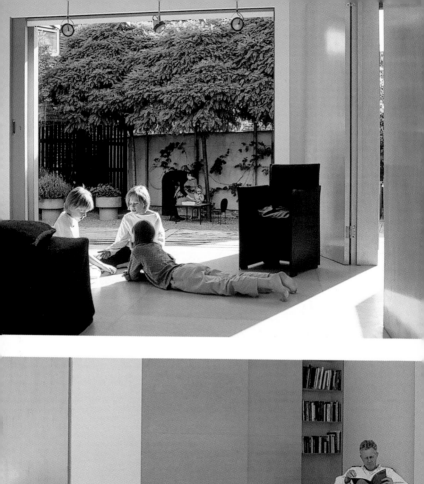
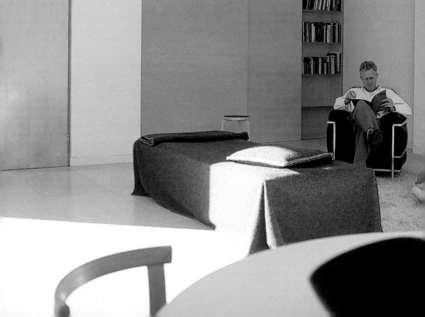

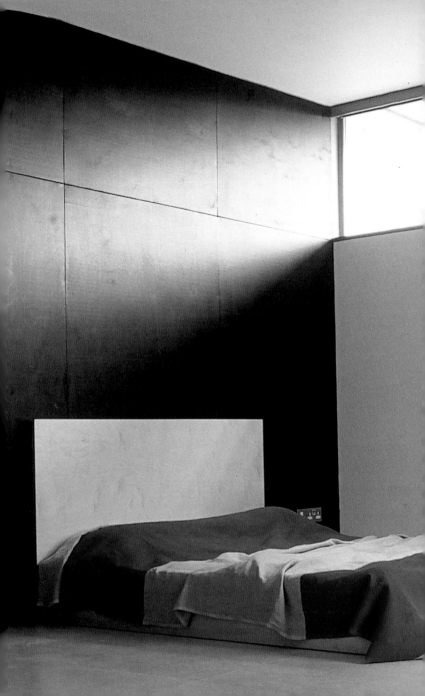

Basement Flat in Chalcot Square
Walters & Cohen

Photos: © **Dennis Gilbert / View** Completion date: **2000** mail@waltersandcohen.com

Remodelling this ground floor and basement-level apartment revolved around the long and lavish garden at the rear of this house. Architects conserved the layout of the ground floor which contained a central bathroom flanked by a bedroom with windows on either side. The four rooms on the lower level became a singular long space lined on one side by sliding screens that block off functional areas like the kitchen and laundry room. This space culminates in a sliding glass wall that flows straight through to the patio and garden. Efficiency and aesthetic intuition combine to generate a relaxed home that coexists with its natural surroundings.

Der Umbau des Erdgeschosses und Semi-Souterrains drehte sich um den langen und üppi-gen Garten hinter dem Haus. Die Architekten hielten sich an den Grundriss des Erdgeschosses mit dem in der Mitte gelegenen Bad, flankiert von einem Schlafzimmer mit Fenstern auf jeder Seite. Die vier Zimmer des Souterrains wurden zu einem langen Raum vereint; Wandschirme decken an einer Seite Küche und Waschküche ab. Der Raum ist über eine Glaswand aus Schiebeelementen direkt mit Innenhof und Garten verbunden. Rationalität und ästhetische Intuition zusammen ergeben eine entspannte Atmosphäre, die mit der natürlichen Umgebung in Einklang steht.

La rénovation de cet appartement en rez-de-chaussée et sous-sol a gravité autour d'un jardin majestueux, situé sur son arrière. Les architectes ont conservé la disposition du rez-de-chaussée, avec une salle de bain centrale encadrée des deux côtés par une chambre avec fenêtres. Les qua-tre pièces du niveau inférieur sont devenues un espace unique doté, sur un côté, de cloisons coulissantes créant des aires fonctionnelles, ainsi une cuisine et une buanderie. Une baie vitrée coulissante, s'étendant jusqu'au patio et au jardin, constitue le point culminant de cet espace. Efficacité et intuition esthétique s'associent pour créer un foyer tranquille, coexistant avec la nature environnante.

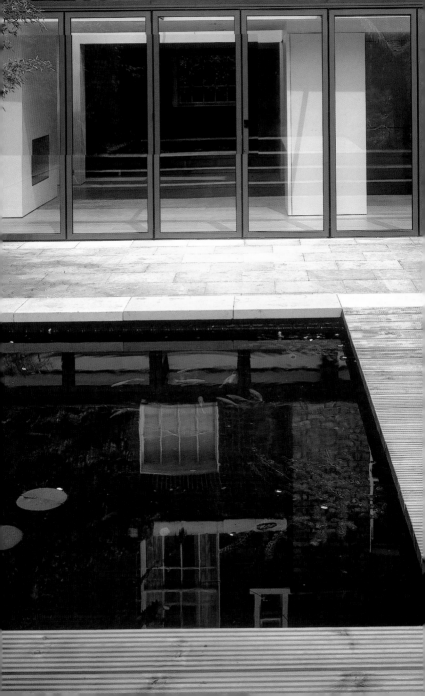

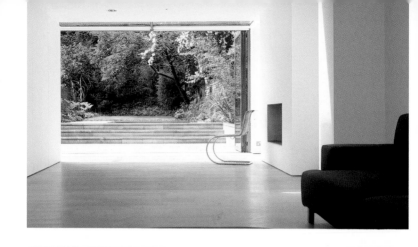

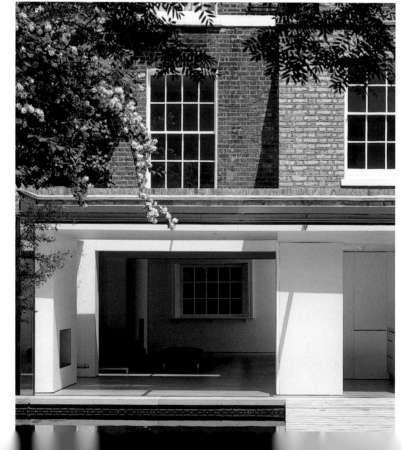

A sliding wall shuts off or opens up the home to the exterior patio and garden.
The new lower structure blends in effortlessly with its original architecture, its
open plan taking advantage of its typically lush English garden.

Schiebeelemente verschließen oder öffnen die Wohnung zum Innenhof und Garten.
Das neue Geschoss fügt sich harmonisch in den Bestand ein, und der
offene Grundriss nutzt die Vorteile des typisch englischen üppigen Gartens.

Une séparation coulissante ferme/ouvre la demeure sur le patio extérieur
et le jardin. La structure inférieure fusionne sans effort avec l'architecture d'origine. Son
plan ouvert tire parti de la luxuriance typique du jardin anglais.

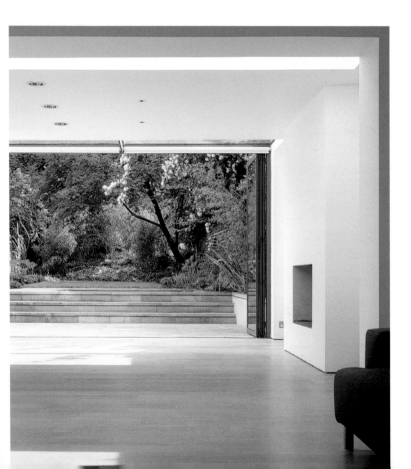

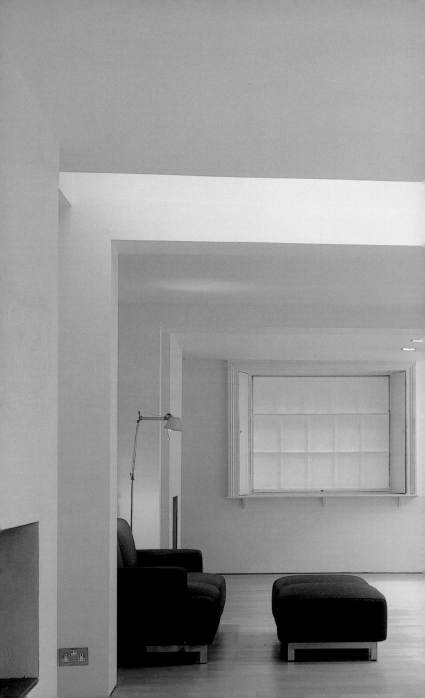

This project, home to a journalist and his family, offers a horizontal living space attatched to a typically vertical Victorian house. The small kitchen was eliminated and replaced with a full width kitchen and dining room that extends onto a garden that was raised and decked over. This structure incorporates full length folding windows and creates a shared and continuous environment between the interior and exterior of the house. Behind the kitchen lies a cozy sitting area with warm lighting and comfy furniture. A doorway and wall opening permit the communication between these areas, a concept which is fundamental to this light and fluid space.

Dieses Projekt für einen Journalisten und seine Familie schließt einen horizontalen Wohnraum an ein typisch vertikales viktorianisches Wohnhaus an. Die kleine Küche wurde entfernt und durch einen langen Küchenblock und Essplatz ersetzt, der sich bis zum Garten ausdehnt; dieser wurde aufgeschüttet und mit Planken abgedeckt. Der Anbau hat faltbare Fenstertüren über die gesamte Breite und bildet einen gemeinschaftlichen und durchgängigen Raum zwischen innen und außen. Hinter der Küche liegt eine gemütliche Sitzecke mit warmer Beleuchtung und komfortablen Möbeln. Ein Flur und eine Wandöffnung erschließen die verschiedenen Bereiche, es ist ein fundamentales Konzept in diesem hellen und fließenden Raum.

Ce projet, foyer d'un journaliste et de sa famille, offre un espace de vie horizontal, dans le cadre d'une demeure Victorienne typiquement verticale. La petite cuisine a disparu, remplacée par une beaucoup plus large associée à la salle à manger, s'étendant vers un jardin surélevé et redécoré. Cette structure comprend des fenêtres pliables sur toute leur longueur, créant un environnement partagé et continu entre l'intérieur et l'extérieur de la maison. Derrière la cuisine se cache une aire de repos douillette, à l'éclairage chaleureux et au mobilier confortable. Une entrée et une ouverture dans le mur facilitent la communication entre ces zones, concept fondamental pour cet espace clair et fluide.

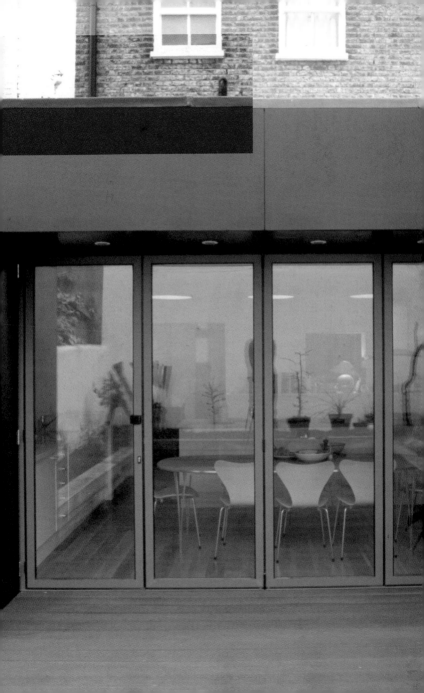

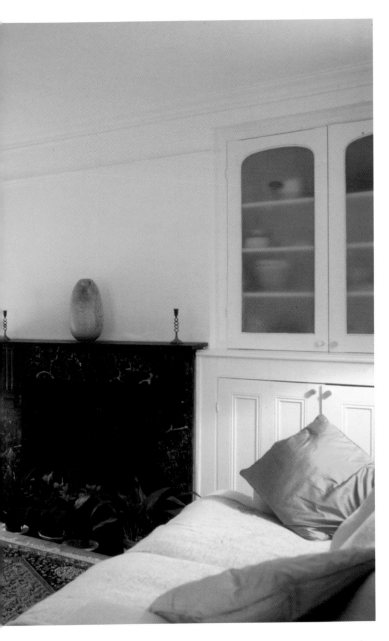

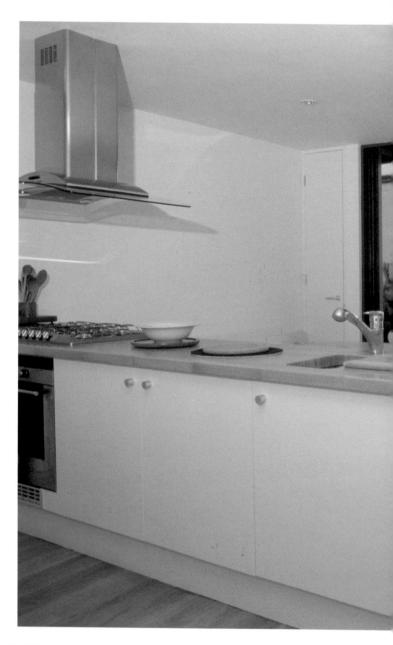

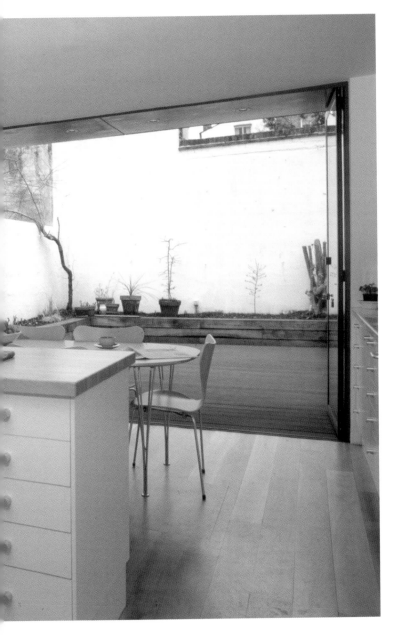

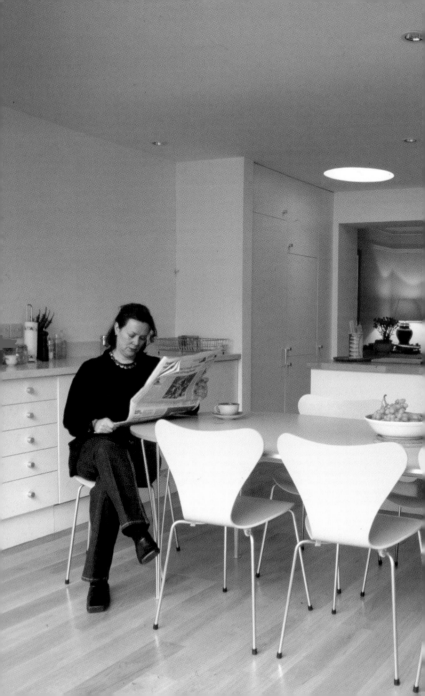

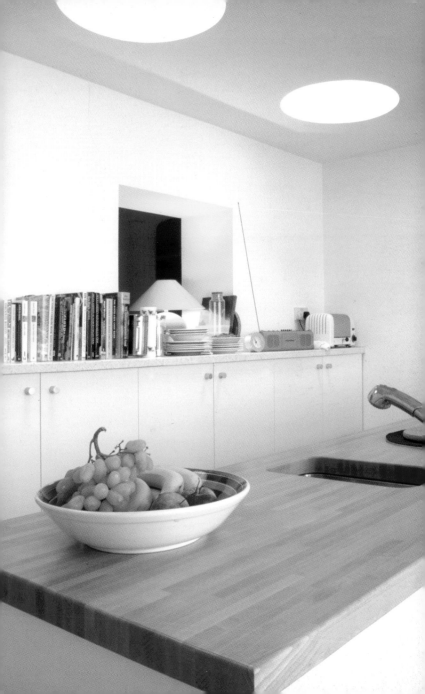

Photos: © **Tim Brotherton** Completion date: **2001** matthewb@hudsonfeatherstone.co.uk

The main challenge in designing this home was to create a series of open, interconnected spaces to suit a modern family lifestyle within a very narrow site. Only four meters wide, the house is arranged around a courtyard and central stairwell. It faces inwards towards the courtyard as opposed to the street. A lozenge-shaped spiral staircase connects the home's different levels, eliminating the need for corridors. Rooms are at half levels to each other across the courtyard and all external walls are fully glazed, enhancing the illusion of space. The rooms are uncluttered, and tangy-toned furniture and accessories spice up the cool white walls.

Die größte Herausforderung bei der Gestaltung dieser Wohnung lag darin, auf einem sehr schmalen Grundstück mehrere offene miteinander verbundene Räume zu schaffen, die dem Lebensstil einer modernen Familie entsprechen. Gerade mal vier Meter breit, liegt das Haus um einen Hof und ein zentrales Treppenhaus. Eine Fassade geht zum Innenhof, die andere auf die Straße. Eine rautenförmige Wendeltreppe verbindet die verschiedenen Ebenen und macht Flure überflüssig. Die Räume liegen um eine halbe Etage versetzt um den Innenhof und alle Außenfassaden sind vollverglast, wodurch der Eindruck von Größe gesteigert wird. Die Zimmer sind frei und geordnet, und knallige Möbelstücke und Accessoires beleben die kühlen weißen Wände.

La conception de ce foyer avait pour défi la création d'une série d'espaces ouverts interconnectés, s'adaptant au style de vie d'une famille moderne, dans un volume réduit. Large de seulement quatre mètres, la maison s'organise autour d'une cour et d'un escalier central. Elle est dirigée vers l'intérieur, vers la cour, tournant le dos à la rue. Un escalier en colimaçon en losange relie les différents niveaux, rendant les couloirs obsolètes. Les pièces s'étagent en demi-palier autour de la cour, et les murs externes sont tous vitrifiés, accroissant l'illusion d'espace. Les pièces sont aérées, et les murs blancs calmes sont pimentés d'accessoires et de mobilier aux tons vifs.

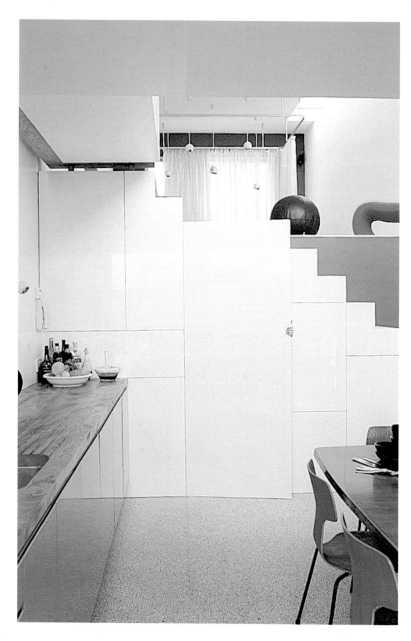

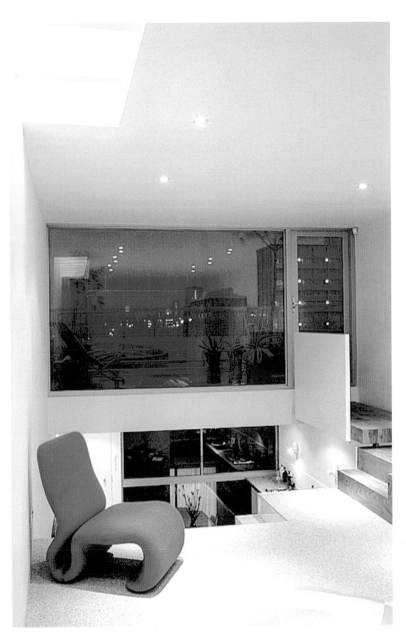

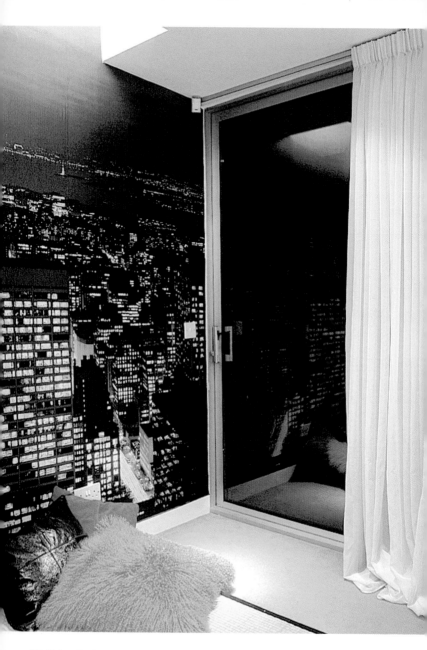

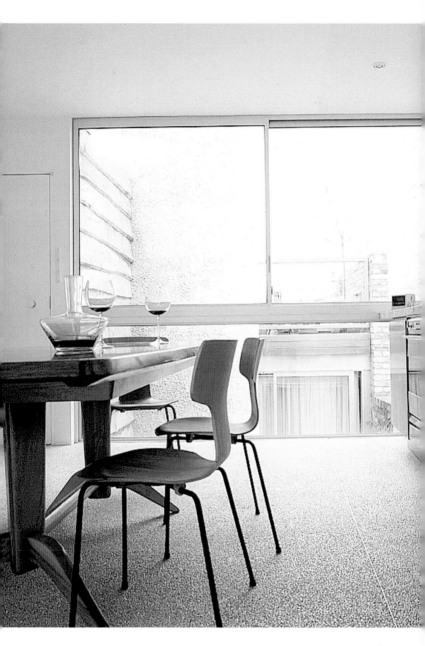

This apartment was inspired by the architect's memories of his childhood in Japan. In order to recreate the Asian qualities of light and texture that he longed for, the flat was divided into three spaces. On one side, a timber frame attaches a series of miniature rooms. On the other side, a four-meter high bamboo wall encloses a bank of storage and utility rooms. This curved wall creats deep shadows penetrated by creeping shafts of light. The main living space enjoys floor-to-ceiling views towards the north. Natural plaster, Japanese tatami mats, dark green slates, translucent 'shoji' paper screens, and dark stained wood frames set off the client's dark red oriental furniture.

Dieses Apartment wurde von den Erinnerungen des Architekten an seine Kindheit in Japan inspiriert. Um die asiatischen Lichtverhältnisse und Texturen zu erzielen, wurde die Wohnung in drei Zonen aufgeteilt. Auf der einen Seite reiht eine Holzrahmenstruktur mehrere Miniaturzimmer auf. Auf der anderen Seite verschließt eine vier Meter hohe Bambusverkleidung eine Wand mit Stau- und Nutzräumen. Diese geschwungene Wand zaubert tiefe Schatten, die von hellen Lichtspitzen durchdrungen werden. Vom Hauptwohnraum genießt man raumhohe Ausblicke nach Norden. Naturfarbener Putz, Tatami-Matten, dunkelgrüner Schiefer, durchscheinende "Shoji"-Wandschirme und dunkelgebeizte Holzrahmen heben die orientalischen Möbel des Besitzers hervor.

Cet appartement est inspiré des souvenirs d'enfance au Japon de l'architecte. Afin de recréer les qualités asiatiques de lumière et de texture dont il se languissait, le lieu fut divisé en trois. D'un côté, un cadre de bois joint une suite de pièces minuscules. De l'autre, un mur de quatre mètres en bambou enceint un ensemble de pièces de rangement et d'entretien. Ce mur recourbé engendre des ombres profondes, percées de rayons de lumière. Le séjour principal jouit de vues plein nord, du sol au plafond. Plâtre naturel, tatamis japonais, ardoises vert sombre, cloisons en papier «shoji» translucide et cadres de bois sombres et colorés mettent en valeur le mobilier oriental rouge profond.

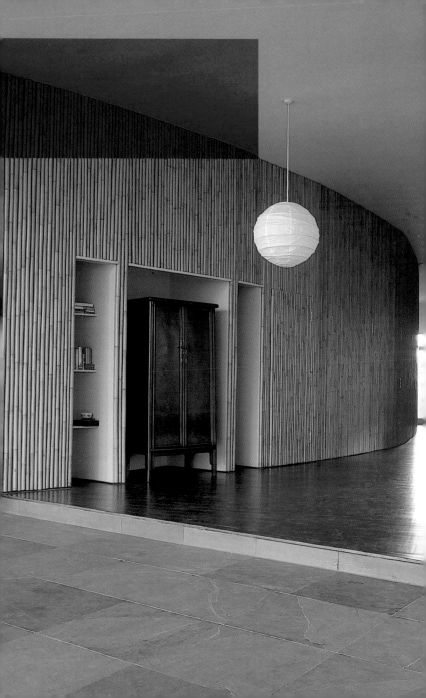

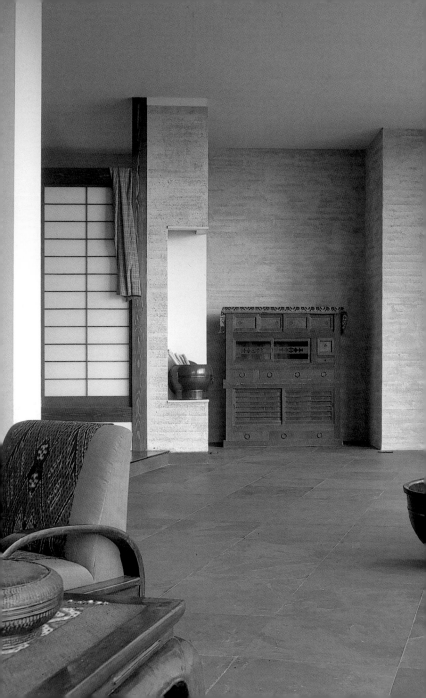

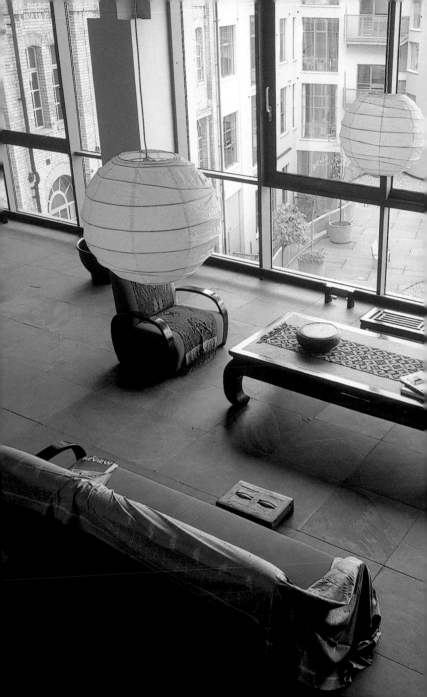

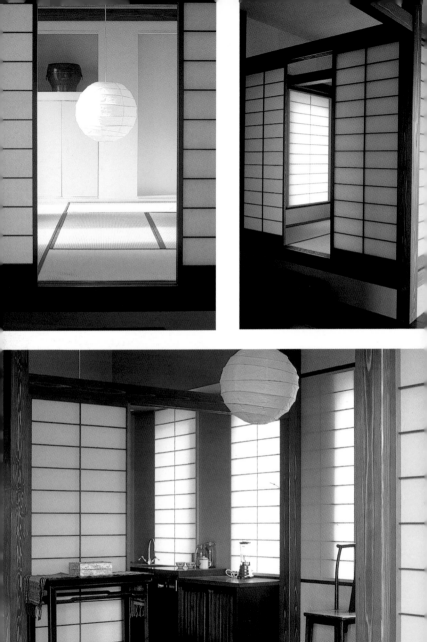

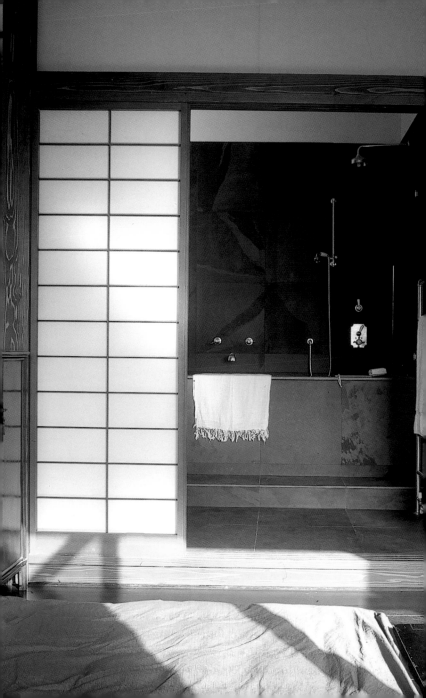

Photos: © **Keith Collie** Completion date: **2000** office@azmanowens.com

Situated on the top floor of a converted Victorian school, this loft was renovated and restructured to suit the owner's needs and lifestyle. Light was a major issue, since only one window accompanies the rooflights across the west side of the roof. Original roof trusses were kept in place, while the two mezzanine floors were modified, introducing a third level at one side and a glass floor panel to allow light to filter down to the lower levels. Two more glass panels on the second level let light flow into the kitchen below. A new metal clad staircase flanked by a tall shelving structure that acts as a balustrade anchors and defines the surrounding space.

In der obersten Etage eines umgebauten viktorianischen Schulgebäudes wurde dieser Loft nach den Bedürfnissen des Besitzers renoviert und neu strukturiert. Dem Licht wurde große Wichtigkeit beigemessen, da neben den Luken in der westlichen Dachseite nur ein Fenster vorhanden war. Die ursprünglichen Dachbalken wurden an Ort und Stelle belassen, zwei Zwischengeschosse jedoch verändert, indem eine dritte Ebene sowie ein Glasboden eingezogen wurden, um das Licht bis nach unten durchzulassen. Zwei weitere Glasflächen in der zweiten Ebene leiten das Licht bis in die darunter liegende Küche. Eine neue metallverkleidete Treppe, flankiert von einer hohen Regalkonstruktion, die als Balustrade fungiert, definiert den umgebenden Raum.

Au dernier étage d'une école Victorienne reconvertie, ce loft a été rénové pour s'adapter au style de vie et aux besoins du propriétaire. La lumière s'est révélée essentielle, la clarté venant de l'angle ouest du toit étant assistée par une seule fenêtre. Les poutres ont été préservées et les sols de deux mezzanines modifiés pour introduire un troisième niveau, d'un côté, et un panneau vitré au sol pour que la lumière s'infiltre vers les étages inférieurs. Au deuxième, deux panneaux supplémentaires laissent la clarté affluer dans la cuisine, au-dessous. Un nouvel escalier de métal, encadré par une structure en rayonnage servant de balustrade, stabilise et définit l'espace environnant.

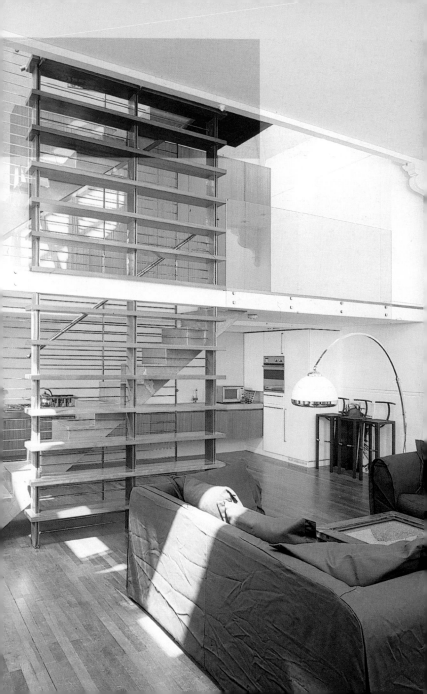

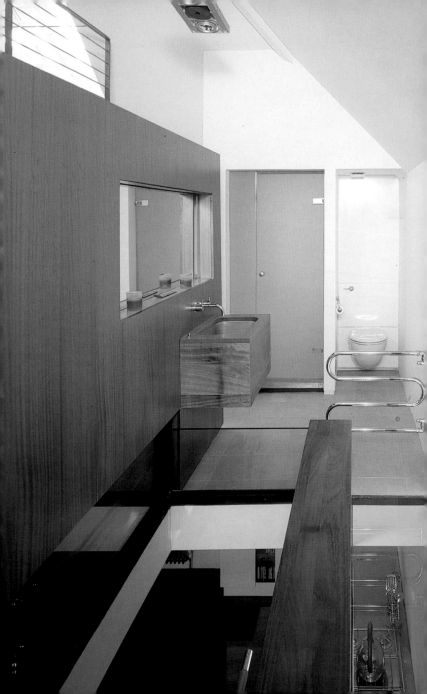

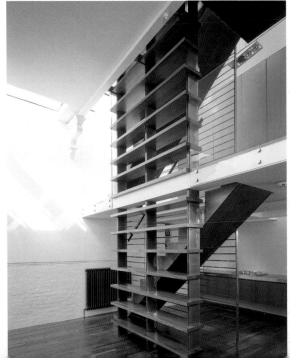

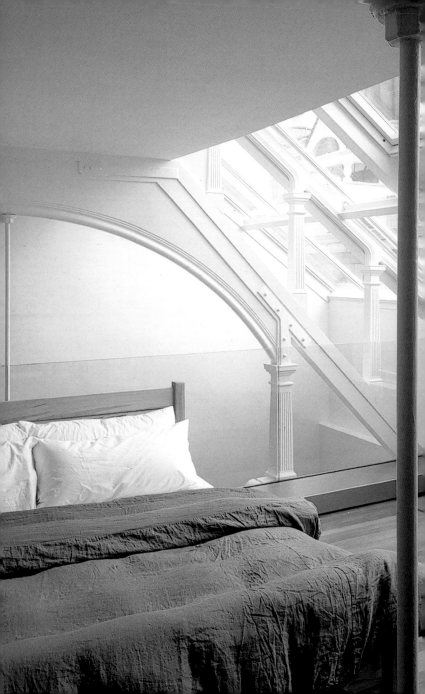

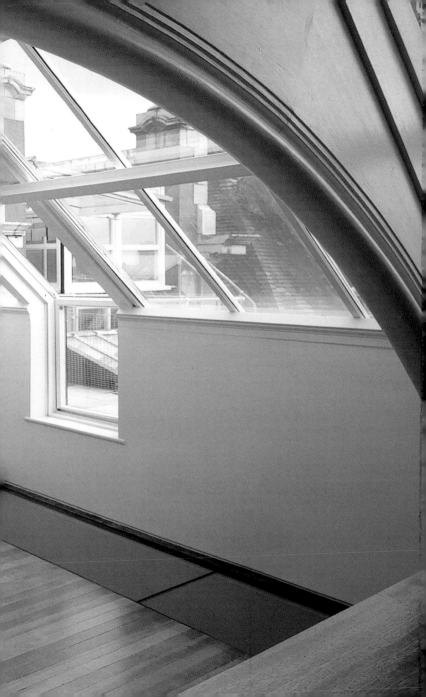

Clark Residence in Little Venice
Jonathan Clark

Photos: © **Jan Baldwin** Completion date: **1995** r&jclark@prrtland.co.uk

Johnathan Clark began reforming this first floor of a Victorian end of a terraced house by eliminating all the existing internal walls and low ceilings. He inserted a new structural frame, obtaining a totally open plan space. The eleven-meter main space is divided by a full-height, top hung sliding acoustic wall that permits the residence to function as either a one or two bedroom home. Natural light passes through French windows and shines through the acid-etched glass shower into the mosaic bathroom. The use of raised platforms enhances the illusion of space. American black walnut floors, stainless steel surfaces, pristine white walls, and retro patterns and furniture complete the look of this architect's stylish home.

Jonathan Clark begann die Renovierung der ersten Etage eines Reiheneckhauses mit der vollständigen Entkernung und dem Einbau eines neuen Tragwerks, um so einen offenen, großen Raum zu schaffen. Der elf Meter lange Hauptraum wird durch eine raumhohe schallisolierte Schiebewand an einer Deckenschiene geteilt, so dass das Apartment entweder als Zwei- oder Dreizimmer-Wohnung fungieren kann. Tageslicht fällt durch die Sprossenfenster und scheint durch die säurebehandelte gläserne Duschkabine bis in das mosaikgekachelte Badezimmer. Podeste verstärken den Raumeindruck. Walnussböden, Edelstahloberflächen, makellos weiße Wände und Retro-Muster und –Möbel vervollständigen den Look des stilisierten Heims.

Jonathan Clark a abordé la rénovation de ce logement en éliminant les parois internes et les plafonds bas existants et en insérant une nouvelle charpente. Un espace complètement ouvert est né. La pièce principale de 11 mètres peut être divisée par un mur acoustique pleine-hauteur, coulissant au plafond, qui permet à la résidence de comporter une ou deux chambres. Au travers de fenêtres, la lumière remplit l'espace, filtrée par une douche en verre dépoli à l'acide dans la salle de bain en mosaïques. Les plate-formes rehaussent l'illusion d'espace. Parquets de noyer noir, surfaces en acier inox, murs d'un blanc virginal, motifs et meubles rétro complètent le look de la demeure stylée.

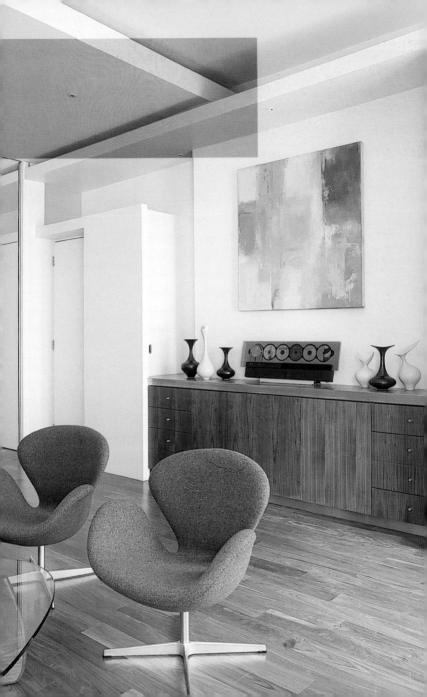

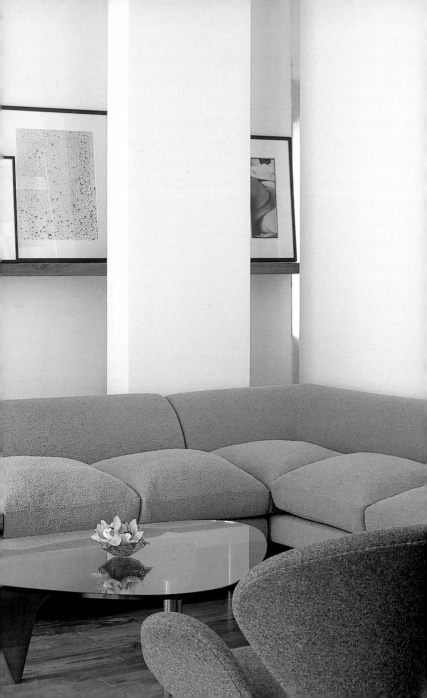

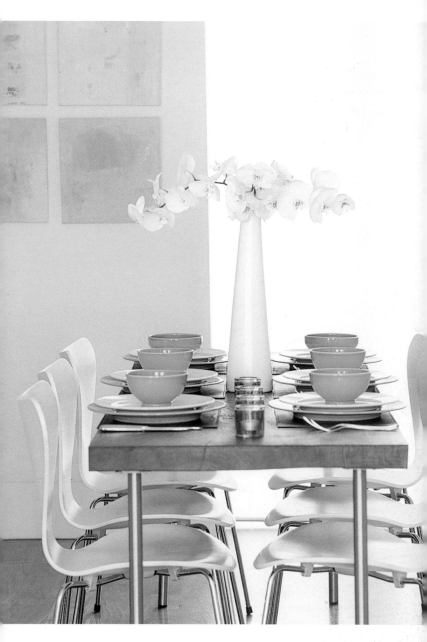

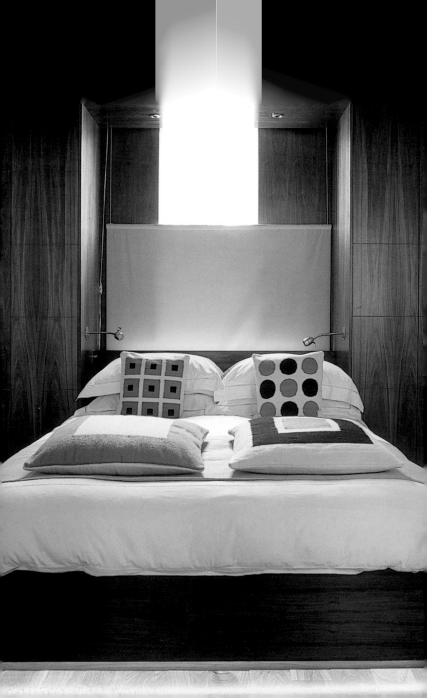

This double-height loft was originally a warehouse inside a building built by the modernist Sir Owen Williams, who was known as the pioneer of reinforced concrete construction. The loft exhibits a clever distribution of space and an innovative use of materials. The kitchen is situated so that it forms the entrance hall and takes advantage of the existing columns and beams. The bedroom occupies a far corner beyond the kitchen. The mezzanine structure and flooring were made from a defective batch of African walnut. The wood was treated as carefully as possible to yield optimal results, both structurally and aesthetically. The mezzanine rests perpendicular to a horizontal row of clerestory windows and overlooks the open-plan living area below.

Ursprünglich ein Lager in einem von Sir Owen Williams, dem Pionier der Stahlbetonkonstruktion, errichteten Gebäude, präsentiert dieser Loft mit doppelter Raumhöhe eine pfiffige Aufteilung und einen innovativen Materialeinsatz. Die Küche bildet den Eingangsbereich und nutzt gleichzeitig die bestehenden Pfeiler und Balken aus. Das Schlafzimmer belegt eine Ecke am anderen Ende. Das Zwischengeschoss und der Boden wurden aus einer defekten Ladung afrikanischen Walnussholzes gefertigt, das so sorgfältig wie möglich verarbeitet wurde, um beste Ergebnisse zu erzielen – hinsichtlich der Gestaltung als auch der Ästhetik. Diese obere Ebene liegt im rechten Winkel zu einer horizontalen Fensterreihe und überblickt das offene Wohnzimmer unten.

Auparavant, ce loft à double hauteur était un entrepôt, partie d'un immeuble construit par l'avant-gardiste Sir Owen Williams, pionnier de la construction en béton armé. Le loft offre une distribution de l'espace astucieuse, et une utilisation novatrice des matériaux. De par sa situation, la cuisine sert de hall d'entrée et tire parti des colonnes et poutres existantes. La chambre occupe un angle éloigné, par delà la cuisine. Structure et plancher de la mezzanine ont été réalisés à partir d'un lot défectueux de noyer d'Afrique. Le bois a été traité avec soin pour un rendu structurel et esthétique optimum. La mezzanine, perpendiculaire aux fenêtres à claire-voie, surplombe l'aire de séjour paysagée.

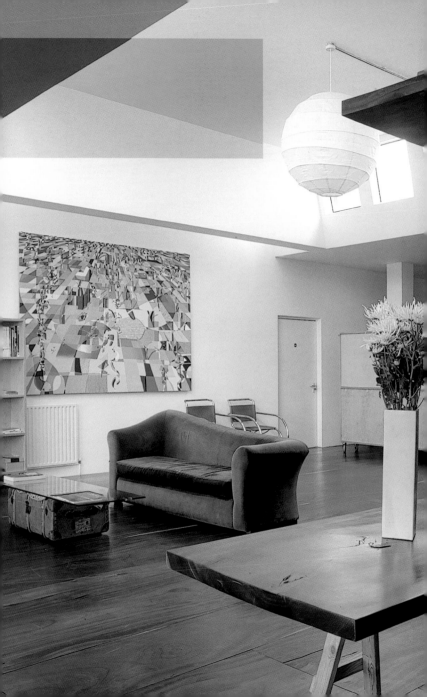

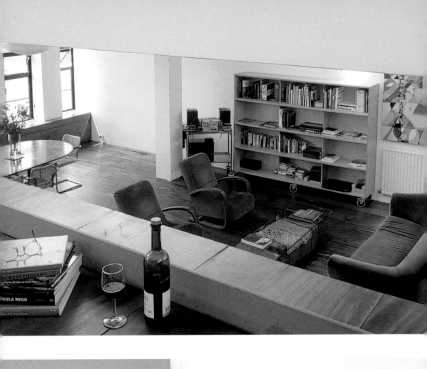
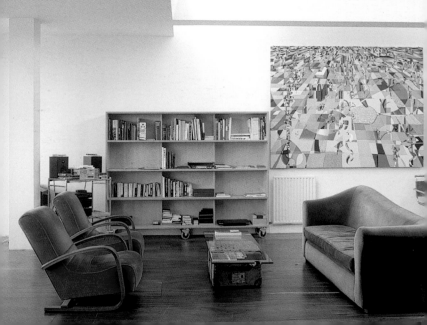

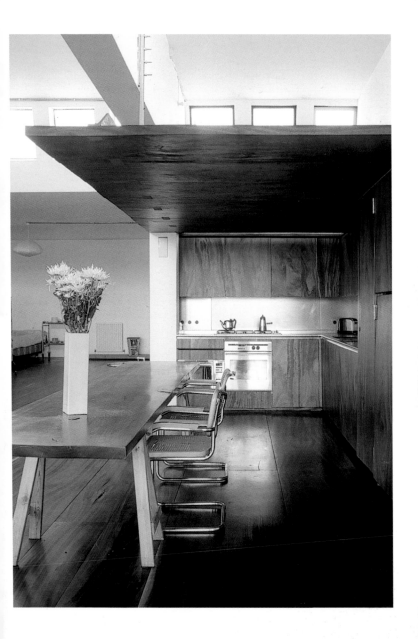

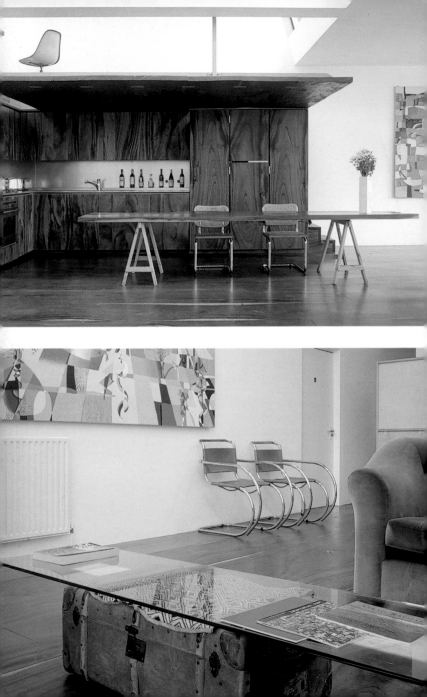

Oliver's Wharf
McDowell & Benedetti

Photos: © **Tim Soar** Completion date: **1996**

This 19th century tea warehouse became residential in the early 1970´s. The double-height space on the top two floors was stripped of its interiors and transformed into a penthouse. The interior combines contemporary and rustic elements, conveying a modern, bohemian feel. Structure-wise, architects preserved the cast iron columns supporting the massive oak trusses and complex steep roof. They repaired the existing fabric and remodeled the interior by introducing mezzanine platforms, a rooftop extension, and two terraces. The kitchen forms the center of the main level. One of the mezzanine platforms houses a bedroom with a terrace and the other contains a studio with views of the river through a pivoting window.

Seit 1970 dient dieses Teelagerhaus des 19. Jahrhunderts als Wohnhaus. Die beiden obersten Etagen wurden entkernt und in ein Penthouse verwandelt. Die Einrichtung kombiniert moderne und rustikale Elemente zu einem Bohème-Stil. Aus Gründen der Statik erhielten die Architekten die gusseisernen Säulen, welche die Eichenbalken und das steile Dach stützen. Sie sanierten das Ziegelmauerwerk und vergrößerten den Innenraum durch Mezzanin-Ebenen, eine Dachgeschoss-Erweiterung und den Anbau zweier Terrassen. Die Küche bildet den Mittelpunkt; in einem der Mezzanine ist ein Schlafzimmer mit Terrasse untergebracht, in dem anderen ein Arbeitszimmer mit Blick auf den Fluss.

Cet entrepôt de thé XIXe devint résidentiel au début des années 70. L'espace à double hauteur de plafond des niveaux supérieurs fut déshabillé et transformé en penthouse. L'intérieur associe contemporain et rustique, communiquant une sensation moderne et bohème. S'appuyant sur la structure, les architectes ont conservé les colonnes de fonte soutenant le toit escarpé de poutres en chêne. La structure existante a été réparée et l'intérieur rénové en introduisant des mezzanines, une extension sur le toit et deux terrasses. La cuisine est le centre du niveau principal. Une mezzanine accueille une chambre avec terrasse, l'autre un studio avec vue sur la rivière par une fenêtre pivotante.

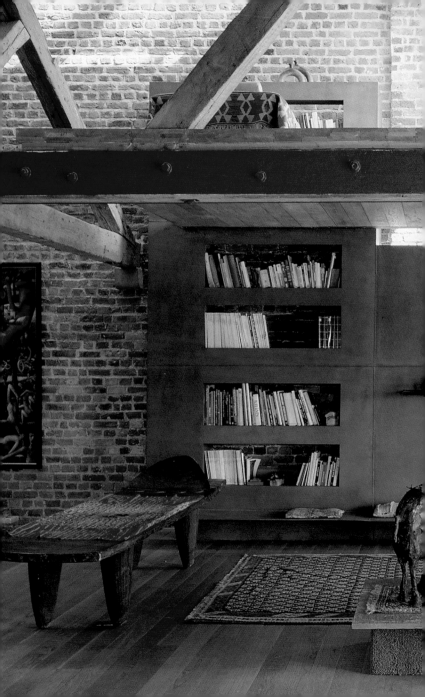

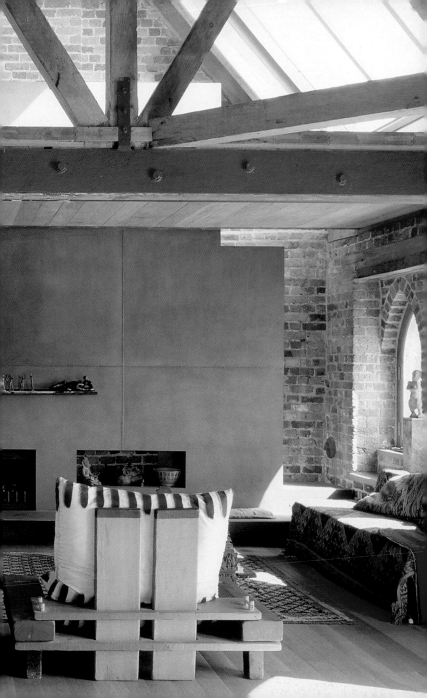

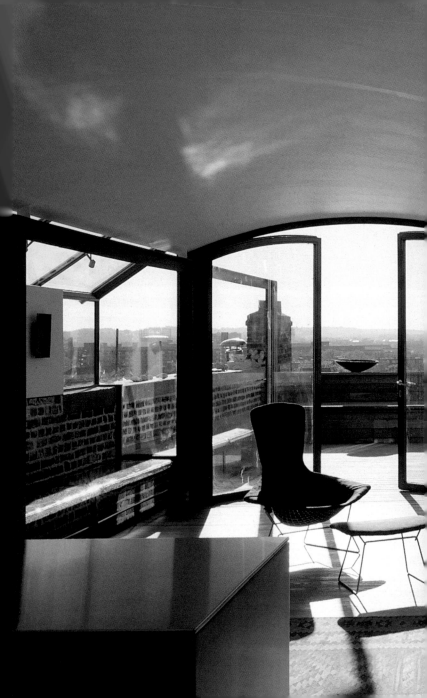

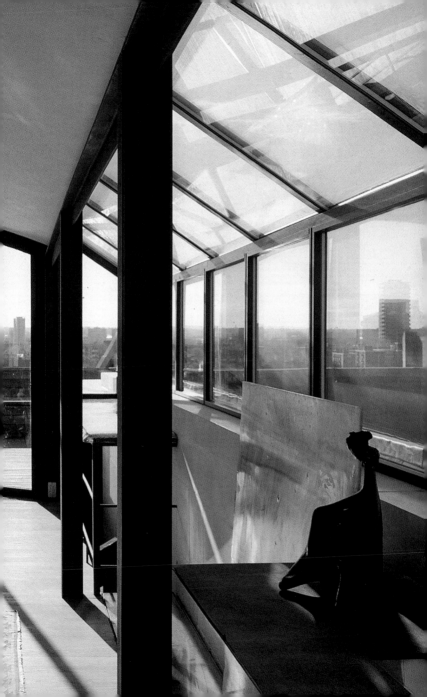

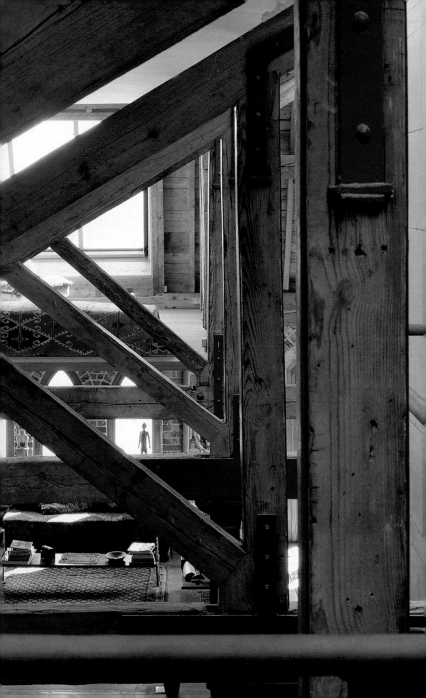

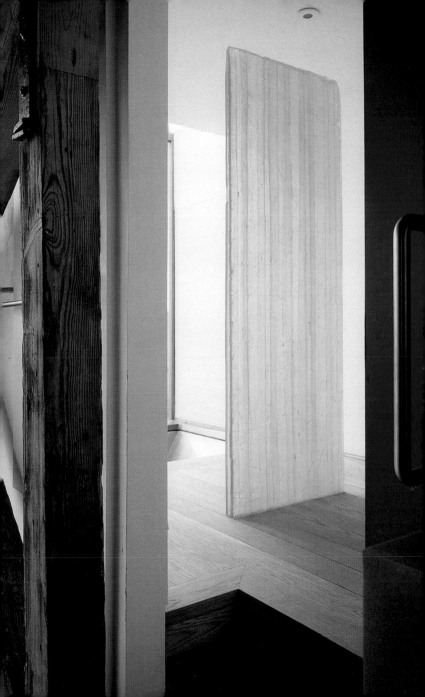

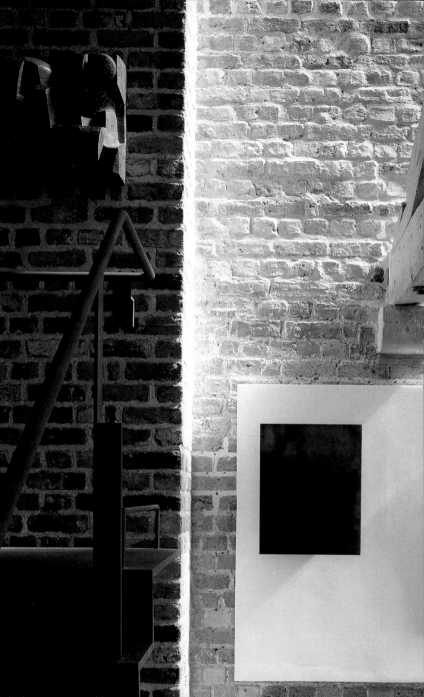

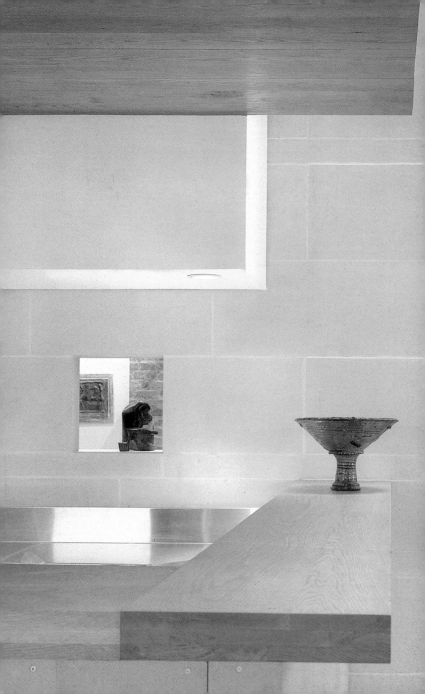

Nile Street
McDowell & Benedetti

Photos: © **Nick Hufton / View** Completion date: **2000**

This apartment sits on the top floor and roof level of a five-story 19th Century warehouse. Its shell was sandblasted and left unfinished, leaving an unpolished concrete ceiling and floor and exposed brick walls. A dark gray, freestanding structure divides the living areas and incorporates a nook for appliances and decorative elements. The kitchen's African walnut boarding adds strong visual and textural elements. Upstairs, the bathroom floor is laid with pebbles and stones, enhancing the dwelling's rustic and natural sensations. The bedroom is located in an intimate corner, and a glass wall frames doors that lead to a private terrace with a magnificent view of the city skyline.

Diese Wohnung thront im obersten Stockwerk und Dachgeschoss eines fünfstöckigen Lagerhauses des 19. Jahrhunderts. Die sandgestrahlten Mauern sind unbehandelt, rohe Betondecken, Betonböden und Mauerziegel liegen offen. Ein dunkelgraues, freistehendes Element gliedert den Wohnbereich und bildet eine Nische für Haushaltsgeräte und Deko-Objekte. Die Küchenfront aus afrikanischem Walnussholz stellt einen starken optischen Reiz dar und die Natursteine des Badezimmerfußbodens verstärken den rustikalen und natürlichen Look des Apartments. Das Schlafzimmer liegt zurückgezogen in einer Ecke; durch Glastüren gelangt man von hier auf eine Terrasse mit phantastischer Aussicht auf die Stadt.

Cet appartement est situé sur le toit et le dernier niveau d'un entrepôt XIXe de 5 étages. Son enveloppe a été sablée en omettant toute finition: sol et plafond sont en ciment brut, les murs en briques apparentes. Une structure gris-noir, sans appuis, divise les espaces de vie et offre un recoin pour les éléments de décoration et les différents appareils. Les lambris en noyer d'Afrique de la cuisine sont de puissants éléments visuels et de texture. À l'étage, un sol de salle de bain, couvert de graviers et de pierres, met en relief l'ambiance rustique et naturelle de la demeure. La chambre se love dans un angle, et une paroi vitrée encadre des portes menant à une terrasse privée, offrant une vue somptueuse de l'horizon.

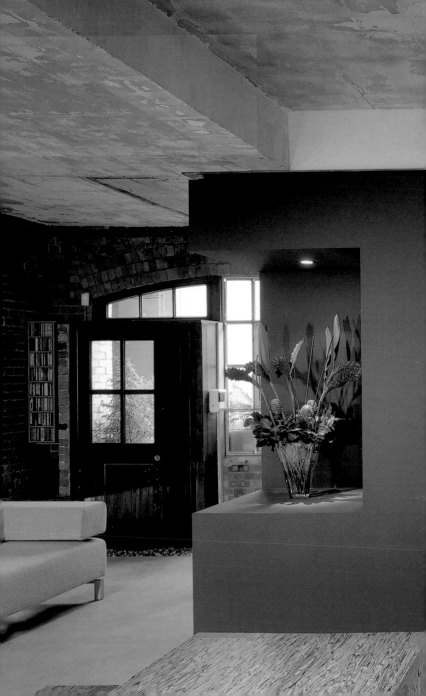

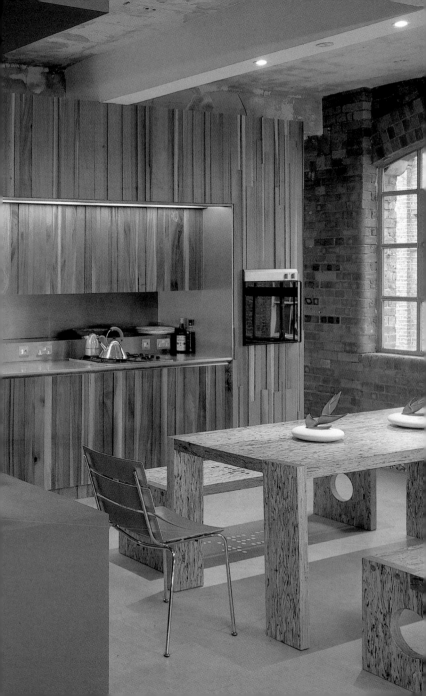

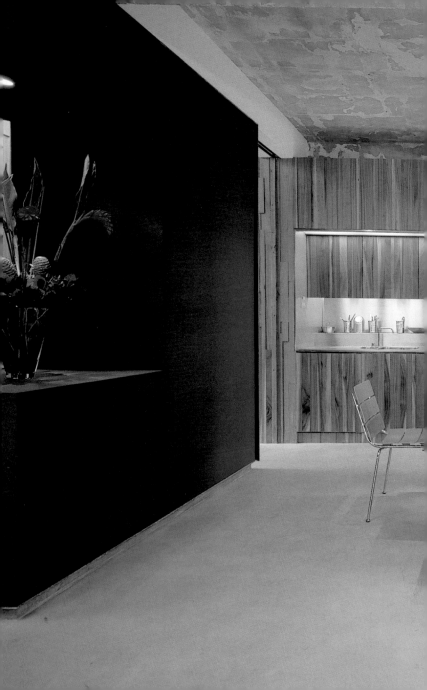

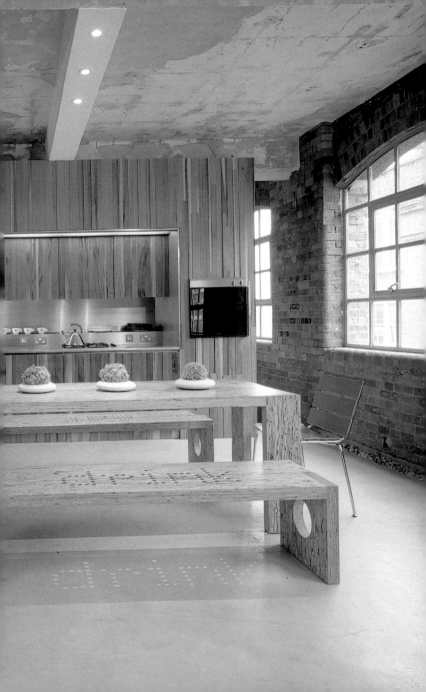

Shell apartments are often fitted with freestanding walls and partitions in order to distinguish different areas. The only partition erected in this concrete-framed flat is a 30-foot long wall built of recycled steel that aesthetically shields a darkroom, toilet, and storage room. The rest of the spaces, including the bedroom, shower, and kitchen, are found in the open, multi-use space. A classical tub and contemporary washbasin are set on a raised concrete dais that stands above the wooden floors. Pillars run down the middle of the flat, and there are few pieces of furniture. The exposed brick walls, neutral colors, and balanced lighting complete the atmosphere in this roughly polished urban home.

Oft werden in Rohbauten Wände und Raumteiler eingezogen, um verschiedene Bereiche voneinander zu unterscheiden. Die einzige Gliederung in dieser Wohnung mit Betonstruktur ist eine neun Meter lange Wand aus Recycling-Stahl, die eine Dunkelkammer, die Toilette und einen Abstellraum abschirmt. Schlafzimmer, Dusche und Küche befinden sich offen im Allzweck-Raum. Die Badewanne und ein modernes Waschbecken stehen auf einem Betonpodest auf dem Holzboden. Die Möblierung ist sehr sparsam. Die Ziegel, neutrale Farben und eine ausgewogene Beleuchtung vervollständigen die Atmosphäre in diesem nur grob geschliffenen urbanen Heim.

Les espaces des appartements modulaires sont souvent délimités par des murs sans appui et des cloisons. La seule cloison de cet appartement à structure de béton est un mur d'acier recyclé de 10 mètres, cachant esthétiquement une chambre sombre, des toilettes et un rangement. Les autres espaces - chambre, douche et cuisine - se trouvent dans le volume ouvert multi-usage. Une baignoire classique et un lavabo moderne sont surélevés sur une marche en béton, posée sur le parquet de bois. Des piliers traversent la moitié de l'appartement, peu meublé. Murs de briques apparentes, couleurs neutres et lumière équilibrée complètement l'atmosphère de ce foyer urbain à peine policé.

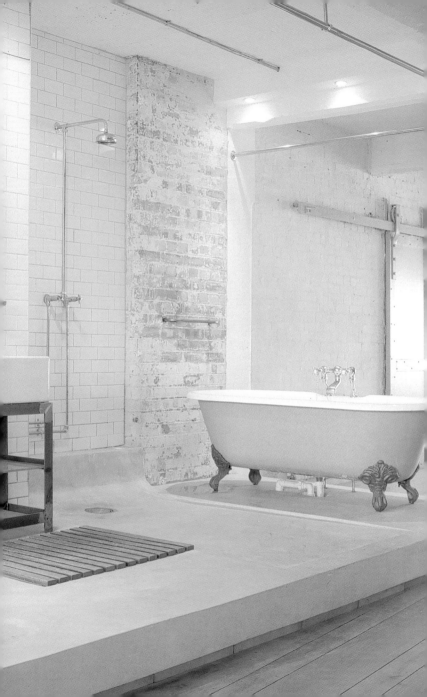

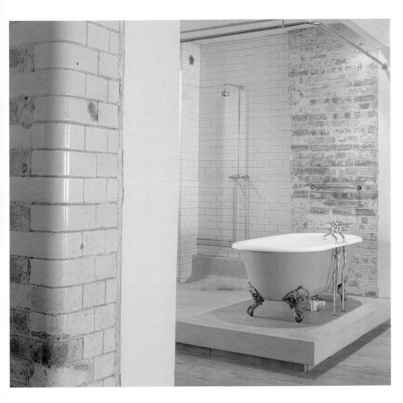

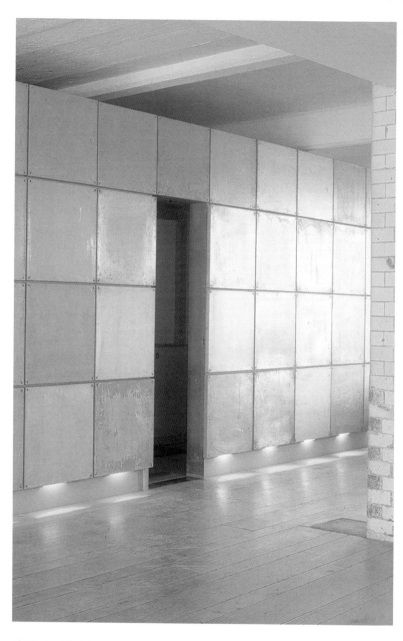

Photos: © **Leon Chew** Completion date: **2001** **graeme@blockarchitecture.com**

The design of this top floor apartment aims to take full advantage of the urban and rural panoramic views. The key was to keep the fairly small space as open as possible without creating conventional rooms. The architects based their solution on a treehouse, creating a cantilevered bed platform in the center of the space made from softwood frames and slatted Iroko hardwood that maintains privacy while permitting visual penetration. White glass is used in the bathroom and kitchen, and Iroko floor strips line both the interior and the terrace deck. Pull-out trays and fold-down flaps provide useful tabletops without occupying extra space. At night, a deep purple ultraviolet light washes over the apartment.

Gestaltungsziel bei dieser Obergeschosswohnung war, die Panoramablicke auf Stadt und Land optimal auszunutzen. Der Trick bestand darin, den kleinen Raum so offen wie möglich zu halten, ohne klassische Zimmer abzuteilen. Auf der Basis der Idee eines Baumhauses richteten die Architekten eine frei tragende Bettplattform in der Mitte des Raumes ein, die aus einem Weichholz-Rahmen und Iroko-Hartholzleisten zusammengesetzt ist; sie wahren die Intimsphäre und lassen doch visuelle Durchblicke zu. Weißes Glas wurde im Bad und in der Küche verarbeitet, und sowohl im Innenbereich als auch auf der Terrasse liegen Iroko-Paneele. Ausziehbare Tafeln und wegfaltbare Klappen ergeben nützliche Tischflächen, ohne viel Platz zu belegen.

La conception de cet appartement situé au dernier étage tire parti des panoramas sur la ville et la campagne. L'élément clé a consisté à garder aussi ouvert que possible l'espace réduit, sans créer de pièces conventionnelles. La solution des architectes: une cabane dans les arbres avec, au centre, une plate-forme couchage suspendue avec un cadre de bois tendre et des lattes en Iroko, gardant l'intimité et ouvrant le champ visuel. Salle de bain et cuisine recourent au verre blanc, un parquet en lames d'Iroko habillant intérieur et coursive. Plateaux gigognes et tablettes rabattables offrent des tables commodes, sans occuper d'espace additionnel. De nuit, une lumière UV pourpre balaye l'appartement.

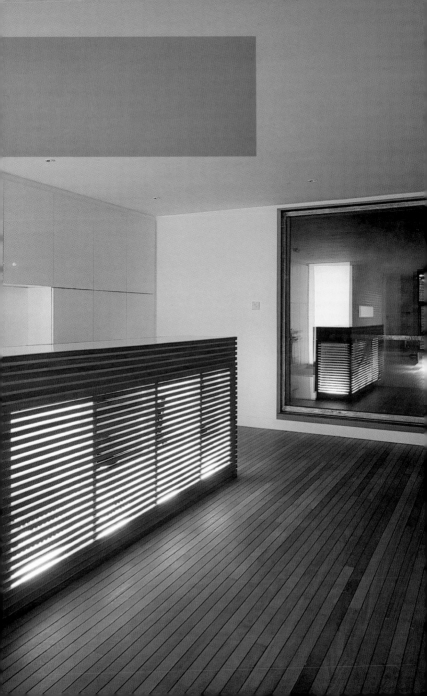

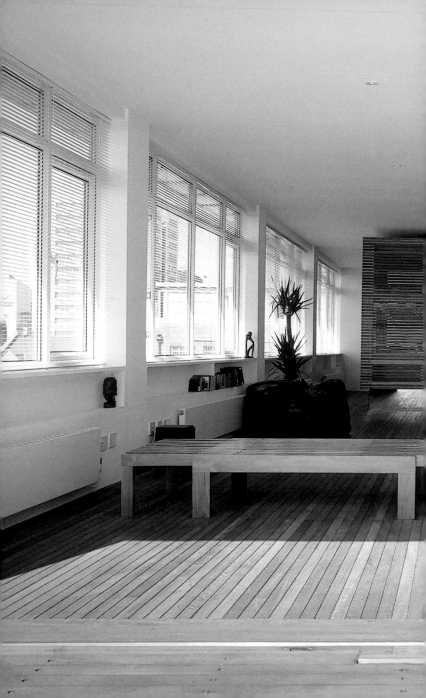

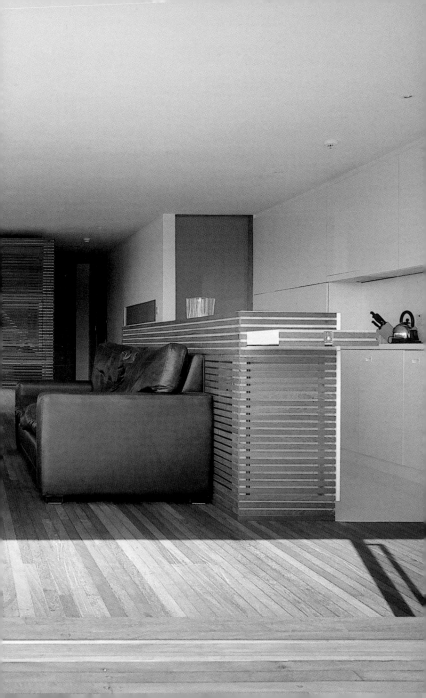

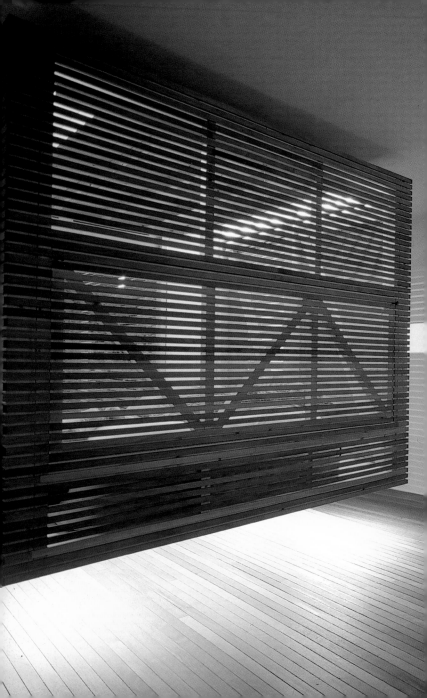

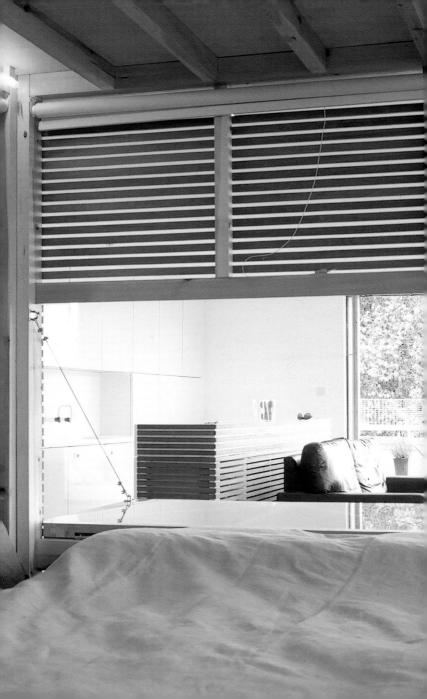

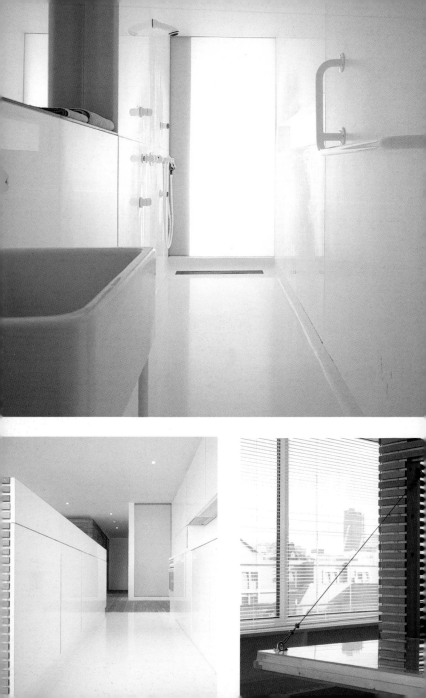

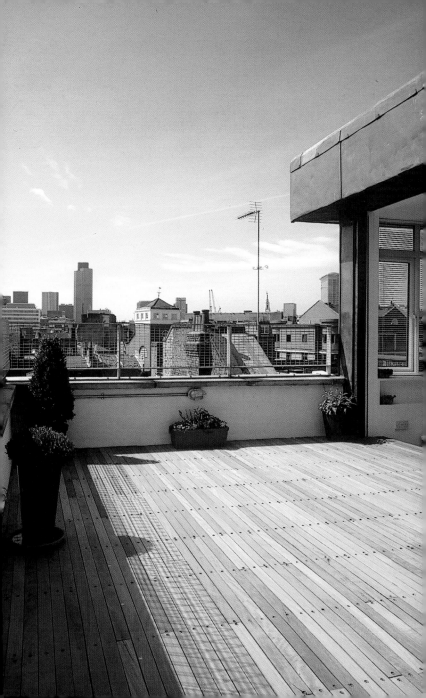

Millenium Lofts
Child Graddon Lewis

Photos: © **Dennis Gilbert / View** Completion date: **2000** hq@cgluk.com

In the heart of Covent Garden lies this Victorian building refurbished by architects to house 22 shell apartments distributed on six floors, with a retail shop on the ground floor. Clients possess the freedom to create their own environments. In this example, a column visually separates the steel kitchen and the spacious living room, which is divided from the office area by a partition made of transparent, curved plastic tubes. Further on, a wooden separator hides the bedroom and bathroom for privacy. Modern lighting enhances the black, white, stone, and wood materials. The loft's consistent style is comfortable, relaxed, and fluid.

Mitten in Covent Garden liegt dieses viktorianische Gebäude, das von den Architekten saniert wurde, um 22 Apartments auf sechs Geschossen und einem Geschäft im Erdgeschoss Platz zu bieten. Den Bewohnern steht es frei, ihre Umgebung selbst zu gestalten. In diesem Beispiel teilt ein Pfeiler optisch die Stahl-Küche und das weitläufige Wohnzimmer, das wiederum vom Büro durch einen Paravent aus transparenten, gebogenen Plastikrohren abgetrennt ist. Ein hölzerner Wandschirm versteckt Bad und Schlafzimmer. Moderne Lampen heben Materialien in schwarz, weiß, aus Stein und Holz hervor. Der durchgängige Stil dieses Lofts ist behaglich, entspannt und fließend.

Le cœur de Covent Garden abrite ce bâtiment victorien rénové par des architectes pour accueillir 22 appartements modulaires, sur six étages, un magasin occupant le rez-de-chaussée. Les clients sont libres de créer leur propre environnement. En l'occurrence, une colonne distingue visuellement la cuisine en acier et le séjour spacieux, qui est séparé du bureau par une cloison en tubes plastiques courbes et transparents. Plus loin, pour l'intimité, une séparation en bois cache chambre et salle de bain. L'éclairage moderne rehausse les matériaux de bois, de pierre, noirs et blancs. Confortable, tranquille et fluide: le style du loft est cohérent.

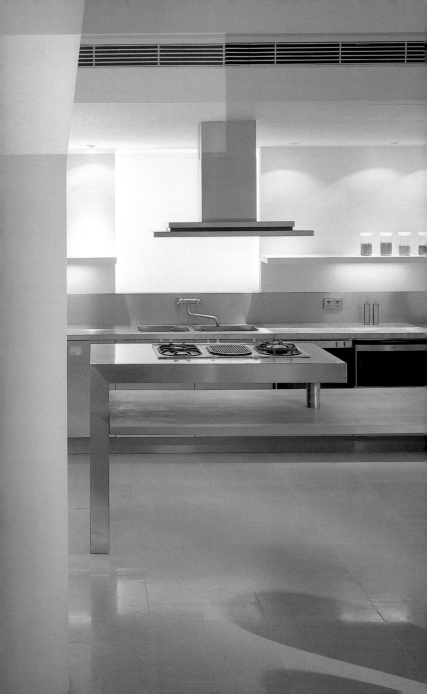

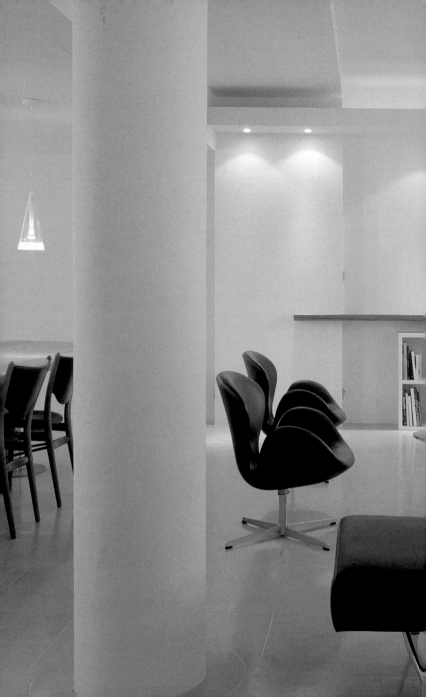

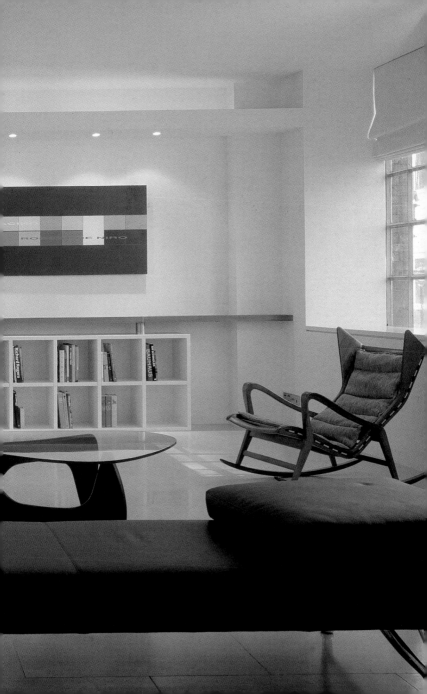

While some partitions are solid and full
height, others are semi-transparent to
enhance the illusion of continuity and space.

Raumteiler spielen eine Hauptrolle in dieser Wohnung,
da sie den langen Raum in verschiedene Zonen gliedern.
Einige sind massiv und raumhoch, andere durchscheinend,
um den Eindruck von Kontinuität und Weite zu verstärken.

Les cloisons jouent, ici, un rôle primordial, divisant
un grand espace en divers environnements. Certains
solides et tout en hauteur, d'autres semi-transparents,
pour rehausser l'illusion de continuité et d'espace.

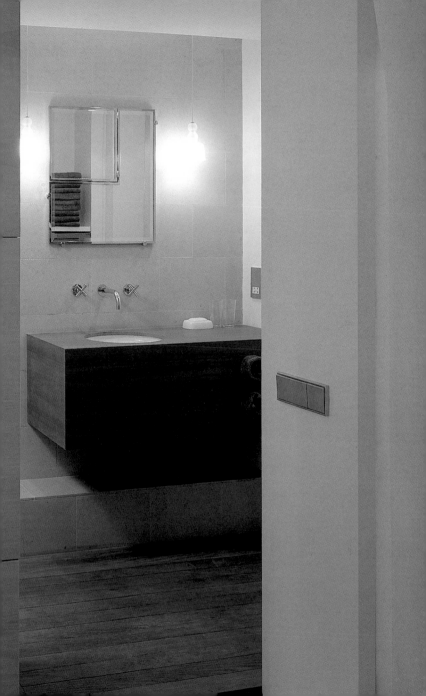

Canalside Apartment
Child Graddon Lewis

Photos: © Johnathan Moore Completion date: 2000 hq@cgluk.com

The building which houses this apartment is a conversion of an 30 year-old factory into a dynamic setting incorporating residential units that are located above the ground floor. This apartment was designed by the architects as a model to demonstrate the project's potential. Conserving the diaphanous quality of a loft, spaces are continuous and distinguised by concrete pillars, furniture, and wheeled shelves. The bedroom and bathroom are light and airy, divided by a sliding translucent door. Gaps between ceilings and partitions emit a luminous glow, also heightening the sense of space. Subtle lighting reflected off surfaces, wood floors, whites and occasional colors adorn this refreshing apartment.

Eine 30 Jahre alte Fabrik wurde in Wohnungen, Büros und Geschäftslokale umgewandelt. Die Architekten entwarfen dieses Muster-Apartment, um das Potenzial des Projektes zu demonstrieren. Den Vorzügen eines Lofts entsprechend gehen die Räume ineinander über und werden nur durch Betonpfeiler, Möbelstücke und rollbare Regale gegliedert. Eine Schiebetür aus Milchglas trennt das helle, luftige Schlafzimmer vom Bad. Breite Lücken an den Anschlüssen der Trennwände strahlen im hellem Licht und steigern den Raumeindruck. Weitere Besonderheiten des erfrischenden Entwurfs sind die subtile, von den Oberflächen reflektierte Beleuchtung, Holzböden und hier und da verteilte Farbtupfer.

Une usine, transformée en un cadre dynamique incluant logements, bureaux et commerces, accueille cet appartement. Les résidences sont au-dessus du rez-de-chaussée. Cet appartement a été conçu par les architectes pour souligner le potentiel du projet. En accord avec la pureté du loft, les espaces sont continus, uniquement différenciés par des piliers de béton, des meubles et des étagères mobiles. Une porte coulissante translucide sépare chambre et salle de bain, lumineuses et aérées. Les interstices entre plafond et cloisons brillent d'un éclat lumineux, intensifiant la sensation d'espace. Cet appartement se caractérise enfin par un éclairage subtil réfléchi sur les surfaces, parquets, blancs et taches colorées.

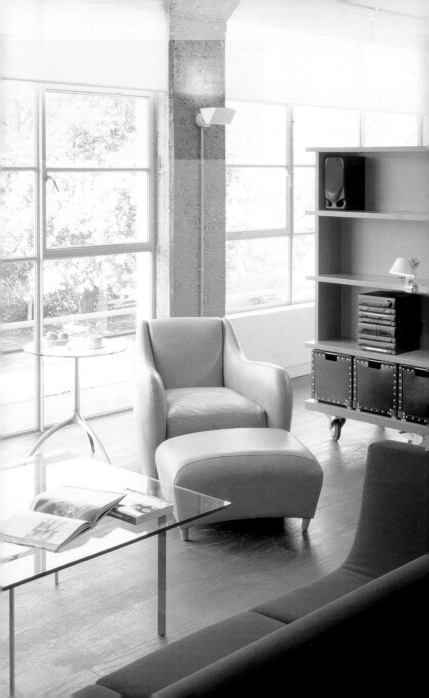

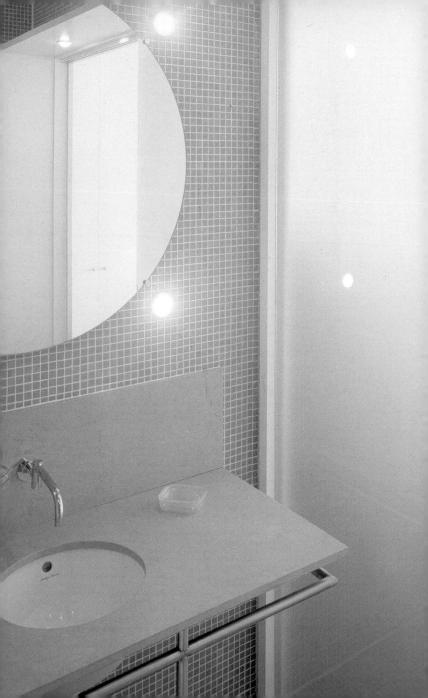

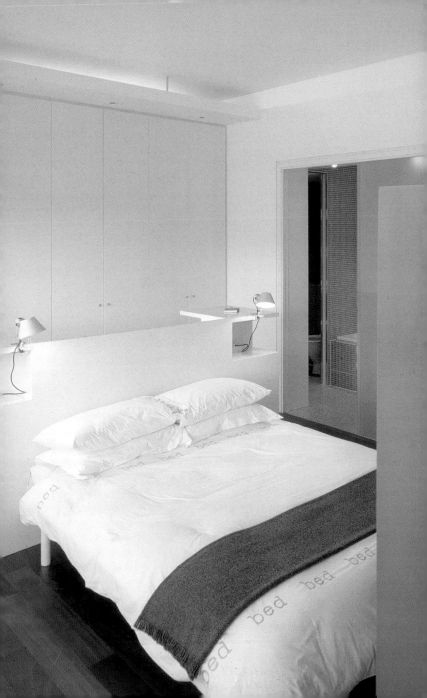

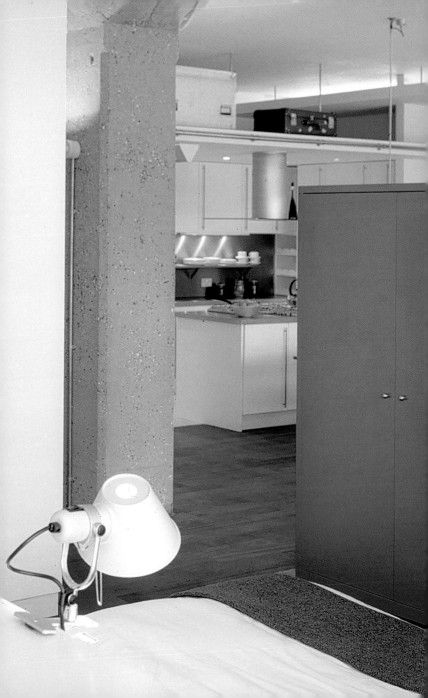

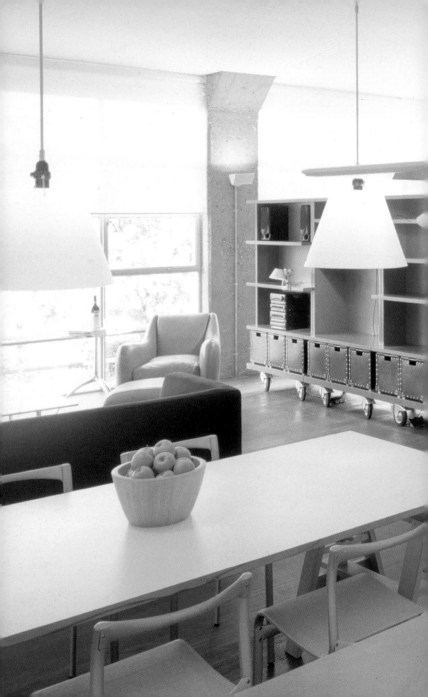

Conversion of a Warehouse

Simon Conder

Photos: © **Chris Gascoigne / View** Completion date: **1999**

This space, once an old warehouse, was kept as open as possible to take advantage of the limited floor space. The main area is defined by vertical elements: the stainless steel kitchen and the two cylinders that enclose the shower and bathroom. A staircase on one side leads to the bedroom upstairs. Walls incorporate cupboards and closets, installations, and a fold-out bed. The materials and palette used confer a minimalist aspect. The furniture, save the Wegner Wishbone dining chairs, is also designed by the architects and features integrated artificial light. Only essential structures and lighting fixtures are visible, the rest hidden away behind surfaces to transmit a spacious and uncluttered atmosphere.

Diese Wohnung, ein altes Lagerhaus, wurde so offen wie möglich gestaltet, um den begrenzten Raum bestmöglich auszunutzen. Der Hauptbereich wird durch vertikale Elemente definiert: die Edelstahlküche und zwei Zylinder, in denen sich Dusche und Bad befinden. Eine Treppe an der Seite führt in das Schlafzimmer oben, und in den Wänden sind Regale, Schränke, Installationen und ein Klappbett eingebaut. Materialien und Farbtöne sorgen für einen minimalistischen Eindruck. Das Mobiliar, abgesehen von den Wegner Wishbone Stühlen, wurde von den Architekten entworfen. Nur die wichtigsten Strukturen und Beleuchtungselemente sind sichtbar, der Rest ist hinter den verschiedenen Oberflächen versteckt.

Ce lieu, auparavant un ancien entrepôt, a été maintenu ouvert autant que possible, pour exploiter un espace au sol limité. L'aire principale est définie par des éléments verticaux: la cuisine en acier inox, et les deux cylindres ceignant la douche et la salle de bain. Sur un côté, un escalier mène aux chambres, à l'étage. Les murs offrent armoires, placards, appareils ainsi qu'un lit pliant. Les matériaux employés confèrent à l'endroit un aspect minimaliste. Hormis les chaises Wegner Wishbone, le mobilier a été conçu par les architectes et comporte un éclairage artificiel. Seules les structures essentielles et les éclairages s'offrent à la vue, le reste étant camouflé derrière des surfaces.

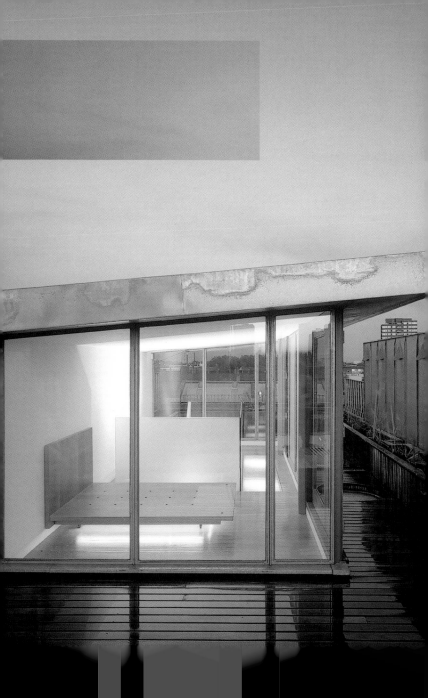

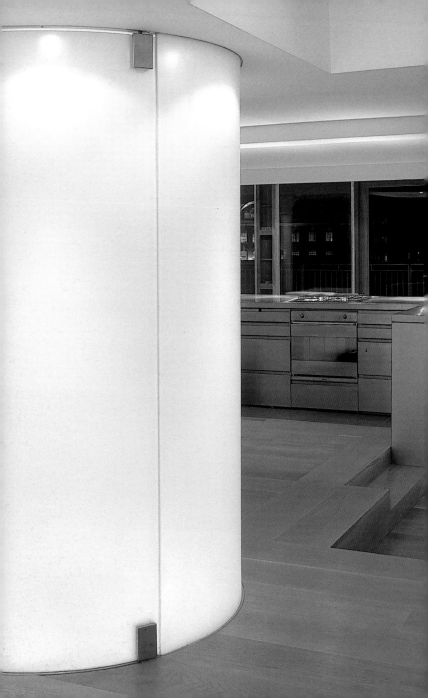

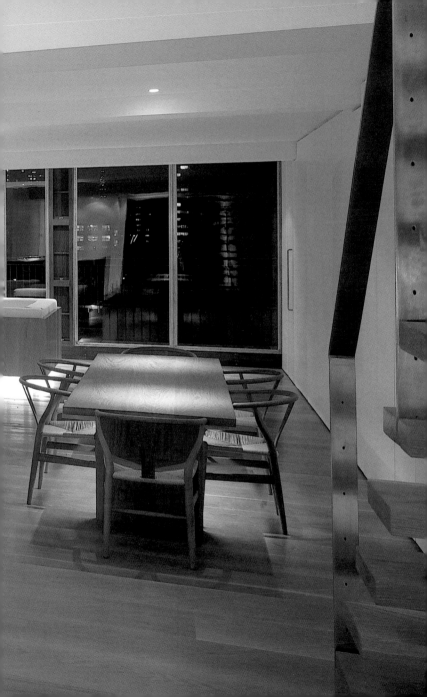

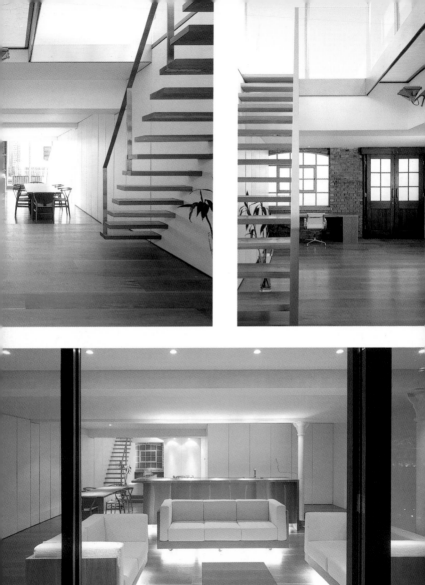
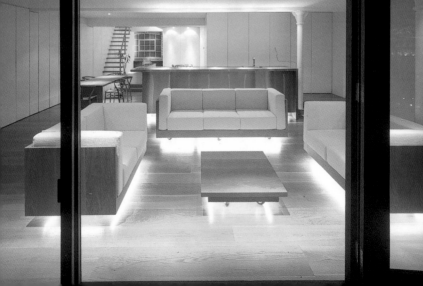

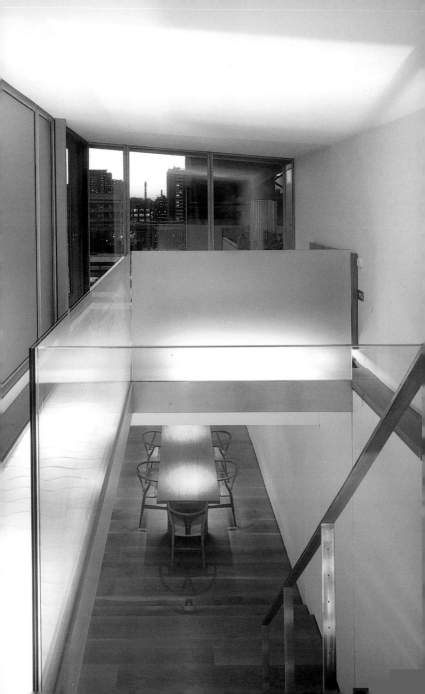

Conversion of a Fire Station
Simon Conder

Photos: © **Chris Gascoige / View** Completion date: **1995**

In the West End lies this apartment refurbished from an old fire station and into the new home of a musician/chef couple. Being a long and narrow building and lacking enough windows, dividing screens were eliminated on all three floors and a glass roof was introduced to flood the spaces below with natural light. During warm months, the glazed ceiling opens, transforming the third floor into a terrace. A stone staircase runs up along the sides, and arched wooden structure used for storage separates them from the rest of the apartment. Most elements -floors, furniture, partitions- are wood, steel, and translucent glass, creating a uniformity of style while transmitting light that radiates throughout the whole household.

Dieses West-End-Haus war eine alte Feuerwache, bis es für ein Musiker/Küchenchef-Paar in eine Wohnung umgebaut wurde. Da das Gebäude lang, schmal und fensterlos war, entfernte der Architekt die Trennwände auf allen drei Ebenen und zog ein Glasdach ein, um alle Räume mit Licht zu durchfluten. In den wärmeren Monaten öffnet sich die Verglasung und verwandelt die dritte Etage in eine Terrasse. Eine steinerne Treppe führt an einer Seite nach oben; sie ist durch ein hölzernes bogenförmiges Element, das als Stauraum dient, von der Wohnung getrennt. Böden, Möbel und Raumteiler sind vornehmlich aus Holz, Stahl und Glas; sie schaffen einen homogenen Stil und geben dem Licht den Weg durch das ganze Haus frei.

Restauré pour accueillir un couple musicien/chef, cet appartement du West End abritait auparavant une station de pompier. L'étroitesse, la longueur et l'absence de vitres du bâtiment ont amené l'architecte à supprimer les cloisons sur les trois niveaux, et à introduire une verrière pour déverser une lumière naturelle sur les espaces inférieurs. Aux temps chauds la verrière s'ouvre, transformant le troisième étage en terrasse. Un escalier de pierre grimpe le long du côté, séparé du reste de l'appartement par une structure en bois. L'essentiel des éléments - sols, meubles et cloisons – sont en bois, en acier ou en verre translucide, créant un style uniforme qui inonde de lumière l'ensemble de l'habitation.

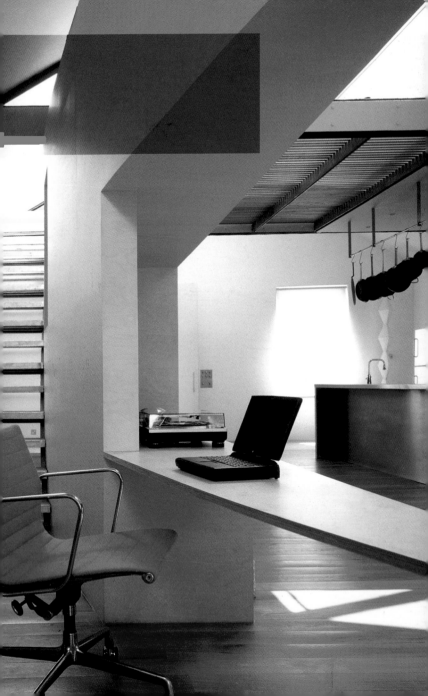

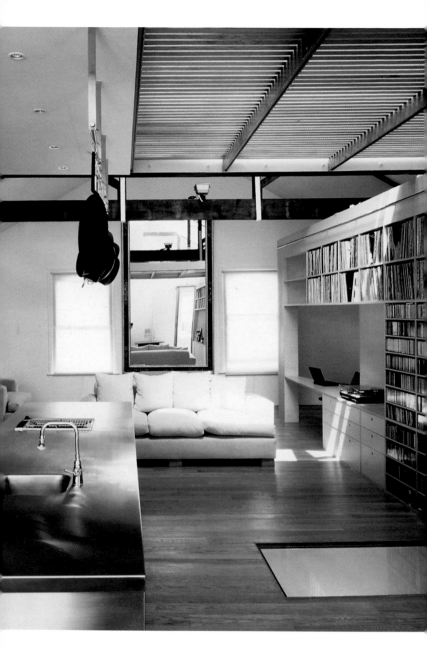

218 Simon Conder

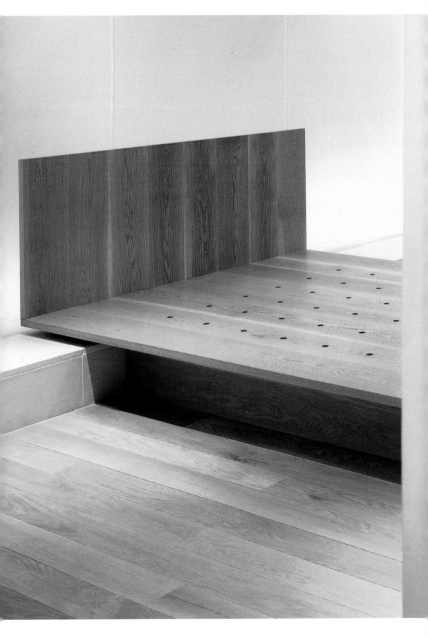

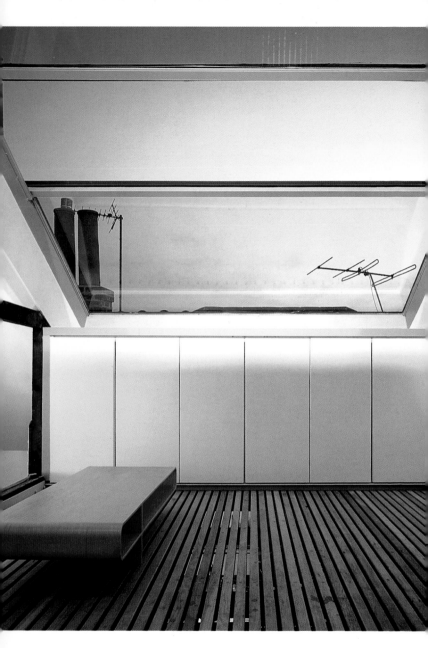

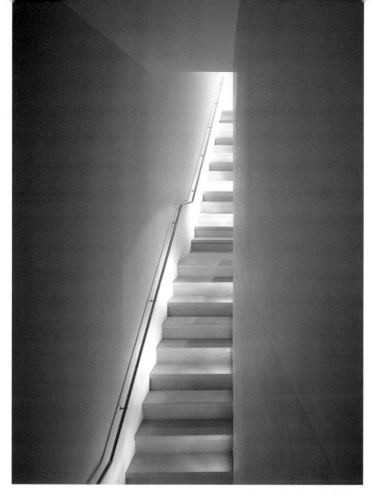

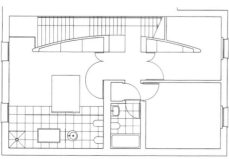

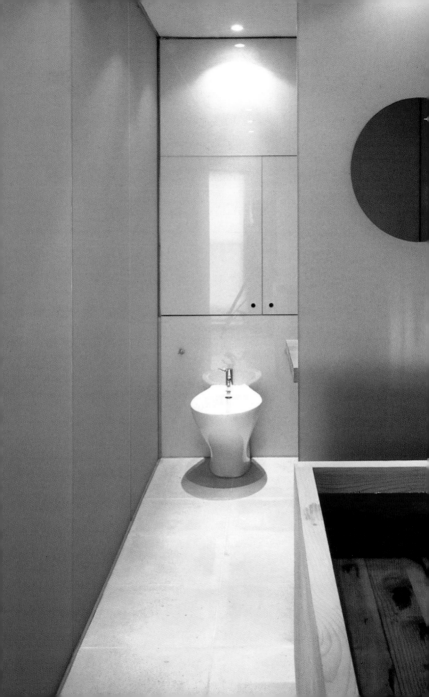

Glass Garden Room
Simon Corder

Photos: © **Jordi Miralles** Completion date: **2001** www.simonconder.co.uk sca@simonconder.co.uk

This 19th century house in North London revealed to its owner an unused piece of land that had been overshadowed by the house, garage and large Sycamore tree. To take advantage of this space, architects constructed a glass box that could be used as a living area, especially during warm months. A solid flat roof of concrete paving slabs acts as an external terrace for the existing first floor of the house. Pivoting iroko screens open and close off views of the garden room, also allowing access to a low hallway and new utility room. The large double glazed walls create invisible borders that bring the garden into this comfortable new living area.

Neben diesem Haus aus dem 19. Jahrhundert lag ein ungenutztes Stück Land, das vom Haus, der Garage und einem hohen Bergahorn beschattet wurde. Um diesen Raum auszuschöpfen, bauten die Architekten eine gläserne Kiste, die besonders in den warmen Monaten als Wohnzimmer genutzt werden kann. Ein stabiles Flachdach aus Betonplatten dient als externe Terrasse für die erste Etage des Hauses. Schwingtüren aus Iroko-Holz öffnen und verschließen den Blick auf den Garten und erlauben auch den Zugang zu einem niedrigen Gang und einem neuen Allzweckraum. Die großen doppeltverglasten Fassaden schaffen unsichtbare Grenzen, die den Garten in diese neue komfortable Wohnfläche hereinholen.

Cette maison XIXe du nord de Londres a révélé à ses propriétaires un terrain abandonné, éclipsé par la demeure, le garage et un grand sycomore. Pour tirer parti de cet espace, les architectes ont construit une boîte en verre pouvant servir de séjour, spécialement aux beaux jours. Un toit plat et massif en dalles de béton offre une terrasse extérieure au premier étage de la maison. Des cloisons pivotantes en Iroko ouvrent/obturent la vue sur la chambre du jardin, donnant aussi accès à un couloir bas et à une pièce d'entretien. Les grands murs vitrifiés créent des limites invisibles, amenant le jardin jusque dans cette nouvelle et confortable aire de séjour.

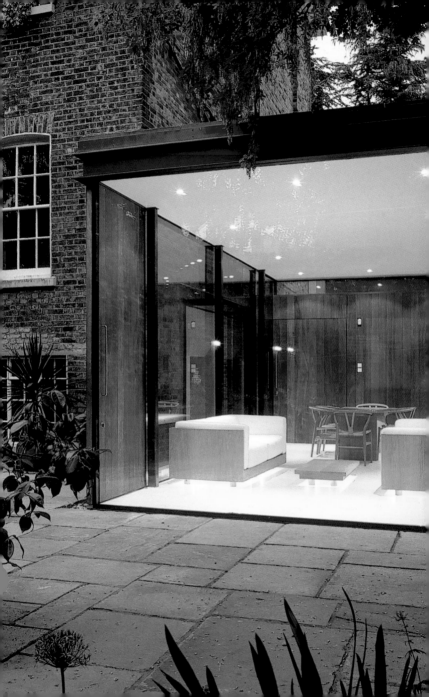

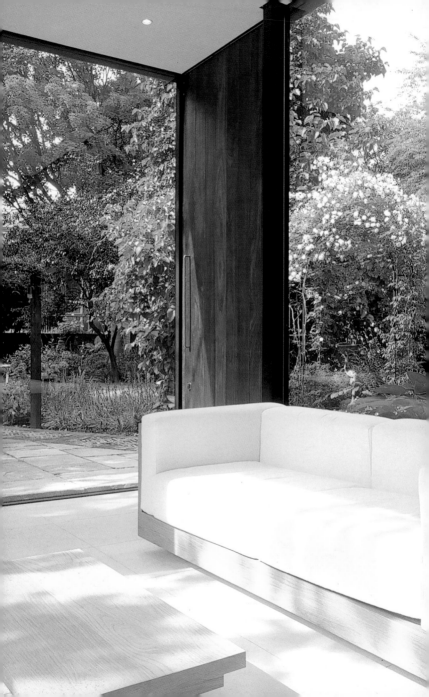

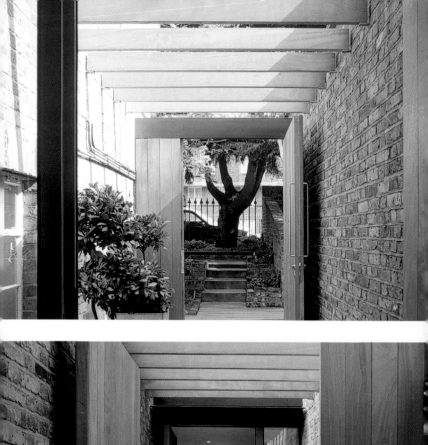
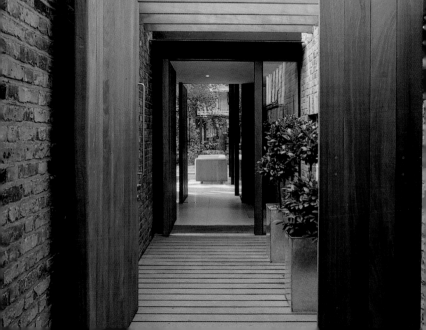

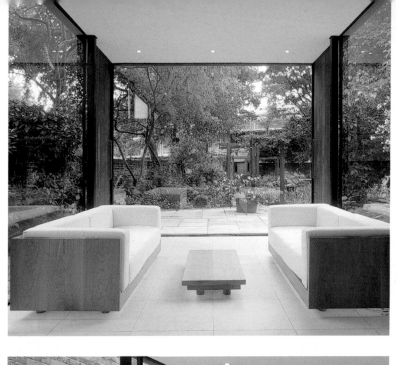

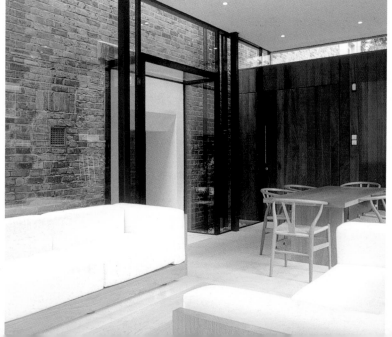

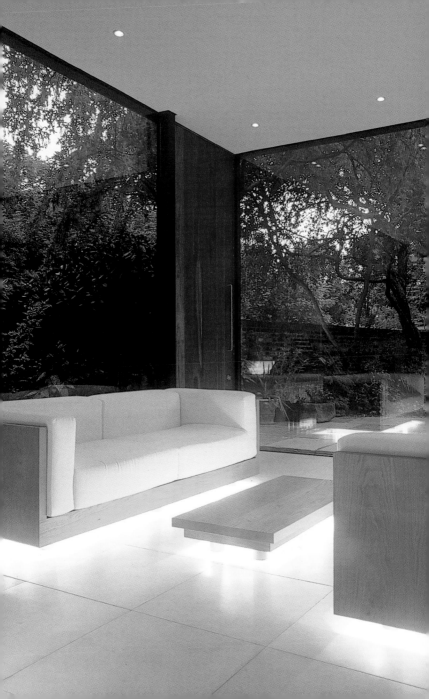

The Piper Building
Wells Mackereth Architects

Photos: © **Chris Gascoigne** / **View** and © **Dominic Blackmore** / **Mitchell Beazley Picture Library**
Completion date: **1998** hq@wellsmackereth.com

Designed by British Gas in the late 50´s and named after artist John Piper whose murals decorate the facade, this concrete office building in Fulham was reformed by Lifschutz Davidson in 1997 and now houses a number of lofts. This one, in particular, designed for a young executive, represents the skillful formation of a fluid space that facilitates the life of its tenants. Planks of birchwood cover the floors, and tall pivoting doors made of reinforced glass allow the space to be redistributed. The rounded rail of the staircase evokes motion and leads to the upper level where another sitting area and bathroom are located. The loft's dark beams and white walls reflect the light that floods in through large glass windows.

Das Bürogebäude aus Beton in Fulham, entworfen von British Gas in den 50er Jahren und nach dem Künstler John Piper benannt, dessen Fresken die Fassade schmücken, wurde 1997 von Lifschutz Davidson renoviert; heute beherbergt es mehrere Lofts. Dieser bietet ein anschauliches Beispiel für die sorgfältige Gestaltung eines fließenden Raums. Birkenholz bedeckt den Boden und hohe Schiebetüren aus verstärktem Glas erlauben die Neugliederung des Raumes. Das geschwungene Treppengeländer vermittelt Bewegung und führt zur oberen Ebene, wo ein weiterer Wohnraum und ein Bad eingerichtet wurden. Die weißen Wände reflektieren das Licht, das durch große Fenster hereinströmt.

Conçu par British Gas à la fin des années 50, cet immeuble de bureaux en béton, nommé d'après John Piper, auteur des fresques qui adornent la façade, a été réformé par Lifschutz Davidson en 1997 et abrite de nombreux lofts. Celui-ci, prévu pour un jeune directeur, concrétise la création d'un espace fluide qui facilite le quotidien de ses occupants. Un parquet de bouleau et des portes pivotantes en verre armé permettent une redistribution de l'espace. L'arrondi de la rampe d'escalier évoque le mouvement et conduit au niveau supérieur, logeant une aire de repos et une salle de bain. Poutres sombres et murs blancs reflètent une lumière qui se déverse au travers de larges fenêtres.

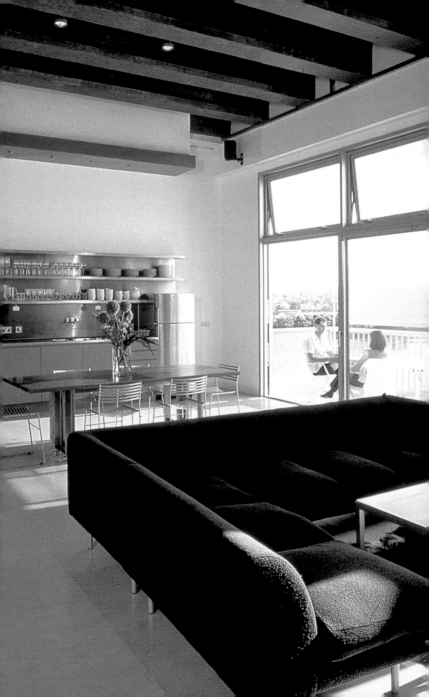

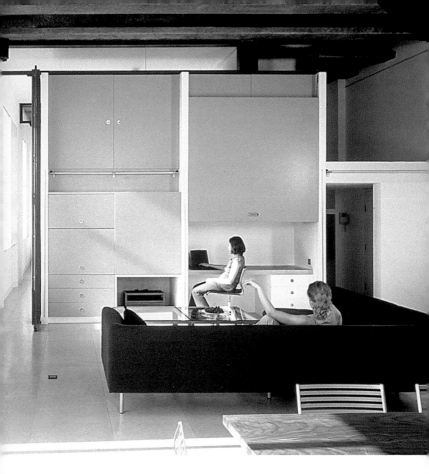

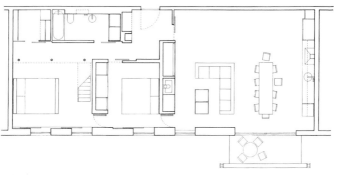

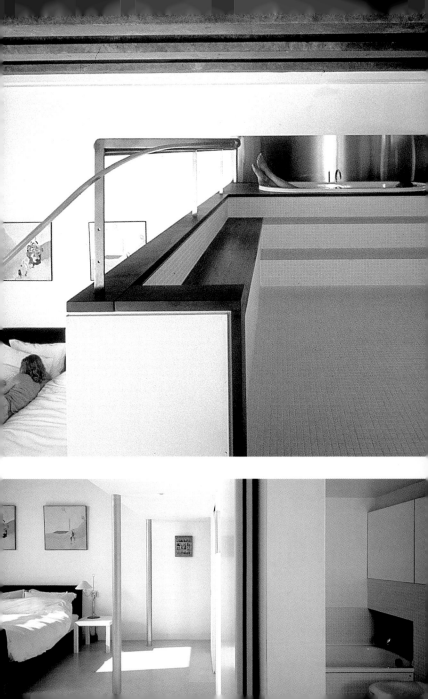

Maida Vale Flat
Wells Mackereth

Photos: © **Dominic Blackmore** Completion date: **1999** hq@wellsmackereth

Architects began remodeling this ordinary flat by stripping most of its interiors. The new entrance opens onto an American black walnut floor, which leads to windows overlooking a private garden square. The architect opted for fixed walls for the kitchen, cloakroom, and study in order to disguise structural supports and pipes. A floating ceiling conceals them overhead and reflects ambient light back down on the space. A polished plaster tobacco-brown wall flanks a theatrical staircase. Clean surfaces, shiny lacquered reds, abstract patterns, and random antique pieces combine to form a warm and spacious home with a dynamic and eclectic approach to modern design.

Die Architekten begannen die Renovierung dieser Durchschnittswohnung, indem sie die meisten Wände entfernten. Vom neu geschaffenen Eingang gelangt man über amerikanische schwarze Walnuss-Böden zu einem Fenster mit Blick auf den Garten. Neue Wände für Küche, Garderobe und Arbeitszimmer verstecken tragende Elemente und Rohre. Die eingezogene Decke dient demselben Zweck und reflektiert das Licht. Eine Wand mit tabakbraunem Gipsverputz flankiert die Treppe. Blanke Oberflächen, glänzendes Lackrot, abstrakte Muster und Antiquitäten wurden mit ausgesuchten Elementen modernen Designs zu einem warmen, großzügigen Zuhause kombiniert.

Les architectes ont recréé cet appartement ordinaire en retirant d'abord l'essentiel de sa décoration intérieure. La nouvelle entrée s'ouvre sur un parquet de noyer noir, qui conduit aux fenêtres surplombant un jardin privé. L'architecte a opté pour des murs fixes pour la cuisine, le vestiaire et l'étude afin de masquer charpente et tuyauterie. Un faux plafond dissimule ces derniers et réfléchi la lumière ambiante sur l'espace inférieur. Un mur couleur tabac en plâtre brillant flanque un escalier théâtral. Surfaces nettes, rouges laqués brillants, formes abstraites et antiquités s'associent pour créer un foyer chaleureux et spacieux, doté d'une approche dynamique et éclectique du design moderne.

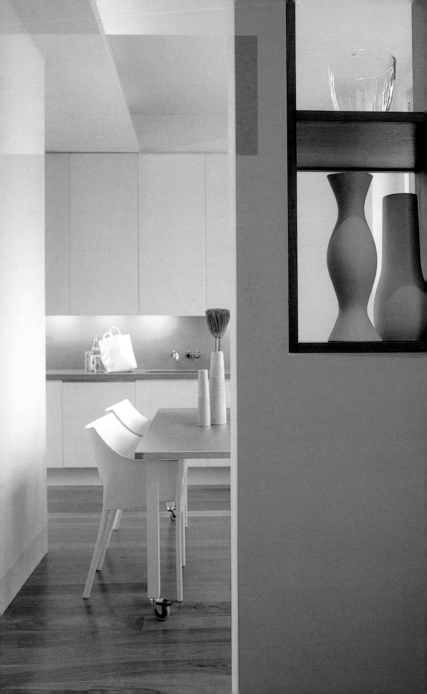

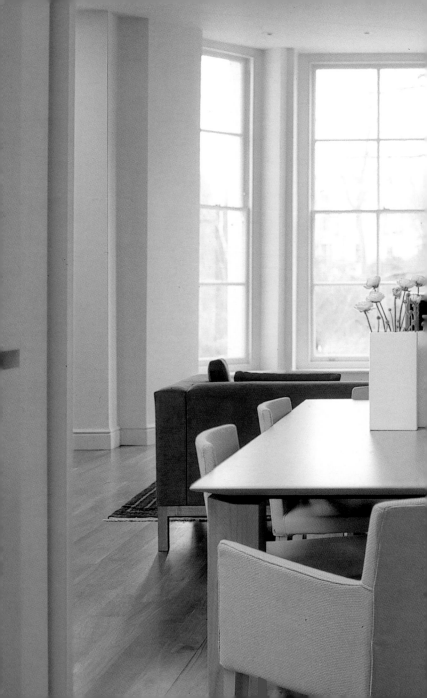

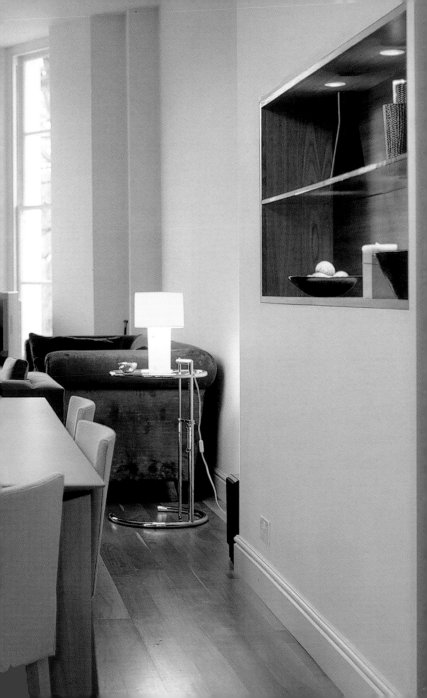

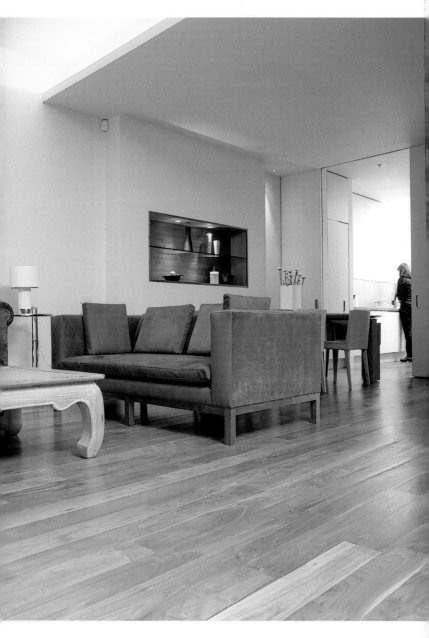

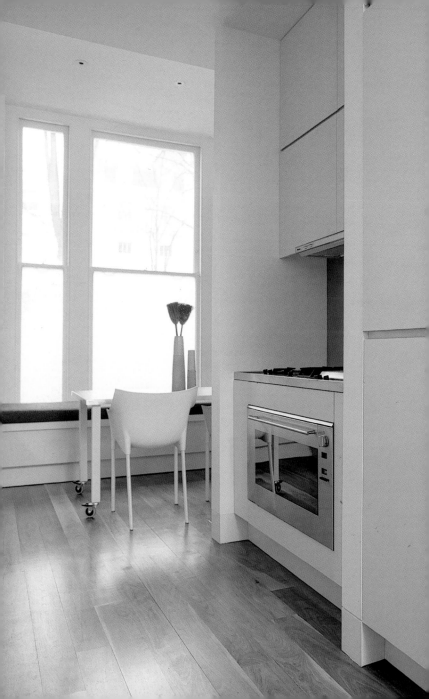

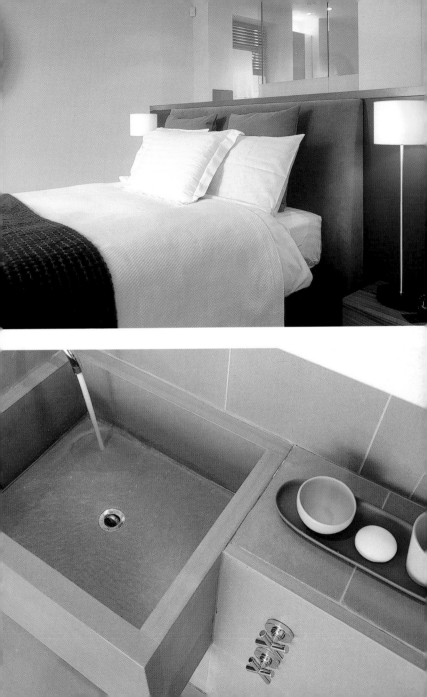

Conversion of a Post Office
Orefelt Associates

Photos: © **Alberto Ferrero** Completion date: **1997**

Converted from a postal service into a residence, this project offers an interesting arrangement of space and a humorous sense of style. From the entrance on the lower level, two freestanding boxes stand between a hallway that leads to a painter's workshop with a skylight and a terrace. The staircase on the left leads up to the living room and kitchen/dining area, while another heads up to a rooftop that looks down through the whole house. Ideal for hosting parties, this dwelling enjoys different environments that always maintain visual contact with each other. Unpredictable angles and views complement the outlandish kitsch interiors, which include a leopard print sofa and a Jeff Koons dog.

Dieser Umbau einer ehemaligen Poststelle präsentiert eine interessante Raumfolge und einen humorvollen Stil. Hinter dem Eingang in der unteren Etage stehen zwei Blöcke frei im Raum, daneben führt ein Flur in das Maleratelier mit Oberlicht und Terrasse. Die Treppe links erschließt den Wohnraum oben sowie den Koch-/Essbereich; eine andere führt aufs Dach, von dem man das ganze Haus überblicken kann. Die Wohnung ist wie geschaffen, um Parties auszurichten, denn alle Bereiche stehen in Blickkontakt zueinander. Überraschende Winkel und Ansichten vervollständigen die verschroben-kitschige Einrichtung, zu dem ein Leopardendruck-Sofa und ein Hund von Jeff Koons gehören.

Service postal transformé en résidence, ce projet offre une organisation de l'espace intéressante et un comique sens du style. De l'entrée du niveau inférieur, deux cabines sur pied protègent un vestibule menant à un atelier de peintre doté d'une lucarne et d'une terrasse. L'escalier de gauche conduit au séjour et au coin cuisine/repas, l'autre aboutissant sur le toit avec vue plongeante sur l'ensemble de la maison. Idéale pour les réceptions, cette demeure bénéficie de diverses ambiances, toujours en contact visuel entre elles. Angles et points de vue improbables complètent les intérieurs kitsch et étranges, incluant un canapé imprimé léopard et un chien Jeff Koons.

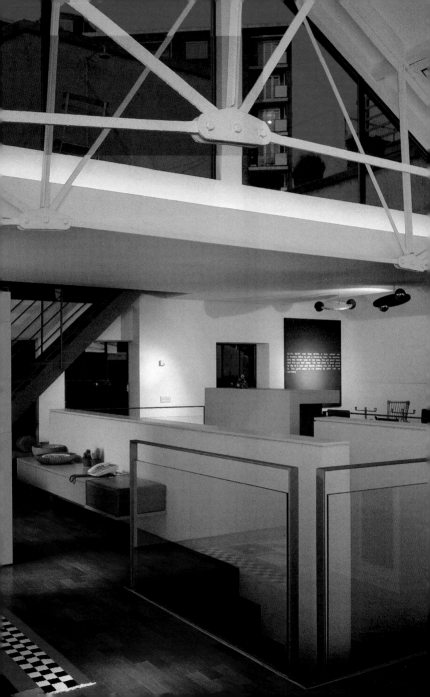

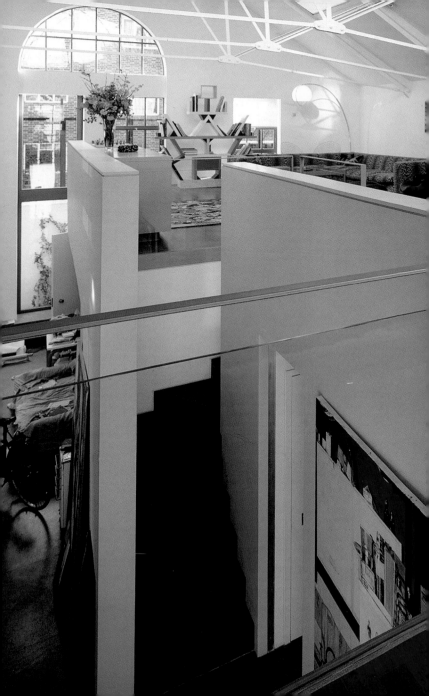

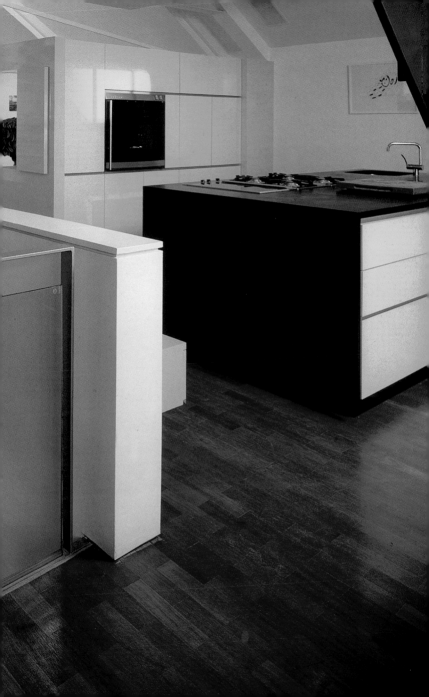

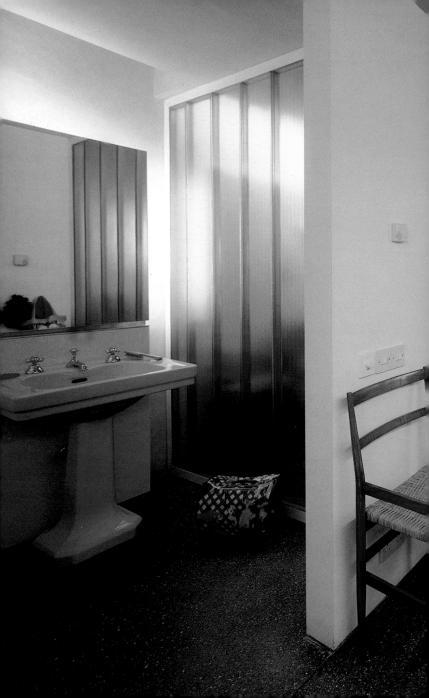

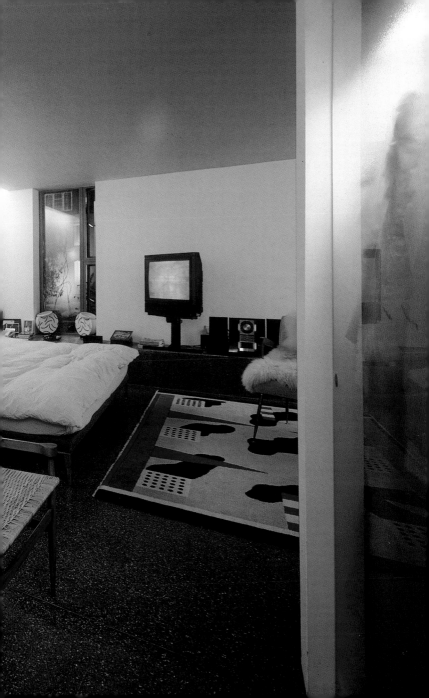

Hampstead House
Orefelt Associates

Photos: © **Jordi Miralles** Completion date: **1996**

Screened by trees and surrounded by typical Georgian mansions and cottages, this contemporary home was designed for the needs of a young family. The front of the house remained the same, while a new large glass panel at the back overlooks a flat roof and terrace. The extension is built mainly in blockwork and stucco rather than brick and incorporates a glass ceiling. The dining and living areas are located upstairs, while the bedrooms and bathrooms are on the ground floor. Materials include stone and timber floors, plaster and glass walls, and bronze, complemented by strong and bright colors that breathe life into the home and its surroundings.

Von Bäumen abgeschirmt und von typischen Georgianischen Villen und Cottages umgeben, wurde dieses moderne Haus nach den Bedürfnissen einer jungen Familie gestaltet. Die vordere Fassade wurde im ursprünglichen Zustand belassen, während hinten eine neue, große Glasfassade Blick auf das Flachdach und die Terrasse bietet. Der Anbau ist vornehmlich in Betonsteinmauerwerk und Putz ausgeführt und schließt auch ein Glasdach mit ein. Ess- und Wohnzimmer liegen oben, Bäder und Schlafzimmer im Erdgeschoss. Zu den Materialien gehören Stein- und Holzböden, gipsverputzte und Glas-Wände sowie Bronze; alles wird von starken, leuchtenden Farben vervollständigt, die Leben in dieses Zuhause und seine Umgebung bringen.

Masquée par des arbres et cernée de cottages et d'hôtels particuliers, cette demeure contemporaine a été conçue pour les besoins d'une jeune famille. La façade est restée intacte, alors qu'une grande verrière donnant sur l'arrière est venue surplomber un toit plat et une terrasse. L'extension est construite en aggloméré et en stuc, préférés à la brique, et comprend un plafond vitré. Les aires séjour et salle à manger se situent à l'étage, les chambres et salles de bain au rez-de-chaussée. Les matériaux, incluant sols en pierre et en plancher, murs de verre et de plâtre, et bronze, sont complétés par des couleurs fortes et vives qui insufflent la vie dans ce foyer et ses alentours.

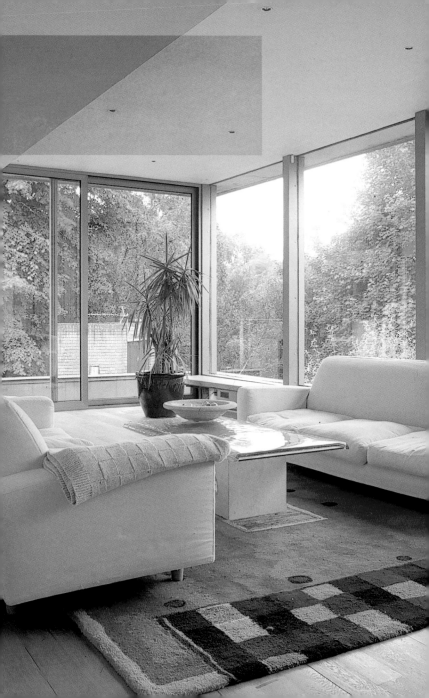

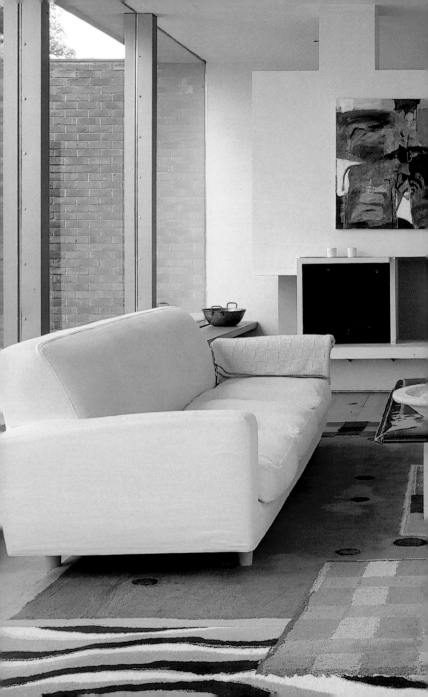

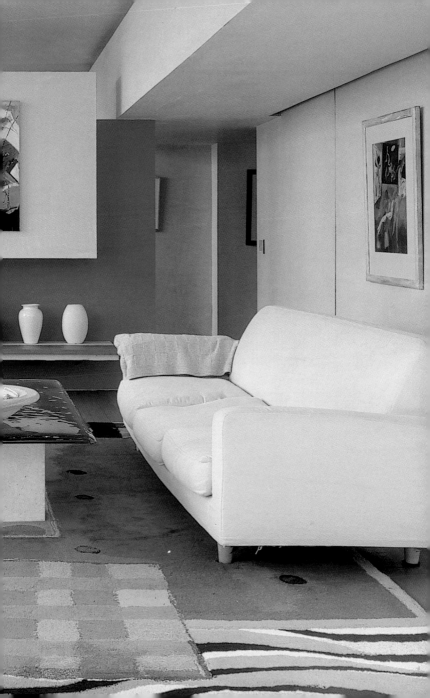

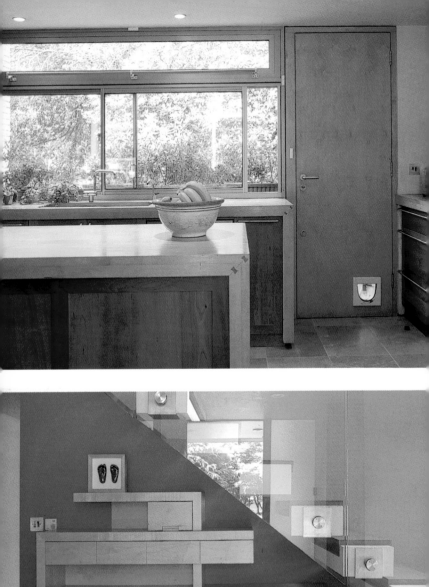
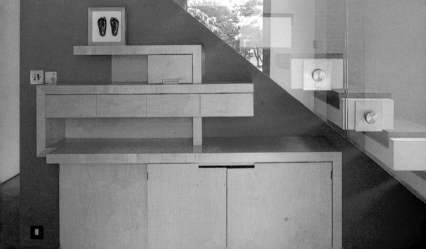

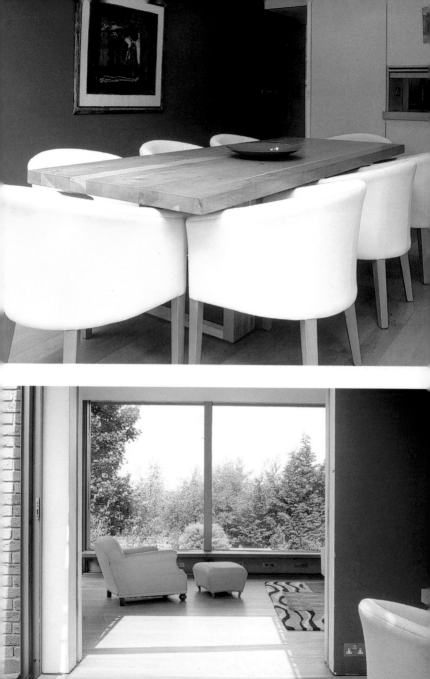

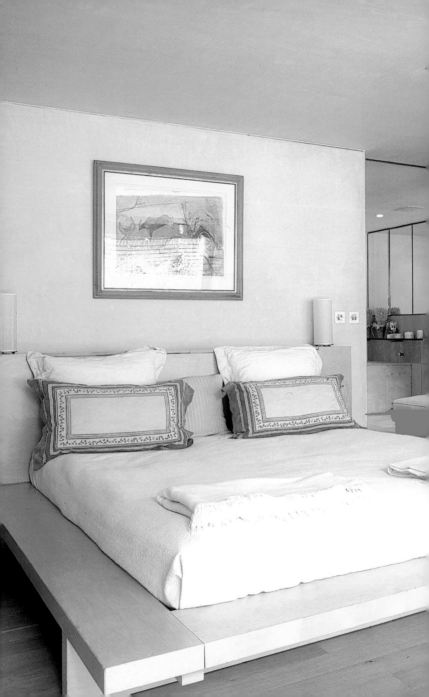

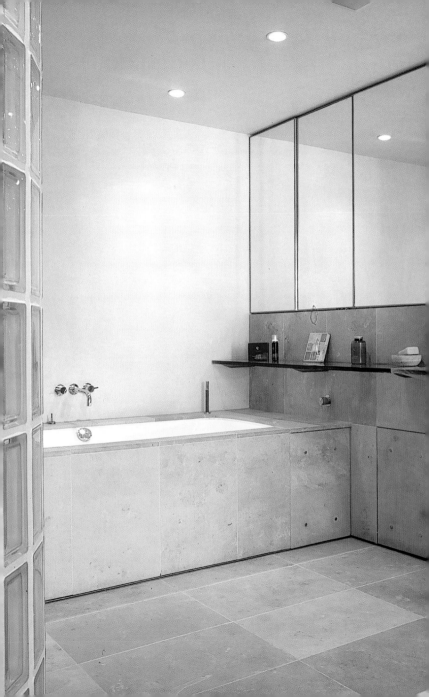

Portobello Apartment
Orefelt Associates

Photos: © **Alberto Ferrero** Completion date: **1994**

This residence forms part of a complex next to the trendy Portobello market. Created by and for the architect as a working/living space, the apartment includes a ground floor that consists of two bedrooms, a bathroom, and a guest bathroom. On the second floor, a longitudinal space situates the kitchen and workroom on one side and the living/dining room on the other. From here, a spiral staircase links the double-height studio. The small inner patio, a private garden, connects these spaces and is accessible from the bedroom and studio. Enclosing the space is a curved facade of zinc sheeting with circular windows alongside linear white volumes of light concrete.

In der Nähe des beliebten Portobello Markts liegt dieser Gebäudekomplex, von den Architekten als Wohn- und Arbeitsraum gestaltet. Das Apartment besteht aus dem Erdgeschoss mit zwei Schlafzimmern und zwei Bädern - eins davon für Gäste - sowie der ersten Etage, in der sich Küche und Arbeitsraum auf einer Seite und Wohn-/Esszimmer auf der anderen einen langgestreckten Raum teilen. Von hier führt eine Wendeltreppe in das Arbeitszimmer mit doppelter Raumhöhe. Ein kleiner Innenhof verbindet die Räume, er ist vom Schlafzimmer und Arbeitszimmer aus zugänglich. Eine gewölbte Fassade aus Zinkblech mit runden Fenstern sowie weiße geradlinige Körper aus Leichtbeton verschließen das Haus.

Cette résidence fait partie d'un complexe proche du marché branché de Portobello. Créé par et pour l'architecte comme un espace de vie et de travail, l'appartement inclut un rez-de-chaussée comprenant deux chambres et deux salles de bain, dont une pour invité. Au second, un espace longitudinal place la cuisine et le bureau d'un côté, le séjour/salle à manger de l'autre. De là, un escalier en colimaçon relie le studio à plafond surélevé. Le petit patio intérieur, un jardin privé accessible depuis la chambre et le studio, unifie ces espaces. Une façade curviligne en zinc, aux lucarnes arrondies, enceint le lieu, côte à côte avec des volumes en béton léger, blancs et linéaires.

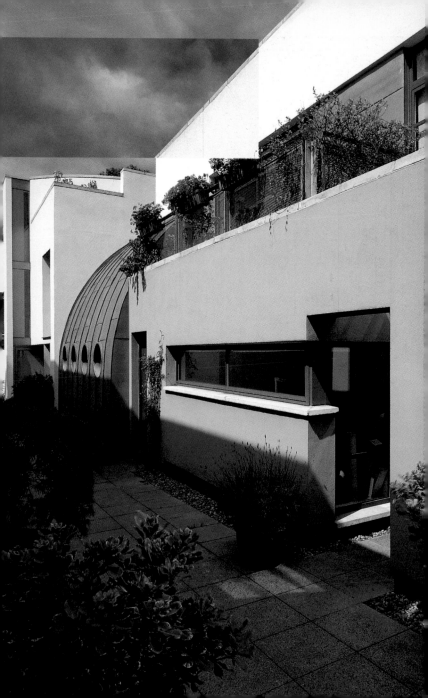

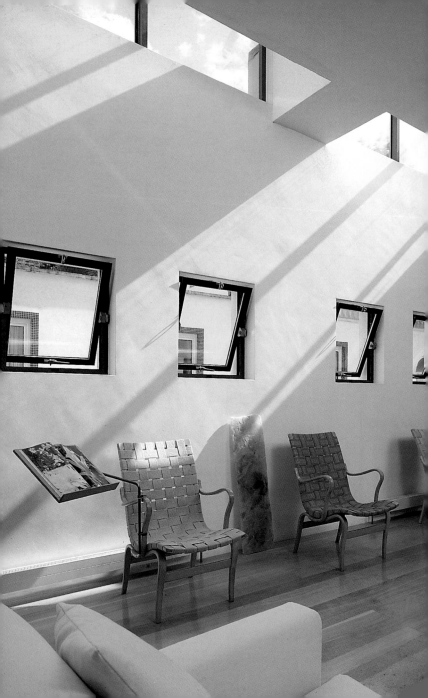

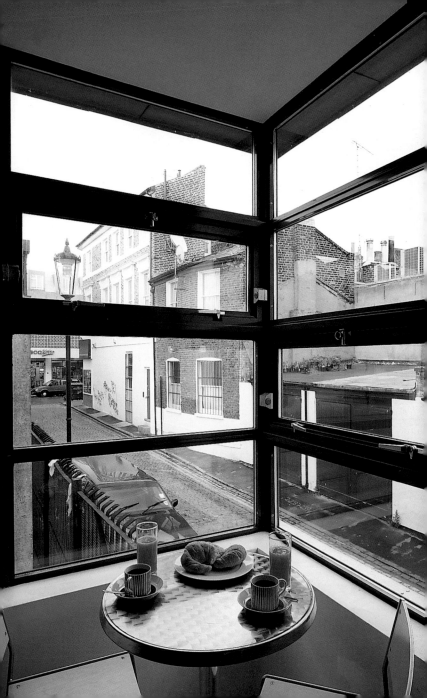

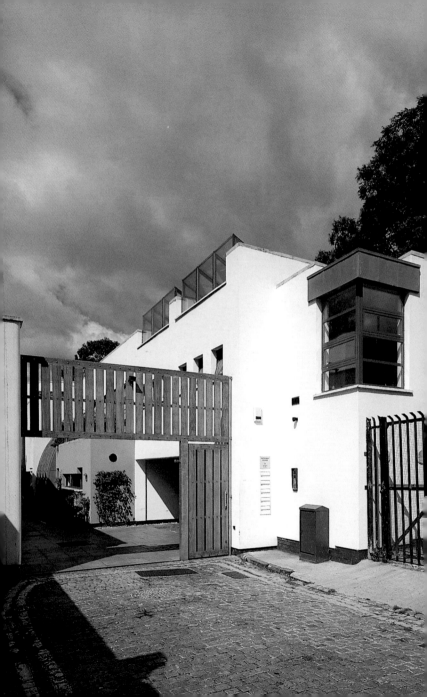

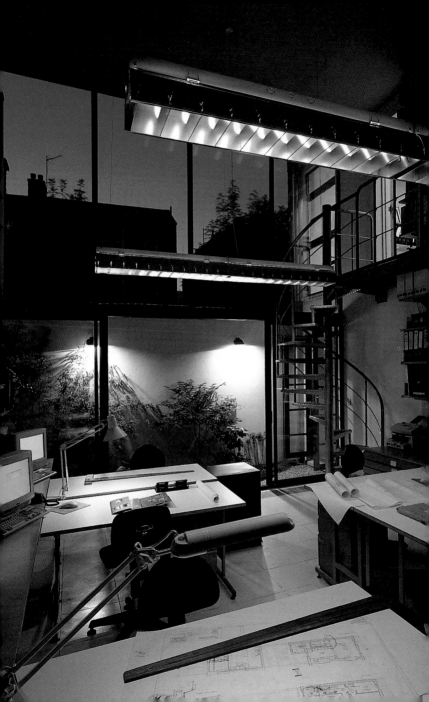

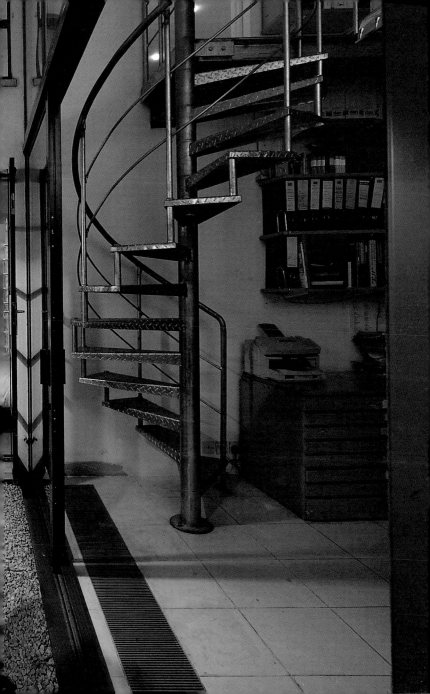

Emperor's Gate
Hugh Broughton

Photos: © **Richard Davies** Completion date: **1997** hugh@hbarchitects.demon.co.uk

Vacant for over a year, this compartmentalized maisonette was in desperate need of a full make-over. The first floor was opened up to serve as the living room and kitchen area, with the utility room on a lower split-level. Steel beams replaced the old structural walls framed by timber. The result is unobstructed views from front to back and a full width elevation that opens onto a paved balcony. The second floor contains two bedrooms with ensuite bathrooms. Bleached whites, matte steel, and crisp blue tones predominate. Wood floors complement the light, uncluttered architecture. This apartment represents a cohesive spatial arrangement that has a calm and contemplative atmosphere.

Über ein Jahr stand diese aufgesplitterte Maisonette-Wohnung leer und benötigte dringend eine Überholung. Die untere Ebene wurde geöffnet, um den Wohnraum aufzunehmen sowie die Küche mit einem Allzweckraum auf einer niedriger gelegenen Zwischenebene. Stahlträger ersetzen die alten tragenden Fachwerkwände. Das Ergebnis sind freie Durchblicke von vorne bis hinten und eine Erhöhung über die ganze Breite, die auf einen mit Platten belegten Balkon führt. In der oberen Ebene wurden zwei Schlafzimmer mit angeschlossenen Badezimmern eingerichtet. Weiß, matter Stahl und kräftige Blautöne dominieren. Der Holzboden rundet die helle, schlichte Architektur ab. Es ist ein geschlossenes räumliches Arrangement mit ruhiger, besinnlicher Atmosphäre.

Inoccupée plus d'un an, cette maisonnette nécessitait désespérément une réfection complète. Le premier étage a été ouvert pour servir de séjour et de cuisine, la pièce d'entretien se situant sur un demi-niveau inférieur. Des poutres d'acier ont remplacé l'ancienne charpente en bois, avec pour résultat final des vues dégagées avant/arrière et une façade sur toute la largeur, s'ouvrant sur balcon carrelé. Le second étage abrite deux chambres avec salles de bain attenantes. Les tons blanc cassé, acier mat et bleu vif prédominent. Des parquets complètent cette architecture légère et sobre. Cet appartement jouit d'une distribution cohérente de l'espace, et d'une atmosphère calme, propice à la contemplation.

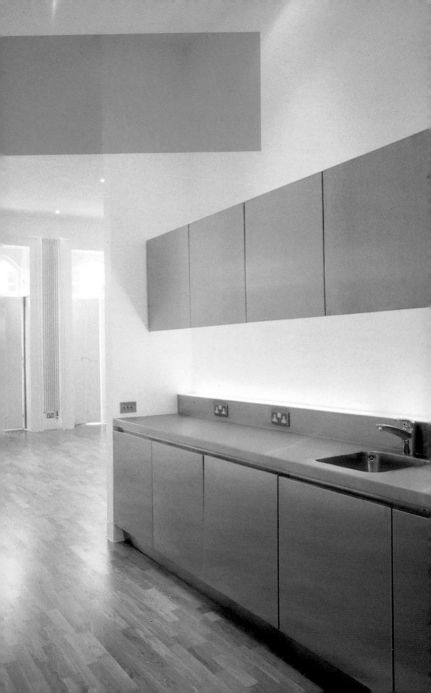

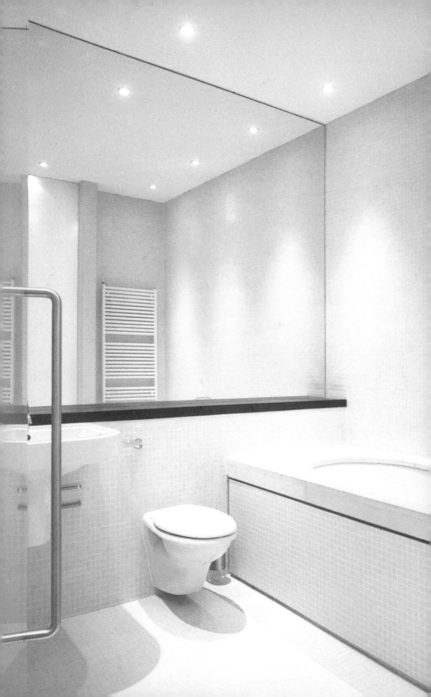

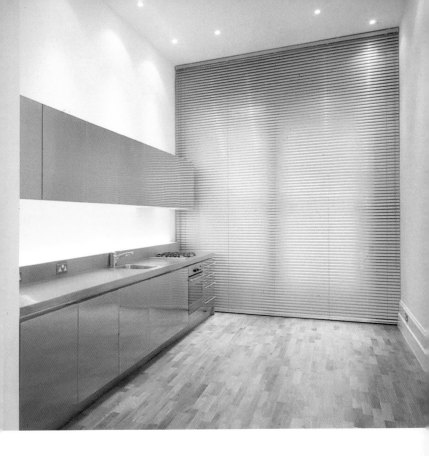

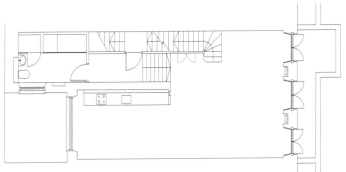

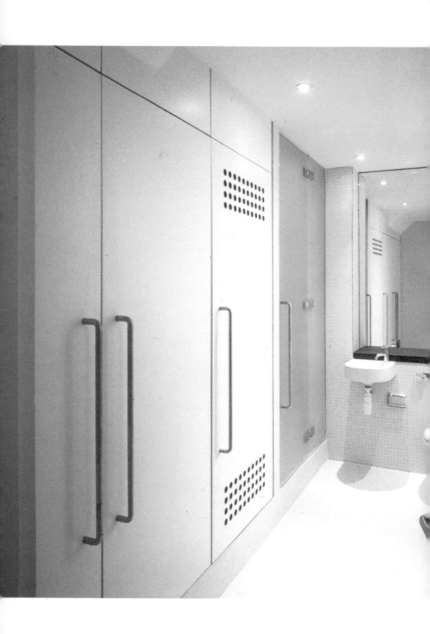

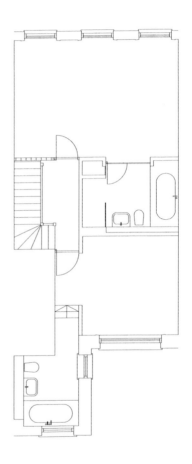

Underwood Street

Hugh Broughton

Photos: © **Carlos Domínguez** Completion date: **1997**

This second floor warehouse-style apartment was transformed into a crisp, clean-cut loft that preserves elements from its industrial origins. The architect conserved the cast-iron pillars and brick walls and added materials like white walls and ceilings, an acid-etched glass-block wall around the bathroom, and Opepe African hardwood floors. Spotlights run across the spine of the space, along with floor lamps. Diffused light shines through white laminated glass to offer dramatic lighting effects. The dynamic and diaphanous quality of the living room continues without interruption along a straight line to the visually divided kitchen, bathroom, and bedroom beyond.

Dieses Apartment im Stil eines Lagerhauses wurde in einen frischen, klar umrissenen Loft umgebaut, der einige Elemente seines industriellen Ursprungs bewahrt hat. Geblieben sind gusseiserne Säulen und Ziegelwände, neu sind die weiße Farbe für Wände und Decken, eine Wand aus geätzten Glasbausteinen, das Badezimmer und die Böden aus afrikanischem Opepe-Hartholz. Strahler und Stehlampen reihen sich entlang der Raumachse auf. Diffuses Licht sickert durch weißbeschichtetes Glas, um eindrucksvolle Effekte zu erzielen. Die Dynamik und Offenheit des Wohnraumes setzt sich in gerader Linie bis zu den dahinter gelegenen Räumen fort: Küche, Bad und Schlafzimmer.

Cet appartement, de style entrepôt, a été transformé en un loft à l'aspect net et soigné, qui préserve ses éléments industriels originels. L'architecte a conservé les piliers en fonte et les murs de briques, et ajouté des murs et plafonds blancs, un mur en briques de verre dépoli à l'acide autour de la salle de bain et des parquets de Bilinga. L'ensemble de l'espace est parcouru par des spots et des lampadaires. La lumière diffusée à travers le verre feuilleté blanc offre de surprenants jeux de lumière. La nature vive et diaphane du séjour s'étend sans interruption le long d'une ligne, qui se divise en rencontrant la cuisine, la salle de bain et la chambre à coucher.

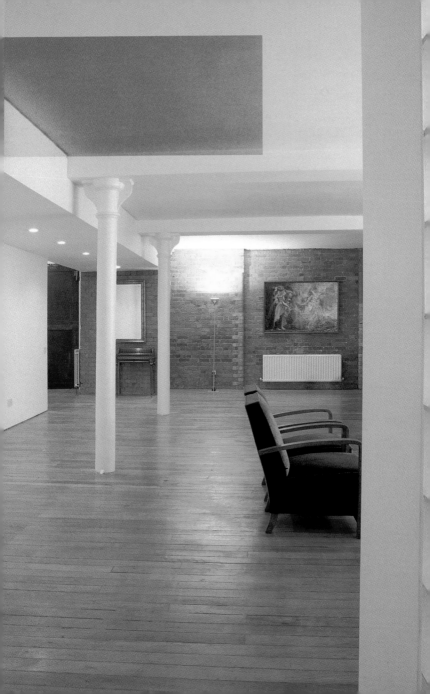

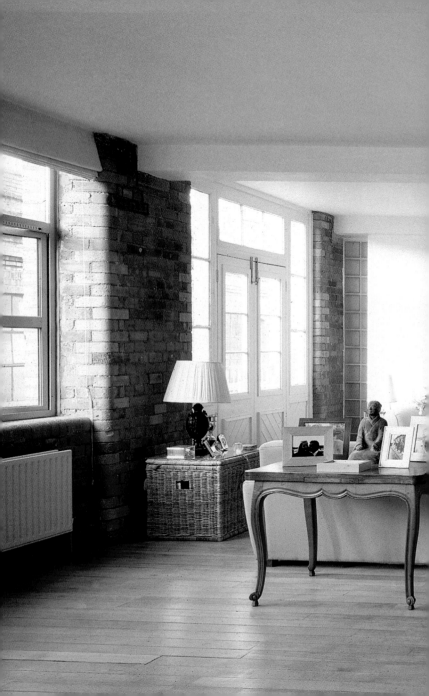

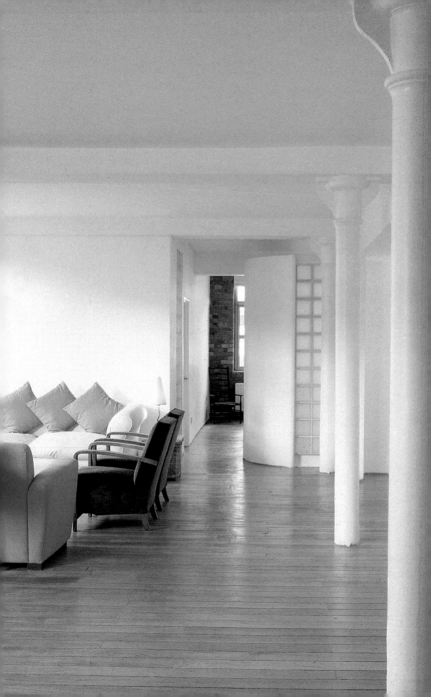

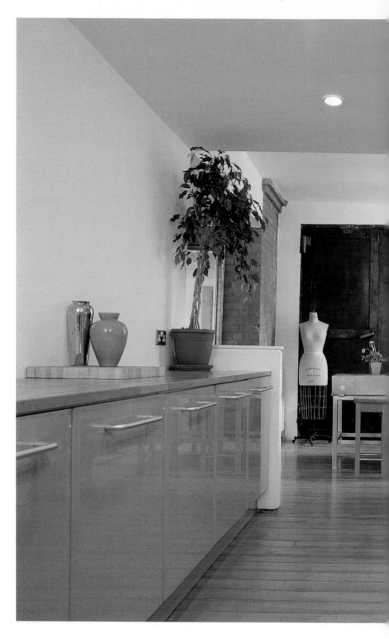

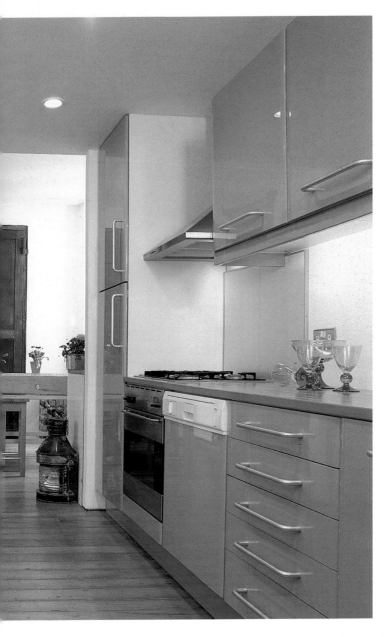

H House
Sauerbruch & Hutton

Photos: © **Hélène Binet** Completion date: **1995**

For this project, architects created a 32 by 32-foot concrete cube, its three floors of colored volumes offering different ambiences linked by a steel spiral staircase. The interior is separated from the exterior with wall-to-wall sliding glass panels. A translucent glass pane divides the ground floor from the swimming pool and garden. Brightly colored furniture and objects, ranging from cool blues and vibrant yellows to intense pinks and reds, define the open-plan spaces and their different zones against white surfaces and wood floors. The relationship between the home's colored cubic forms and the garden outside creates an urban dwelling that harmonizes with nature.

Für dieses Projekt schuf der Architekt einen Betonwürfel mit knapp zehn Meter Seitenlänge, dessen drei farbige und in ihrer Atmosphäre unterschiedliche Etagen durch eine stählerne Wendeltreppe verknüpft sind. Innen und außen werden durch Fenstertüren getrennt; im Erdgeschoss stellt eine Milchglasfläche die Grenze zu Swimming Pool und Garten dar. Möbel und Objekte in leuchtenden Farben - kühles Blau, irisierendes Gelb, intensive Pink- und Rottöne - setzen die offen angelegten Räume gegen die weißen Oberflächen und Holzböden ab. Die Kombination der kubistischen bunten Formen des Hauses mit dem Garten schafft eine urbane Wohnung, die mit der Natur harmoniert.

Pour ce projet, l'architectes a créé un cube de béton de 100 m², ses trois étages aux volumes colorés étant parcourus par un escalier d'acier en colimaçon et offrant des ambiances différenciées. Le rapport intérieur/extérieur naît autour de panneaux de verre coulissants, une vitre translucide séparant le sol de la piscine et du jardin. Objets et meubles vivement colorés, de bleus froids ou de jaunes vibrants à d'intenses rouges et roses, délimitent les espaces plans ouverts et leurs différentes zones s'appuyant contre les surfaces blanches et le sol en bois. La relation entre le jardin extérieur et les formes cubiques colorées de la maison compose un foyer urbain en harmonie avec la nature.

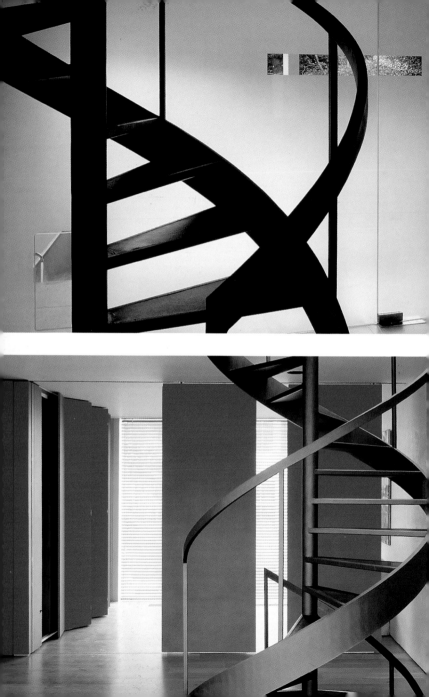

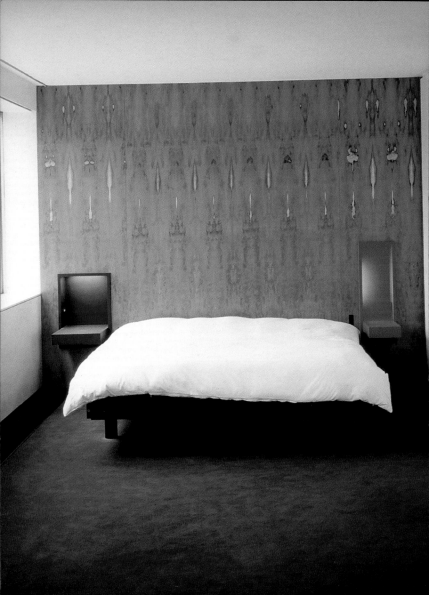

Vibrant colors and assorted textures
coexist with patterned wood panels.
Nooks in the wall are lit from inside,
built in with a bedside table.

Kräftige Farben bestehen neben emusterten
Holzpaneelen, und von innen beleuchtete
Wandnischen dienen als Einbau-Nachttische.
Farben und Texturen spielen eine wichtige
Rolle: warm und samten im Schlafzimmer,
kühl und sanft im Bad.

Couleurs éclatantes / Panneaux de bois
décorés. Les niches murales illuminées
de l'intérieur intègrent une table de nuit.
Couleurs et textures ont un rôle important:
chaud et tendre dans la chambre, frais et
lisse dans la salle de bain.

Sauerbruch & Hutton 285

Formerly a hotel, this six-story listed building was recently reconstructed to create a family dwelling. Floors were replaced with `mats´ made of materials ranging from hardwood and stone to rubber, screed, gravel, carpet, and leather. The various materials differentiate the spaces and their given function: limestone in the entrance hall, parquet in the living room, a plum-colored carpet staircase leading to the bedroom, and a pebble floor in the bathroom. Large furniture inserts, most of which are free-standing, provide the necessary storage and adorn the house with their rich textures and intense colors. These structures stand out more as creative elements rather than useful household installations, giving the home a strong aesthetic character.

Das sechsgeschossige denkmalgeschützte Gebäude diente früher als Hotel und wurde in ein Mehrfamilienhaus umgebaut. Die alten Böden wurden durch 'Matten' aus Hartholz, Stein, Gummi, Estrich, Kies, Teppich und Leder ersetzt. Sie grenzen die einzelnen Bereiche und Funktionen voneinander ab: Kalkstein für den Eingang, Parkett im Wohnzimmer, pflaumenfarbener Teppich auf der Treppe ins Schlafzimmer und ein Kieselboden im Bad. Große Einbaumöbel bieten Stauraum und bereichern die Wohnung durch exquisite Texturen – Beton, Hartholz, Stahl und Lack – sowie intensive Farben: Orange, Mauve, Grün und Blau. Diese Objekte stechen eher als kreative denn als nützliche Haushaltselemente hervor und verleihen der Wohnung einen ästhetischen Charakter.

Autrefois un hôtel, cet immeuble classé a été récemment reconstruit pour accueillir une famille. Les sols existant ont été remplacés par des «nattes», allant du bois dur et de pierres, jusqu'au caoutchouc, cerce, gravier, tapis et cuir. Les matériaux divers déterminent les espaces et leurs fonctions: combe dans le hall d'entrée, parquet dans le séjour, un escalier tapissé couleur prune menant à la chambre, et une salle de bain pavée de galets. Des meubles généreux offrent des rangements suffisants et enrichissent la maison de riches textures et de couleurs intenses. Ces structures sont plus remarquables pour leur créativité que pour leur utilité domestique, donnant à la maison une forte personnalité esthétique.

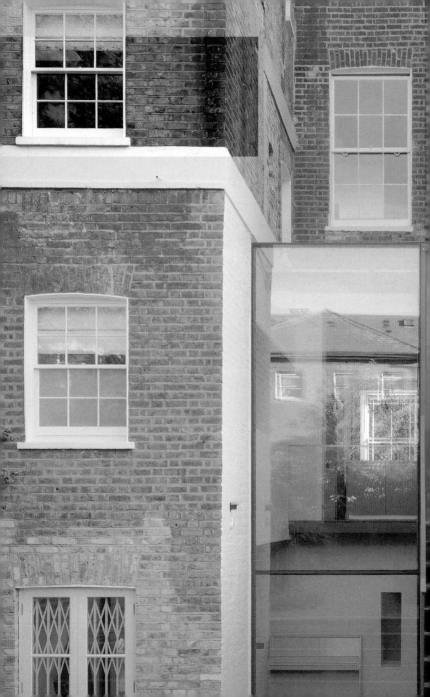

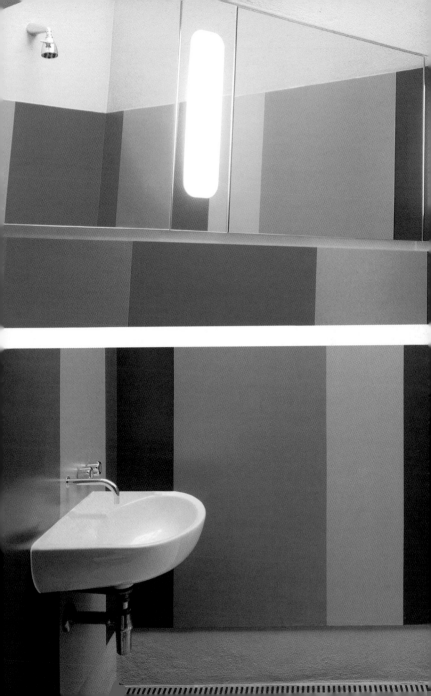

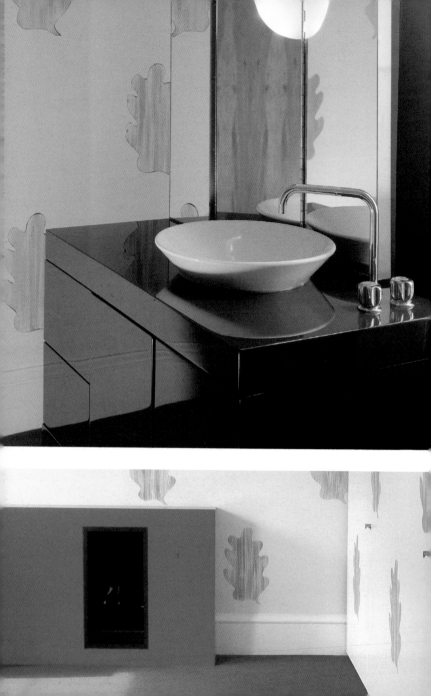

Photos: © **Michael Claus**, © **Katsuhisa Kida**, © **Hélène Binet**, © **Charlie Stebbings** Completion date: **1992**

Formerly an old and conventional Victorian semi-detached house, this site was redesigned to accommodate a working and living space for the architects themselves. The two lower floors were turned into offices and the upper levels became their home. The use of textures, bright colors, and warm wood make the space comfortable, while strategic storage demonstrates the house's functionality. Open areas and simple interiors lead to the top floor where a vast space is shared by the living room, dining room, and kitchen. This area rests underneath a glass panel ceiling that by day shows the ever-changing landscape of the London sky and by night, theatrically shrouds the warm and glowing abode.

Dieses 170 m² große Gebäude war ein klassisches viktorianisches Einfamilienhaus, bis es in Wohnung und Büro für den Architekten selbst verwandelt wurde. In den unteren Ebenen wur-den Büros eingerichtet, in den oberen Wohnräume. Der Einsatz verschiedener Texturen, kräftiger Farben und warmen Holzes machen das Haus wohnlich, während strategisch geplante Stauräume Funktionalität beweisen. Offene Räume und einfache Ausstattungen erstrecken sich bis in die oberste Etage, in der sich Wohn-, Esszimmer und Küche einen weitläufigen Raum teilen. Dieser Bereich liegt unter einem Dach aus Glasplatten, das tagsüber die unablässig sich ändernde Landschaft des Londoner Himmel zeigt und nachts die warm-glühende Behausung einhüllt.

Autrefois une conventionnelle maison adossée victorienne, ce site fut remodelé pour accueillir un espace de vie et de travail pour les architectes. Les deux étages inférieurs transformés en bureaux, le niveau supérieur devint leur foyer. L'emploi de textures, de couleurs vives et de bois chaud rend l'espace confortable, des espaces de rangement soulignant la fonctionnalité du lieu. Des volumes ouverts et des intérieurs simples mènent au dernier niveau, un vaste espace partagé entre séjour, salle à manger et cuisine. Un plafond en verrière veille sur le lieu, découvrant, de jour, le paysage versatile du ciel de Londres. De nuit, la verrière enveloppe théâtralement la demeure chaleureuse et brillante.

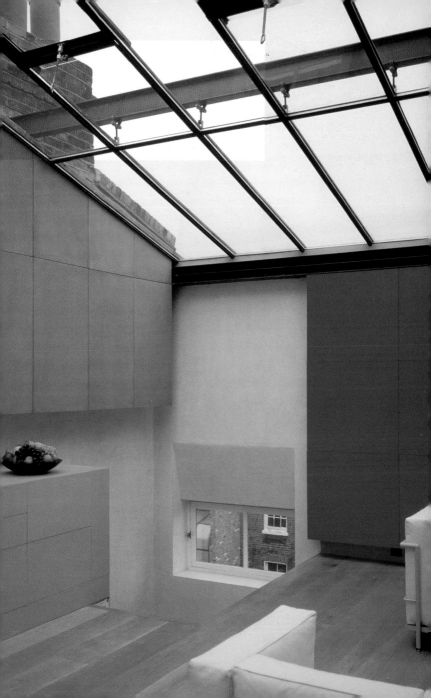

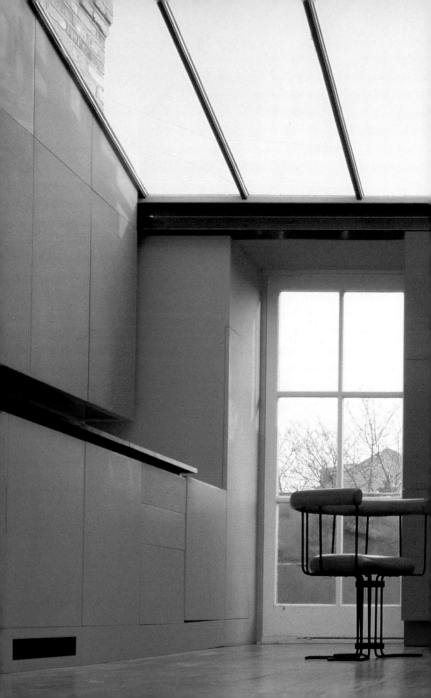

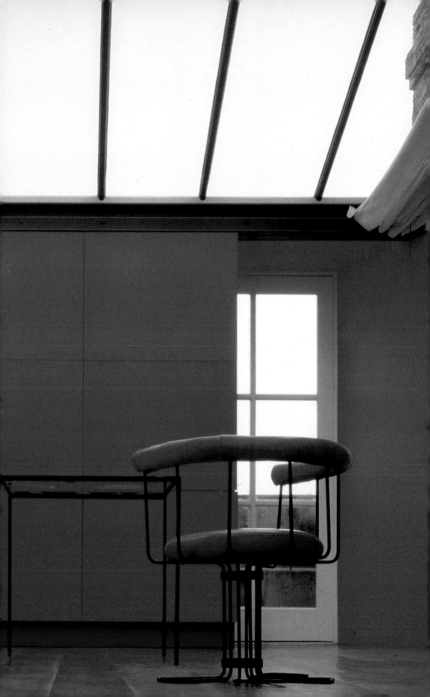

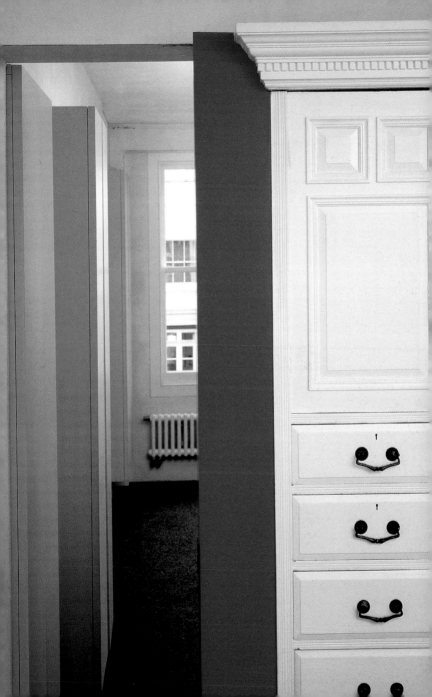

Studio in Camden Town

AEM

Photos: © Alan Williams Completion date: 1999 a-em@dial.pipex.com www.a-em.com

This 30-square meter flat on the attic floor of a 19th century townhouse is a triumphant endeavor in the transformation of space. Its primary innovation is its "hit-and-miss" steel plate staircase that leads to the upper sleeping platform. Pigeonholes in the staircase also function as kitchen storage. Underneath, a pivoting, full-height door was installed between the bedroom and bathroom so that the space can be rearranged. Pale maple wood floors accompany floating planes of orange, blue, and red against fresh white surfaces. Carefully selected modernist-style furniture and minimal decoration keeps the space clean and uncluttered.

Diese nur 30 m² große Dachwohnung in einem Bürgerhaus des 19. Jahrhunderts ist das Ergebnis einer erfolgreichen Umgestaltung. Die Hauptinnovation ist die raumsparende Treppe aus Stahl, die zur Schlafplattform führt. Fächer in der Treppe dienen als Stauraum für Küchenutensilien. Darunter wurde eine raumhohe Schiebetür so zwischen Schlafzimmer und Bad angebracht, dass der Raum umwandelbar ist. Heller Ahornholzboden harmoniert mit schwebenden Ebenen in Orange, Blau und Rot vor den frischen, weißen Oberflächen. Die sorgfältig ausgewählten modernistischen Möbel und eine minimale Dekoration halten den Raum rein und schlicht.

Ce logement de 30 m², situé dans l'attique d'un hôtel particulier XIXe, constitue un effort de transformation de l'espace couronné de succès. Sa première innovation: un escalier à l'emporte-pièce, en plaques d'acier, menant à la plate-forme de couchage. Les casiers encastrés dans les marches servent aussi de rangement de cuisine. Dessous, une porte pivotante en pleine-hauteur a été installée entre la chambre et la salle de bain, pour redistribuer l'espace. Des parquets d'érable clair accompagnent des plans flottants orange, bleus et rouges contre des surfaces blanches. Choisis avec soin, un ameublement moderniste et une décoration minimale maintiennent l'espace clair et dégagé.

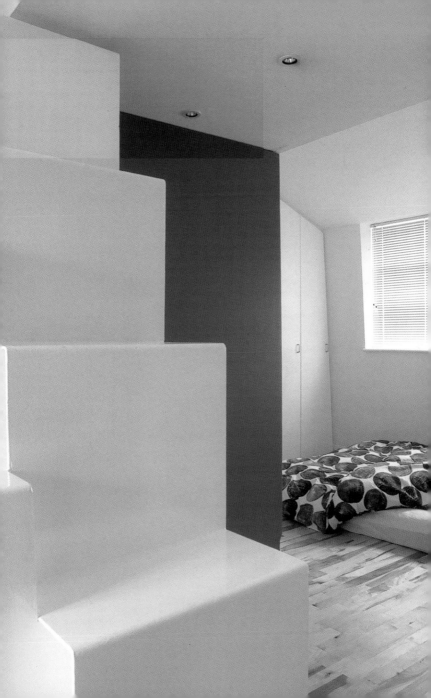

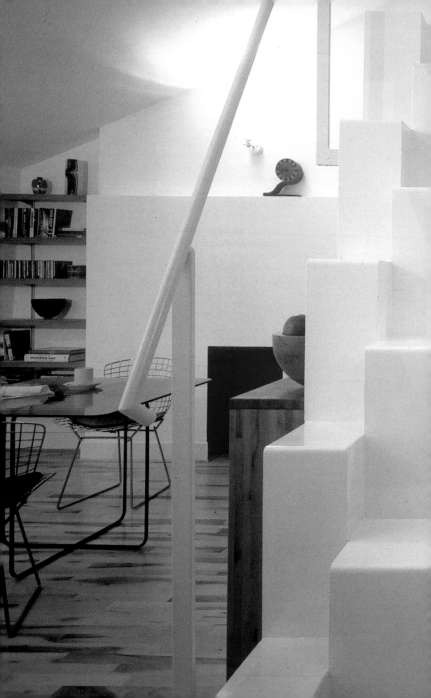

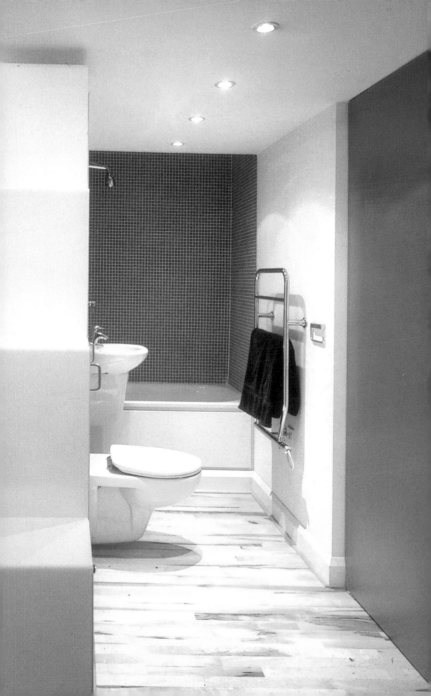

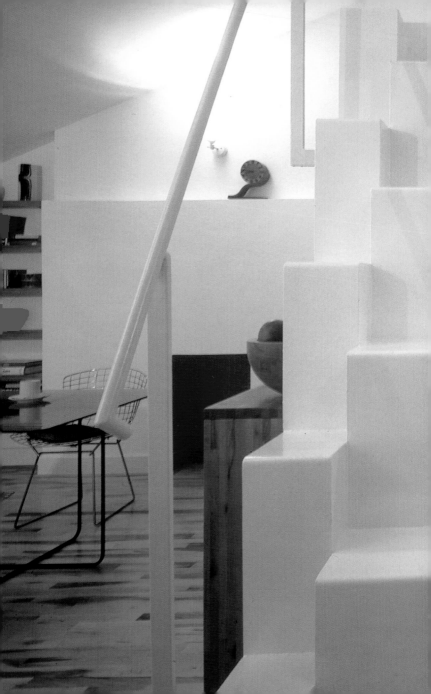

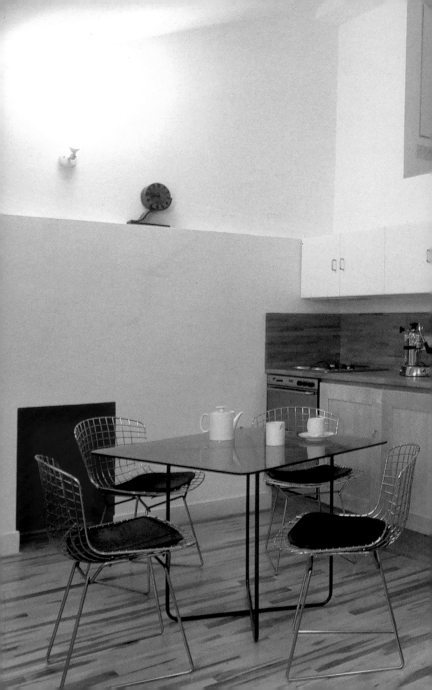

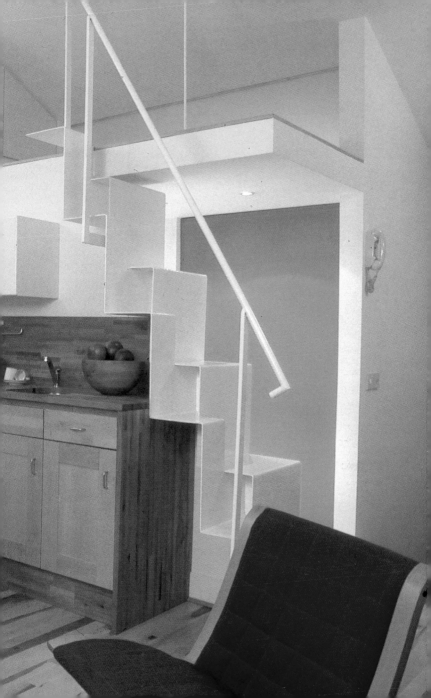

Knightsbridge Flat
AEM

Photos: © **Alan Williams** Completion date: **2000** a-em@dial.pipex.com www.a-em.com

Dismal, compact units of an apartment block of Edwardian mansions were transformed into an arrangement of smooth, uncluttered and light-washed surfaces. This flat is designed for the working, living, and entertaining needs of jet-setting international businessmen. Walls are fitted with fiber-optic lighting, white blinds screen the windows, and the floors are finished in timber and stone. The architect's trademark, a full-height pivoting door, was placed between the dining room and library. The coolness of these areas contrasts with the animated and colorful qualities of the private spaces, distinguished by vivid marbles and Philip Starck bathroom fittings.

Mehrere kompakte Einheiten eines Wohnblocks wurden in ein Arrangement aus zarten, schlichten und lichtdurchfluteten Ebenen verwandelt. Die Wohnung wurde nach den Lebens-, Arbeits- und Freizeit-Bedürfnissen eines internationalen Geschäftsmannes und Jet-setters gestaltet. Glasfaserlampen in den Wänden, weiße Fensterschirme und Böden aus Holz und Stein schaffen Kontinuität. Der Eindruck der räumlichen Einheit wird durch bewegliche Wände und Türen vergrößert. Eine raumhohe Schiebetür wurde zwischen Esszimmer und Bibliothek eingezogen Die Kühle dieses Bereichs steht im Kontrast zur lebendigen Atmosphäre der Privaträume, ausgezeichnet durch exklusiven Marmor und Armaturen von Philip Starck.

Plusieurs unités compactes et ternes d'un groupe d'hôtels particuliers Edouardiens ont été transformées en un ensemble de surfaces harmonieuses, aérées et baignées de lumière. Murs aux éclairages en fibre optique, persiennes blanches masquant fenêtres et sols, revêtus de bois et de pierre pour susciter la fluidité. La sensation d'unité spatiale a été rehaussée en retirant les murs et en élargissant les ouvertures. La marque de l'architecte, une porte pivotante de pleine-hauteur, se place entre la salle à manger et la bibliothèque. Ces zones de calme contrastent avec la nature colorée et animée des espaces privés, se distinguant par des marbres éclatants et une salle de bain Philip Starck.

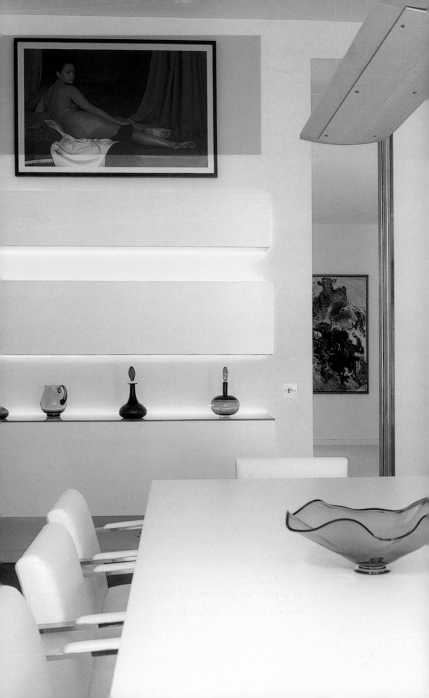

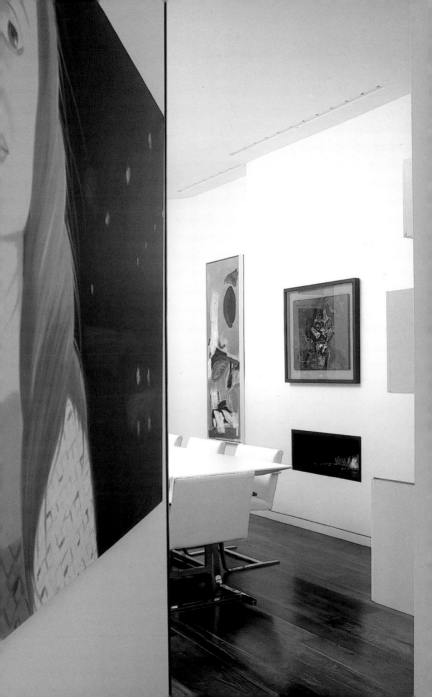

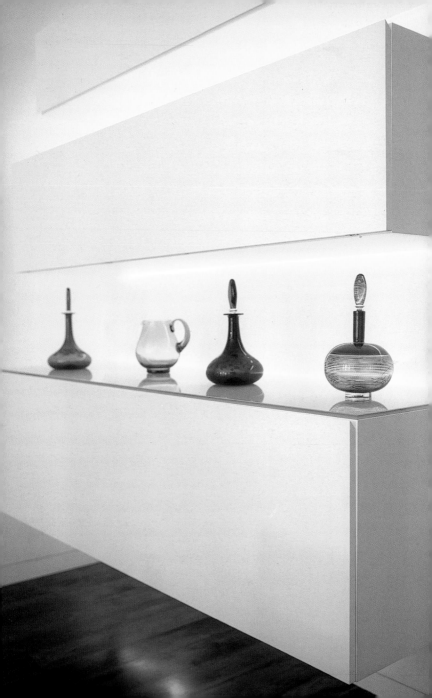

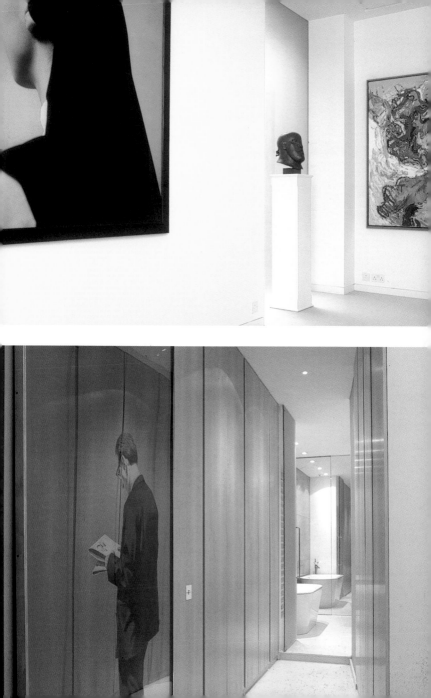

Hampstead Residence
AEM

Photos: © **Alan Williams** Completion date: **1999** a-em@dial.pipex.com www.a-em.com

To achieve a greater sense of space and a more dynamic look in this 1930's single-level house, the architect introduced a double-height volume. The broad living room, characterized by a central, free-standing cylindrical fireplace and chimney-flue, rises up from a staircase on the side to the first floor level that looks at a walled courtyard through a glazed bay window. This top floor promotes the fluidity of space through the use of glass partitions between the master bedroom and the ensuite bathroom. An open study area overlooks the stairwell and leads to a spacious roof terrace decked in timber.

Um einen optimaleren Raumeindruck und mehr Dynamik in diesem Bungalow aus den 30er Jahren zu erreichen, schuf der Architekt einen Körper mit doppelter Raumhöhe. Das geräumige Wohnzimmer, dessen Attraktion ein zentraler, freistehender, runder Kamin ist, zieht sich von der Treppe an einer Seite bis zur oberen Ebene, die durch ein Erkerfenster Aussicht auf einen von Mauern umschlossenen Hof gewährt. Die Verwendung gläserner Abtrennungen zwischen Schlafzimmer und angeschlossenem Bad steigert in der oberen Etage die Fluidität des Raumes. Ein offener Arbeitsbereich sieht auf die Treppe herab und gibt den Blick frei auf die großzügige, holzgedeckte Dachterrasse.

Recherchant une sensation d'espace prégnante et un look dynamisé, l'architecte a introduit un volume de double-hauteur dans cette maison années 30 de plain-pied. Le vaste séjour, caractérisé par une cheminée centrale cylindrique et autonome, s'élève depuis un escalier flanquant le premier étage, face à une arrière cour murée et à travers une baie vitrée. L'étage supérieur stimule la fluidité de l'espace à l'aise de cloisons en verre séparant la chambre principale de la salle de bain attenante. Une aire d'étude ouverte surplombe la cage d'escalier et mène à une spacieuse terrasse sur le toit, revêtue de bois.

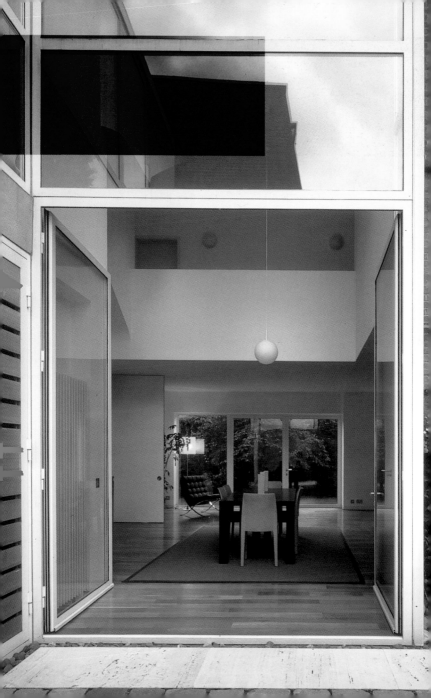

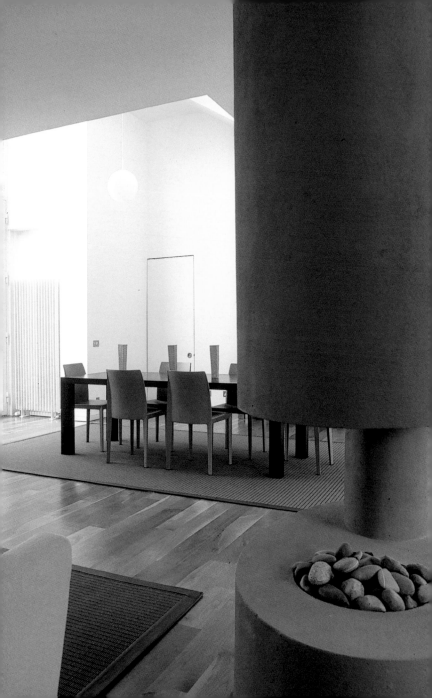

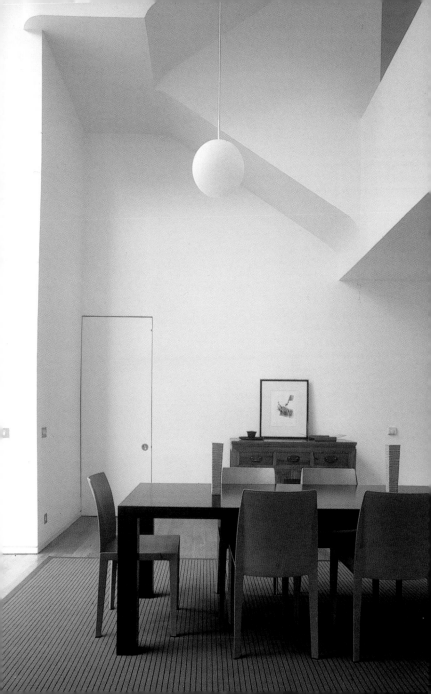

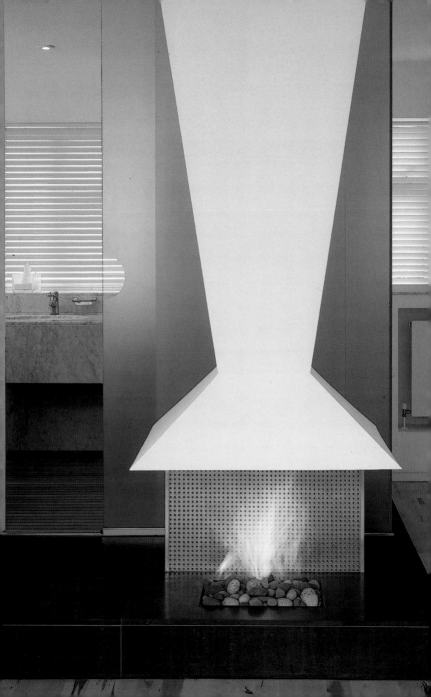

Camden Penthouse
AEM

Photos: © **Alan Williams** Completion date: **2001** a-em@dial.pipex.com www.a-em.com

This penthouse, situated off of one of London's most hip and busiest streets, is a haven from traffic and noise with splendid views of the heterogeneous London skyline. Access from the existing building to the new structure was enabled through a cupboard transformed into a staircase. The flat is glass-fronted, and natural light floods the interior. The penthouse is divided into two parts: a central, generic living area with an integrated kitchen in one corner, and a sectioned-off area near the entrance that contains two bedrooms and bathrooms. In the living room, an unusual fireplace protrudes from the ceiling and hovers above the wooden floors. The house opens onto the surrounding rooftop, which acts as a private terrace.

Dieses Penthouse an einer der lebhaftesten Straßen Londons ist eine Oase inmitten des Tohuwabohus und hat eine wunderbare Aussicht auf die Skyline der Stadt. Für den Zugang zum Neubau vom bestehenden Gebäude aus wurde ein Regal in eine Treppe verwandelt. Die Glasfront versorgt die Wohnung mit natürlichem Licht. Sie besteht aus zwei Teilen: einem Wohnraum in der Mitte mit integrierter Küche in einer Ecke und einem separaten Bereich nahe des Eingangs mit zwei Schlafzimmern und Bädern. Ein ungewöhnlicher Kamin hängt von der Wohnzimmerdecke und schwebt über dem Holzfußboden. Das Dach wird als private Terrasse genutzt.

Ce penthouse, proche d'une des rues les plus branchées et animées de Londres, est un havre de paix loin du tumulte, doté de vues splendides sur un ciel londonien tout en nuances. Depuis l'ancien édifice, un espace de rangement transformé en escalier donne accès à la nouvelle structure. La façade en verre du logement inonde l'intérieur de lumière. Le penthouse est divisé en deux: un espace de séjour commun et central, doté d'une cuisine intégrée dans un angle et, près de l'entrée, une aire partagée entre deux chambres et deux salles de bain. Dans le séjour, une cheminée insolite sort du plafond, surplombant les parquets de bois. La maison s'ouvre sur un toit qui la ceinture, tenant lieu de terrasse privée.

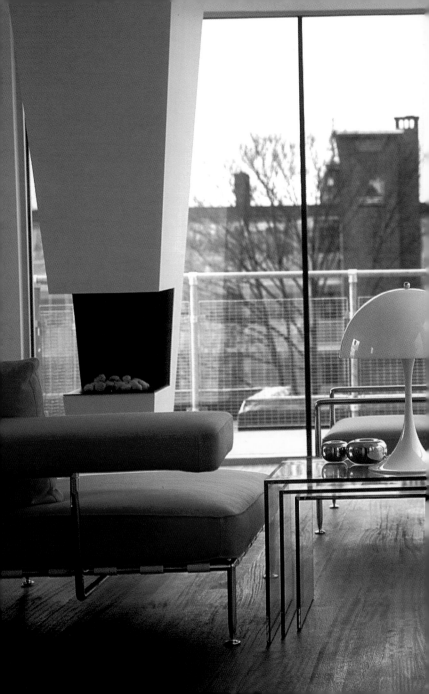

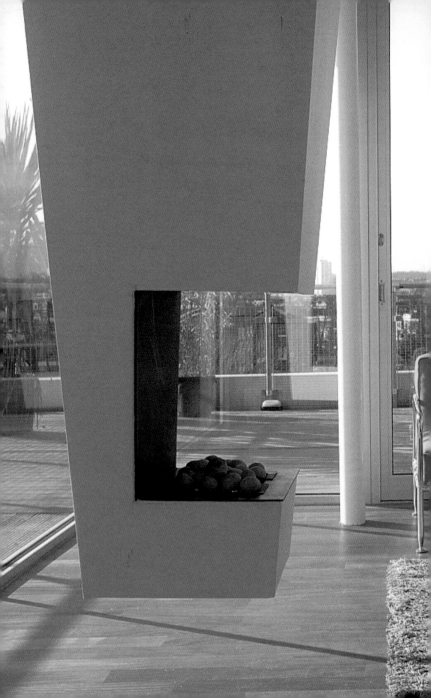

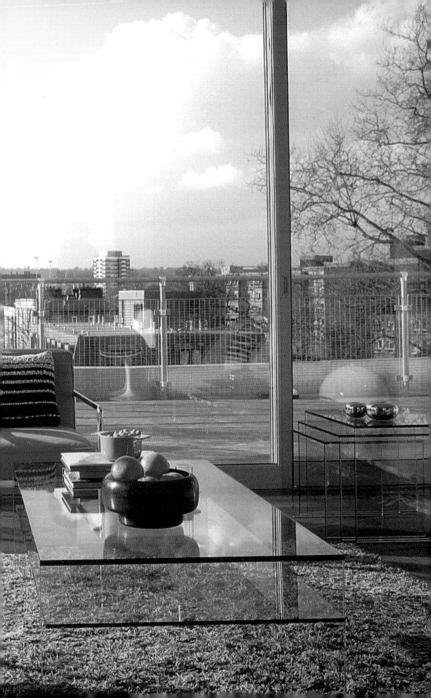

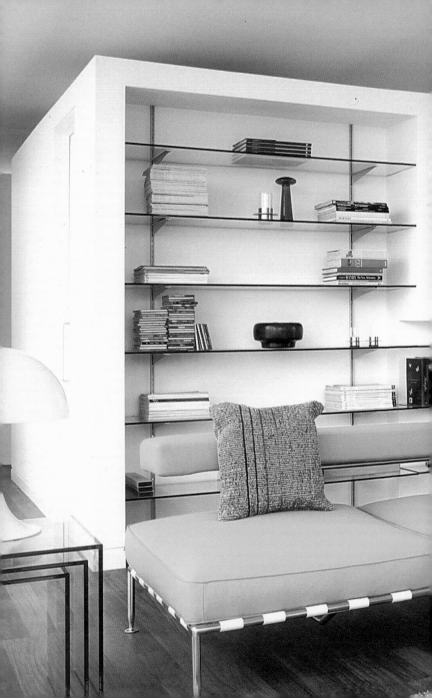

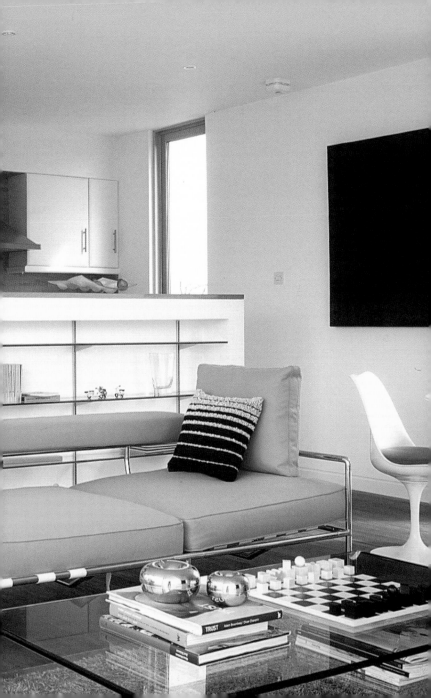

Photos: **Alan Williams** Completion date: **1996** a-em@dial.pipex.com www.a-em.com

Loft living means that unobstructed spaces must adapt to a resident's lifestyle so that his or her activities can easily overlap. This project takes advantage of the qualities offered by such a diaphanous site and peppers it with subtle, creative features. Camouflaged storage space preserves bare white walls, while a few vivid pieces of furniture and special objects spark up the dwelling's personality, setting off neutral tones, warm wood floors, and filtered light. A bathroom behind acid-etched glass and a sectioned off bedroom are hidden from the large main living room and kitchen so that the private and public spaces connect but remain separate entities.

Leben in einem Loft heißt, dass sich ein einziger großer Raum dem Lebensstil des Bewohners anpasst und sich alle Aktivitäten nebeneinander und überschneidend abspielen. Dieser Entwurf nutzt diese positiven Aspekte und bereichert sie mit subtilen, kreativen Ideen. Verkleideter Stauraum lässt die nackten Wände frei, während wenige auffällige Möbel und Deko-Objekte die Atmosphäre der Wohnung beleben, die mit Holzböden und gedämpftem Licht in neutralen Tönen gehalten ist. Das Badezimmer, hinter geätztem Glas versteckt, sowie ein Schlafzimmer sind von Wohnraum und Küche abgetrennt, so dass private und gemeinschaftliche Räume, verbundene, jedoch selbständige Einheiten bilden.

La vie dans un loft implique que les espaces dégagés s'adaptent au style de vie du résident, ses activités pouvant s'interpénétrer. Ce projet s'appuie sur la nature diaphane du lieu, pimenté ici et là d'éléments subtils et créatifs. Un espace de rangement camouflé préserve la sobriété des murs blancs, tandis que meubles et objets spéciaux réveillent la personnalité de la demeure, s'appuyant sur des tons neutres, des parquets chauds et une lumière filtrée. Une salle de bain derrière un verre dépoli et une chambre partagée se cachent du séjour principal et de la cuisine, afin que les espaces publics et privés communiquent mais restent séparés.

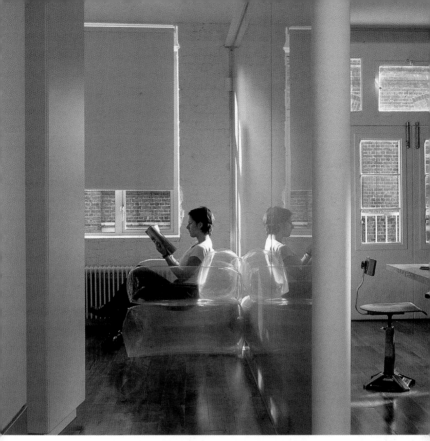

Transformable Apartment
Mark Guard

Photos: © **Mark Guard** Completion date: **1996** mga@markguard.com www.markguard.com

The name of this project accurately describes the function of this cool, simple, and nearly sterile space designed around the modern concept of single person households. This apartment maximizes available space by creating one main area that can be transformed to meet different needs. The master bedroom, guestroom, and cloakroom are contained in three freestanding boxes. The boxes' moveable walls surround the bathroom, and an abstract, sculptural shower adds visual dimension to the space. A 15-meter storage wall opens up to three work areas, which can be divided from the kitchen with sliding doors. The wall is bisected by an austere six-meter stainless steel table.

Nomen est Omen bei diesem coolen, einfachen und fast sterilen Projekt, dessen Funktionen um das moderne Konzept des Single-Haushalts herum entwickelt wurden. Es nutzt den verfügbaren Platz maximal aus, da der einzige Raum wandelbar ist und sich den verschiedenen Bedürfnissen anpassen kann. Schlafzimmer, Gästezimmer und Garderobe stecken in freistehenden Kisten. Deren bewegliche Wände umschließen das Bad, in dem eine abstrakte, plastische Dusche dem Raum eine zusätzliche visuelle Dimension verleiht. Eine 15 Meter lange Stauwand öffnet sich zu drei Arbeitsbereichen, die von der Küche durch Schiebetüren getrennt werden können. Die Wand wird durch einen nüchternen sechs Meter langen Edelstahltisch zweigeteilt.

De par son nom, ce projet décrit précisément le rôle de cet espace simple, froid et quasi stérile, conçu autour du concept moderne de foyer unipersonnel. Cet appartement magnifie l'espace disponible en créant une aire principale transformable selon les besoins. Les chambres principale et d'hôte, ainsi que le vestiaire, sont contenues dans trois cabines autonomes. Les murs amovibles des cabines enceignent la salle de bain, et une douche abstraite et sculpturale ajoute une dimension visuelle à l'espace. Un mur de rangement de 15 mètres s'ouvre sur des aires de travail, pouvant être séparées de la cuisine par des portes coulissantes. Le mur est divisé par une austère table en acier inox de six mètres.

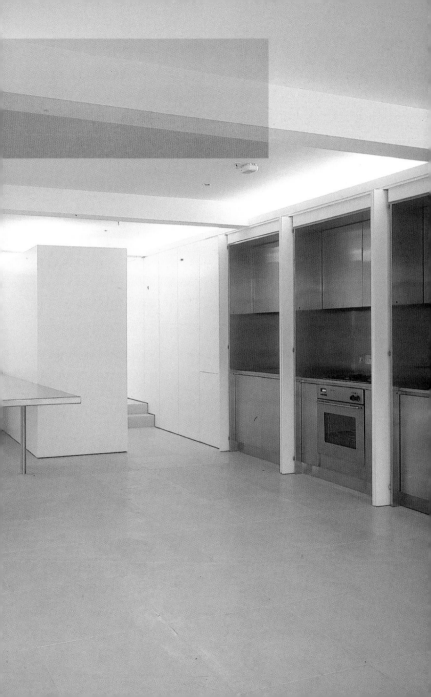

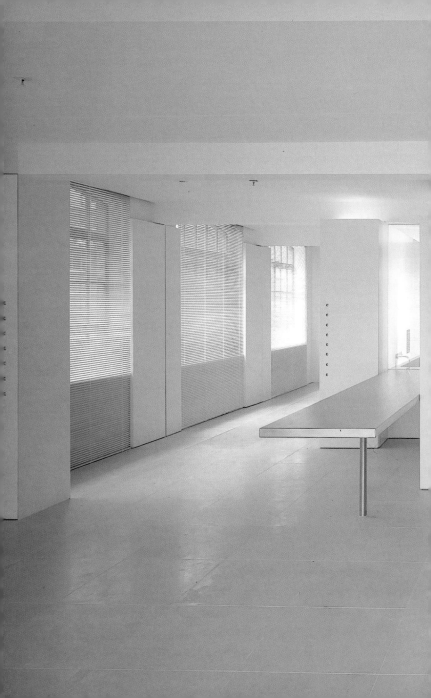

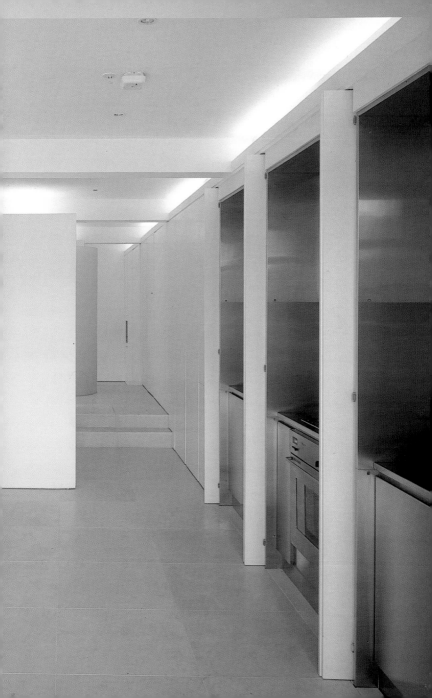

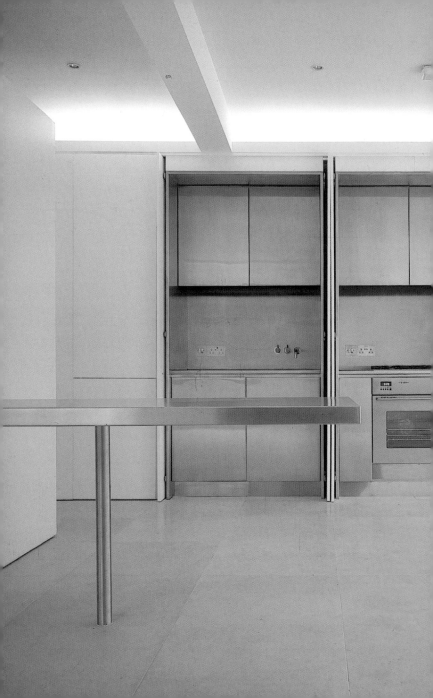

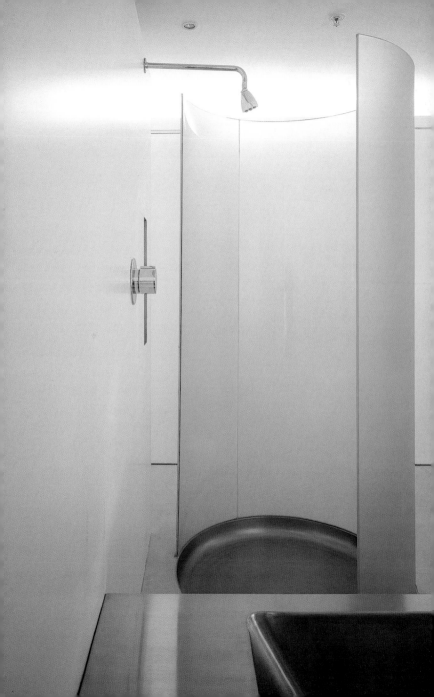

Barbican Tower, 36th floor
Mark Guard

Photos: © **Mark Guard** Completion date: **1996** mga@markguard.com www.markguard.com

An ordinary three-bedroom flat with a dark, narrow corridor was transformed into a bright, spacious, and modern two-bedroom apartment. Taking full advantage of the space views, three independent boxes distribute the areas in several ways, depending on which doors are kept open or closed. The study/guest bedroom was incorporated into the living room, allowing for a central open space that is shared with the master bedroom. The kitchen is concealed behind flush doors, exposing only its unique curved stainless steel and glass counter. The bathroom features a circular glass block structure that stops short of the ceiling to offer a luxurious view of London from inside the shower.

Ein durchschnittliche Drei-Zimmerwohnung mit dunklem, engen Flur wurde in ein helles, geräumiges und modernes Zwei-Zimmerapartment umgebaut. Drei unabhängige Körper gliedern den Raum unterschiedlich, je nachdem welche Türen offen oder geschlossen sind. Das Arbeits-/Gästezimmer ist im Wohnraum integriert und kann zu einem zentralen Raum geöffnet werden, der mit dem Schlafzimmer geteilt wird. Die Küche ist hinter bündig schließenden Türen verborgen, die lediglich die einzigartige geschwungene Theke aus Edelstahl und Glas sehen lassen. Im Badezimmer reicht die runde Wand aus Glasbausteinen nicht bis an die Decke, um von der Dusche aus einen unvergesslichen Ausblick auf London genießen zu können.

Un simple trois-pièces, doté d'un vestibule sombre et étroit, a été transformé en un deux-pièces moderne, spacieux et lumineux. Tirant pleinement parti des points de vue, trois cabines indépendantes redistribuent l'espace diversement selon que les portes sont ouvertes ou fermées. L'atelier/chambre d'hôte a été intégré au séjour, créant un espace central ouvert partagé avec la chambre principale. La cuisine se dissimule derrière des portes isoplanes, révélant seulement le comptoir curviligne en verre et en acier inox. La salle de bain présente une structure circul aire en verre qui s'arrête avant le plafond pour offrir, depuis la douche, une somptueuse vue de Londres.

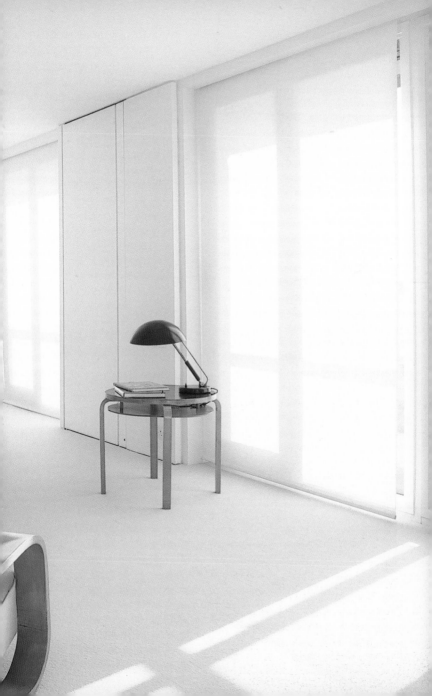

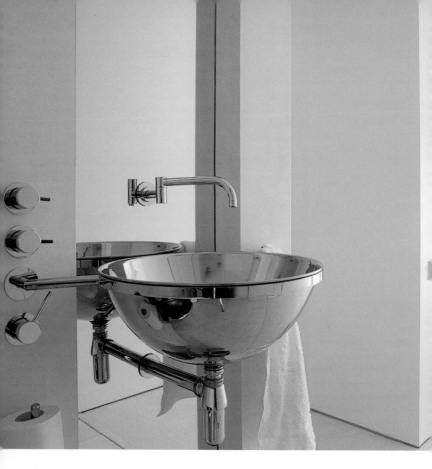

The bathroom is concealed from the living room within a cubic structure.
Unusual features are the raised glass block shower and the sink taps built
in to the wall and miror.

Das Badezimmer liegt vom Wohnraum getrennt in einem
würfelförmigen Element. Ungewöhnlich sind die erhöhte
Dusche mit einer Wand aus Glasbausteinen und die in
Wand und Spiegele ingebauten Armaturen.

La salle de bain se cache du séjour au sein d'une structure cubique.
Éléments inhabituels, le bloc de douche en verre saillant, et les lavabos
encastrés dans le mur et le miroir.

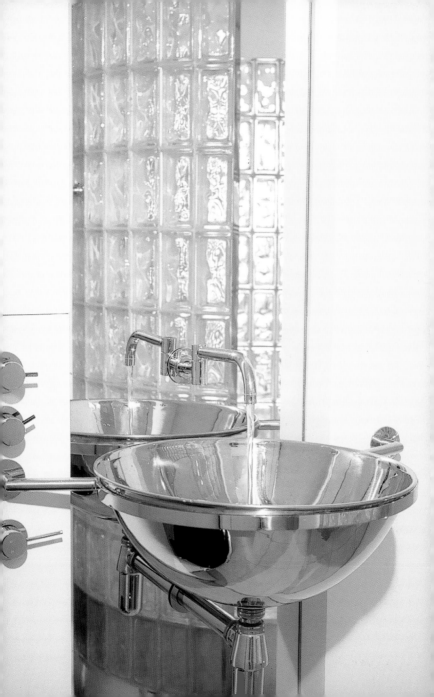

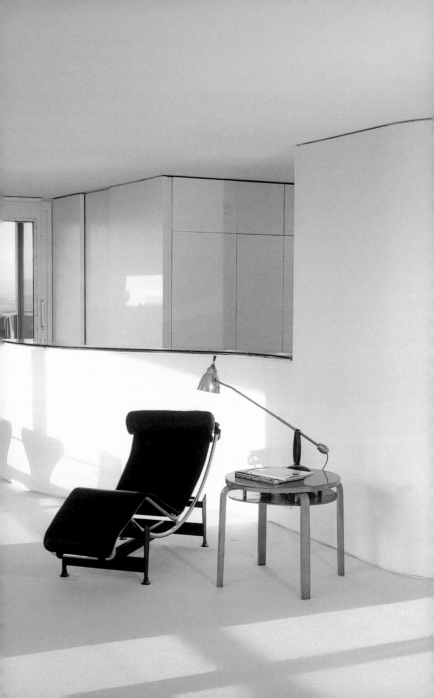

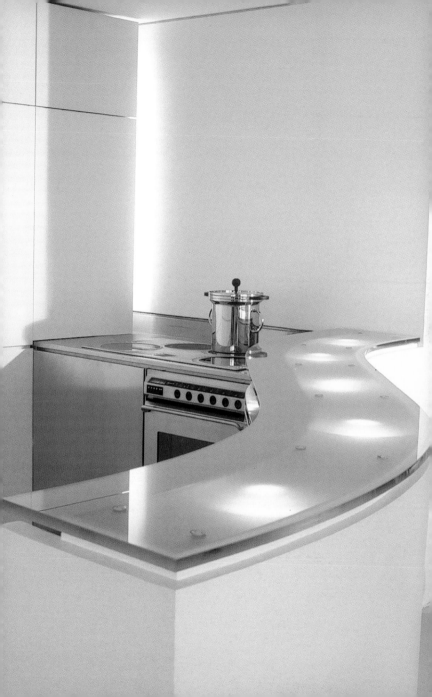

New Concordia Apartment
Mark Guard

Photos: © Allan Power, © John Bennett Completion date: 1998 info@markguard.demon.co.uk

This immaculate residence is a 185-square meter shell on the fifth floor of an old warehouse. Furnished in a minimalist fashion, the living spaces run along a 75-foot long wall, leaving at least sixty percent of the space mostly empty, except for two tables that slide on floor rails and numerous circular pillars. White dominates the space and is further bleached by light that shines through large gridded windows overlooking the river. One table is glass and the other is steel to match the kitchen unit. The floor is made of square stone tiles. All electrical installations are concealed within the walls to complete the unblemished complexion of this Thames side dwelling.

Diese makellose 185 m² Wohnung liegt im fünften Stock eines alten Lagerhauses. Minimalistisch eingerichtet zieht sich der Wohnraum an einer 21 Meter langen Wand entlang, mindestens 60 Prozent der Fläche bleibten frei. Ausnahmen stellen die beiden Tische dar, die auf Schienen im Boden beweglich sind sowie mehrere runde Säulen. Weiß dominiert und wird durch das Licht noch weiter aufgehellt, das durch die großen Gitterfenster scheint. Ein Tisch ist aus Glas, der andere - passend zur Küche - aus Metall. Quadratische Steinfliesen bedecken den Boden. Die Elektroinstallationen sind unter Putz verlegt, um die Makellosigkeit dieser Wohnung an der Themse zu vervollständigen.

Cette résidence immaculée est un module de 185 m² au cinquième étage d'un vieil entrepôt. Meublés de façon minimaliste, les espaces de vie suivent un long mur de 21 m, laissant près des deux tiers de l'espace quasiment vide, hormis deux tables montées sur des rails au sol, et de nombreux piliers circulaires. Le blanc domine l'espace, décoloré plus avant par une lumière brillant au travers de grandes croisées surplombant la rivière. Une table est en verre, l'autre en acier, s'harmonisant avec l'élément cuisine. Le sol est en carreaux de pierre. Toutes les installations électriques se dissimulent dans le mur, complétant la pureté formelle de cette demeure au bord de la Tamise.

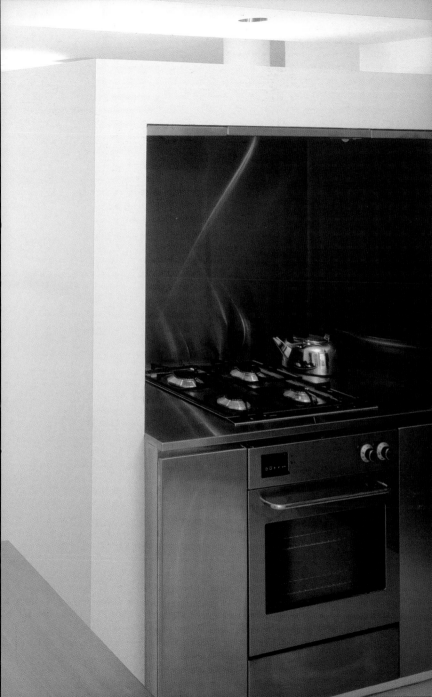

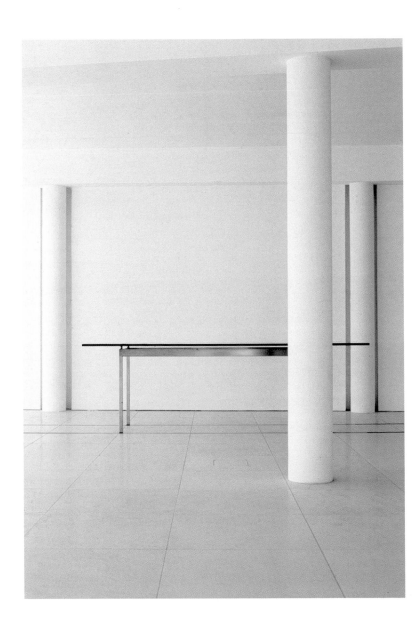

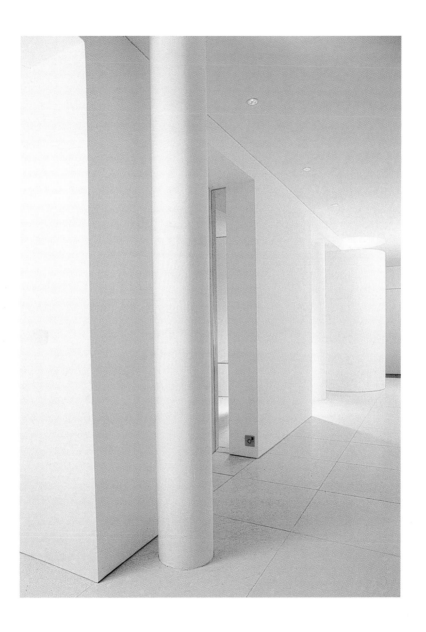

Milverton Street
Voon Wong

Photos: © **Henry Wilson** Completion date: **1997** voon@dircon.co.uk

This flat is located in a converted Victorian terrace house and is arranged on three levels linked by a staircase. A "circulatory spine", the staircase begins at the entrance and leads to a kitchen off a half-landing. It then moves into the main living area and finishes in the attic bedroom above it. All the levels are visible from the half-landing and are filled with light from the windows and attic skylights. Electrical devices and storage spaces are integrated into custom furniture throughout the flat, which visually unifies the rooms. White plaster walls and light gray carpet line the sleeping areas, while the kitchen and bathroom feature ceramic mosaic tiles set against dark, glossy timber floors.

Diese Wohnung liegt in einem umgebauten viktorianischen Reihenhaus und zieht sich durch eine Treppe verbunden über drei Etagen. Wie ein "kreisendes Rückgrat" beginnt sie am Eingang und führt von einem Zwischenpodest in die Küche. Sie gleitet in den Hauptwohnbereich und endet unter dem Dach im Schlafzimmer. Alle Ebenen können vom Zwischenpodest aus eingesehen werden und werden durch Fenster und ein Oberlicht mit Licht überflutet. Elektroinstallationen und Stauräume sind in Möbeln nach Maß untergebracht, wodurch die Räume optisch vereinheitlicht werden. Weiß vergipste Wände und hellgraue Teppichböden in den Schlafzimmern; Küche und Bad sind mit Mosaikfliesen gekachelt, im Kontrast zu den dunkel glänzenden Holzböden.

Dans une maison Victorienne en terrasse, cet appartement s'organise sur trois niveaux reliés par un escalier. «Colonne de circulation», l'escalier naît dans l'entrée, mène à une cuisine en demi-palier, se déplace vers le séjour principal et finit dans la chambre de l'attique. Tous visibles depuis le demi-palier, les niveaux sont baignés de lumière provenant des fenêtres et des lucarnes de la soupente. Dans tout l'appartement, équipements électriques et rangements s'intègrent au mobilier sur mesure, unifiant visuellement les pièces. Murs de plâtre blancs et tapis gris clair habillent les aires de repos, la cuisine et la salle de bain arborant des mosaïques de céramique contrastant avec des parquets sombres et brillants.

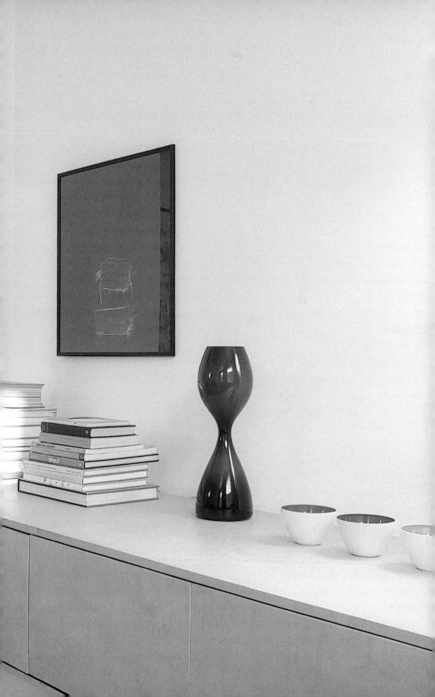

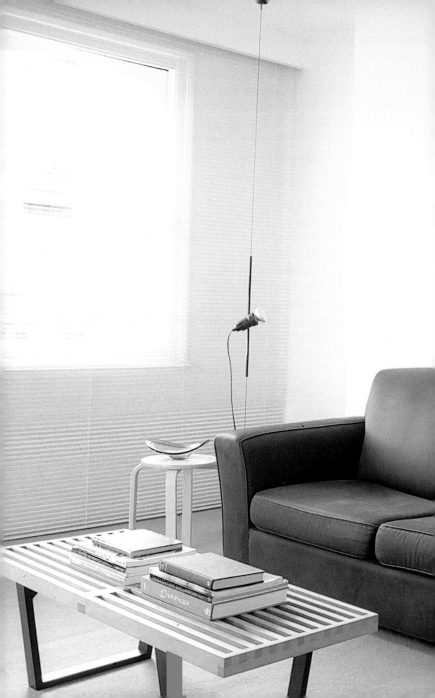

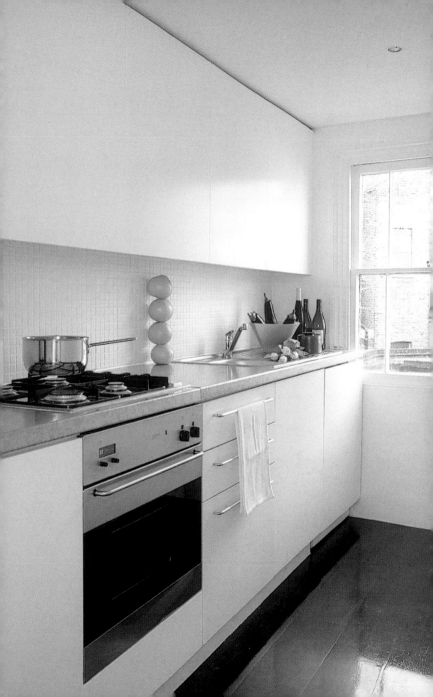

Arquitect's Apartment
Voon Wong

Photos: © **Henry Wilson** Completion date: **1998** voon@dircon.co.uk

Voon Wong refurbished this 13-foot cube, previously a school, into a small apartment in which to live and work. His ingenious structures take full advantage of the small space available. He converted the lower level into a mezzanine, which accommodates the living room, dining room, and kitchen. The kitchen takes the form of a box suspended from the upper section, where the bedroom and studio overlook the main front, as on a terrace. The only partitions installed close off the bathrooms. A glass screen separates the bedroom, while the studio sits on a halfheight partition. The home is a clever and imaginative exploitation of space.

Voon Wong renovierte einen Würfel mit vier Meter Deckenhöhe, eine ehemalige Schule, für eine neue Nutzung als Wohn- und Arbeitsraum. Seine genialen Ideen nutzen den verfügbaren Platz optimal aus: Die untere Etage wurde in ein Zwischengeschoss verwandelt, in dem Wohn- und Esszimmer sowie die Küche untergebracht sind. Die Küche hängt in einer Kiste von der oberen Ebene herab, Schlafzimmer und Arbeitsraum überblicken die Hauptfassade wie von einer Terrasse aus. Die einzigen Wände verschließen das Bad. Eine Glasfläche trennt das Schlafzimmer ab, und das Arbeitszimmer sitzt auf einer halbhohen Trennwand. Das Apartment nutzt den Raum klug und einfallsreich aus.

Voon Wong a rénové ce cube de 4 mètres, jadis une école, en un petit appartement pour vivre et travailler. Ses structures ingénieuses tirent parti du moindre espace disponible. Il a transformé le niveau inférieur en mezzanine, accueillant le séjour, la salle à manger et la cuisine. La cuisine prend l'aspect d'une cabine suspendue à la section supérieure, où chambre et studio surplombent le front principal, comme sur une terrasse. Les seules cloisons installées ferment la salle de bain. Une baie vitrée sépare la chambre du studio, qui repose sur une cloison à mi-hauteur. L'espace est mis à contribution avec astuce et imagination.

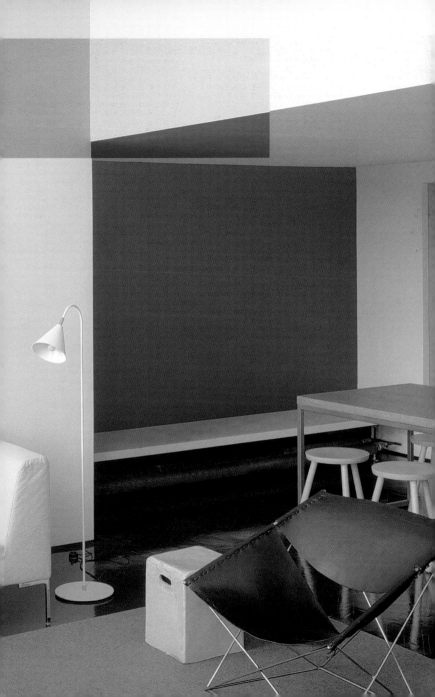

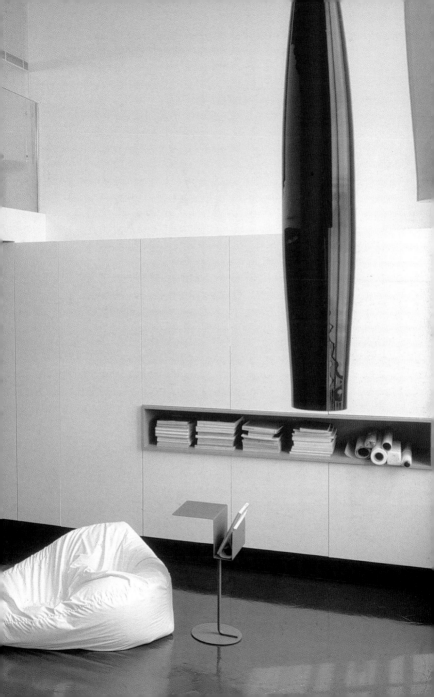

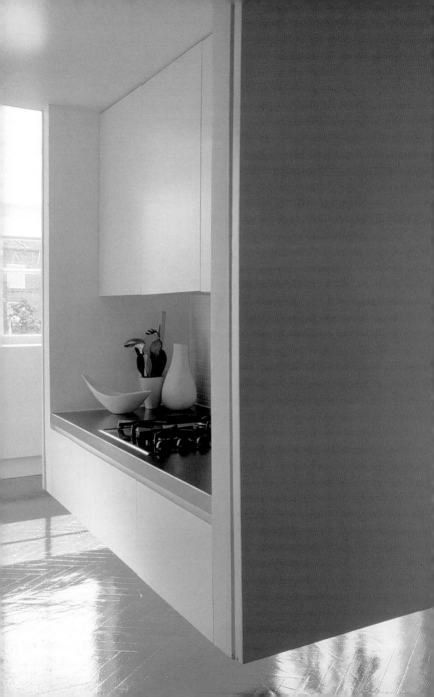

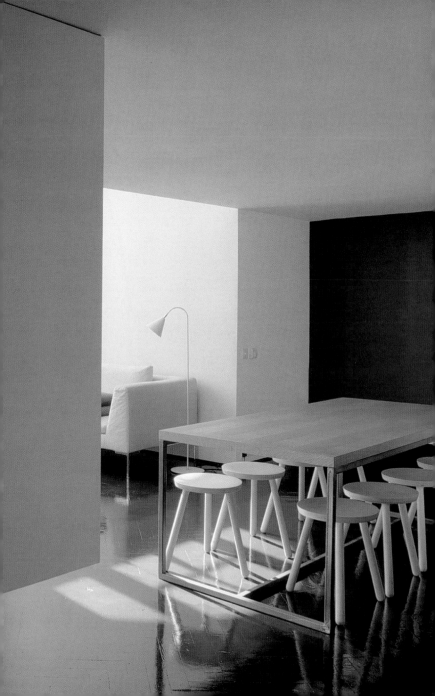

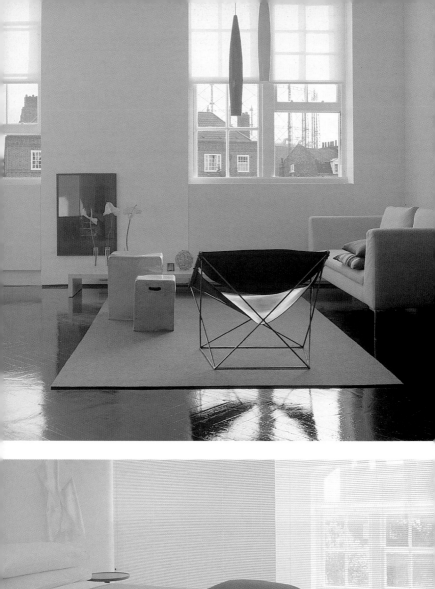
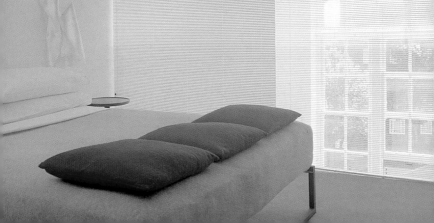

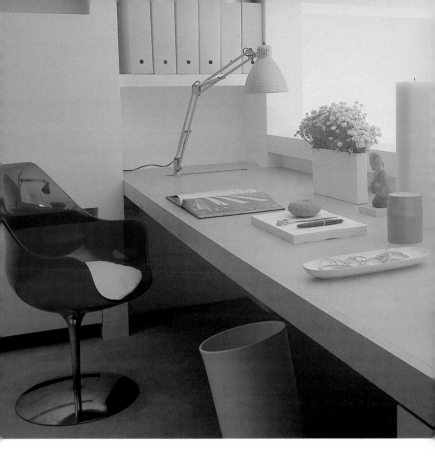

Glossy floors reflect the volume of light let in through the windows in the living room, which incorporates the dining area within a shared space. Doing away with conventional opacity, a glass wall encloses the bedroom uninhibiting light and providing privacy with the addition of blinds.

Glänzende böden reflektieren die helligkeit, die durch die fenster des wohnzimmers dringt; der essbereich ist in diesen gemeinschaftsraum integriert. statt der üblichen opaken glaswände gelangt das licht ungehindert bis ins schlafzimmer, jalousien garantieren die privatsphäre.

Le sol lustré reflète la lumière provenant de la fenêtre du séjour, intégrant le coin repas dans un espace partagé. Oublieux de l'opacité conventionnelle, une baie vitrée ceint la chambre, libérant la lumière et procurant l'intimité grâce à des stores.

Photos: © **Jordi Miralles** Completion date: **2000** **stephenquinn@btinternet.com**

This flat located in Marylebone occupies the entire third floor of a listed house dating back to the 1780's. Architects conserved the remaining 18th century details and renovated the rear portion of the flat refurbished in the 1930's. A new fireplace is the only modern intervention in the ornate Georgian front living room. The kitchen door opens to create fluidity in the space or can be tucked away and disguised as a large cupboard door. The decoration is subtly modern and complements the flat's period features. Placid colors like lilac and turquoise garnish the walls of the comfortable and relaxing rooms.

Diese in Marylebone gelegene Wohnung belegt das gesamte dritte Geschoss eines denkmalgeschützten Hauses aus dem Jahr 1780. Die Architekten bewahrten die aus dem 18. Jahrhundert erhaltenen Elemente und renovierten den hinteren Teil des Hauses, der aus dem Jahr 1930 stammt. Ein neuer Kamin ist der einzige moderne Eingriff in das prunkvolle Georgianische Wohnzimmer zur Straße hin. Die Küchentür öffnet sich, um dem Raum Kontinuität zu geben oder sie wird versteckt als große Regaltür weggeklappt. Die Einrichtung ist maßvoll modern, um nicht von der historischen Ausstattung abzulenken, und angenehme Farben wie lila und türkis schmücken die Wände dieser gemütlichen und entspannenden Zimmer.

Cet appartement de Marylebone occupe tout le troisième étage d'une maison classée, datant des années 1780. Les architectes ont conservé les détails d'époque subsistants, et rénové la partie arrière de l'appartement restaurée dans les années 30. La nouvelle cheminée constitue la seule note de modernité du séjour Georgien. La porte de la cuisine s'ouvre pour fluidifier l'espace, ou peut être dissimulée sous forme d'une porte de placard. La décoration est d'un modernisme subtil, complétant les détails d'époque. Les murs des pièces, confortables et tranquilles, s'ornent de couleurs apaisées, lilas et turquoise.

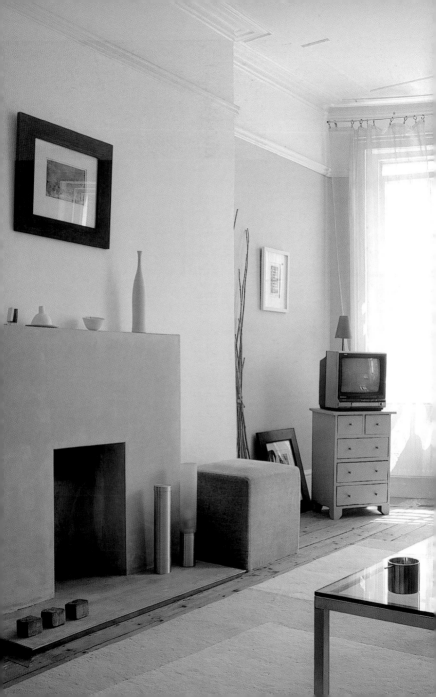

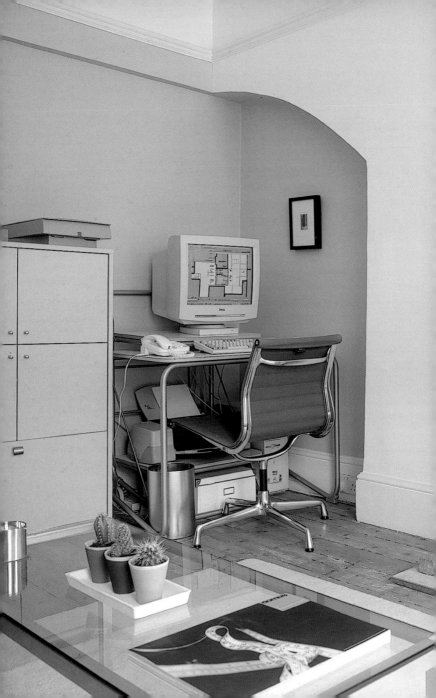

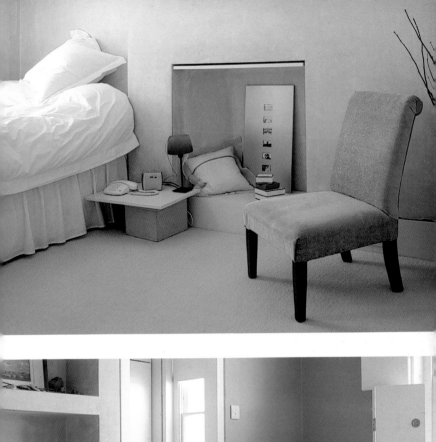
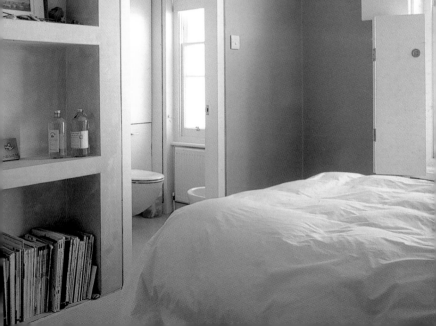

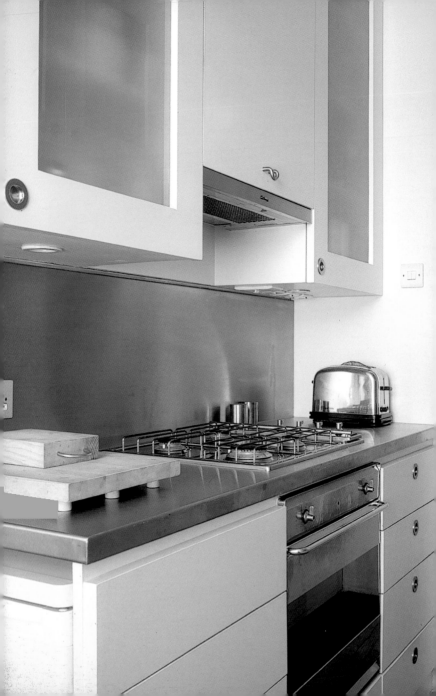

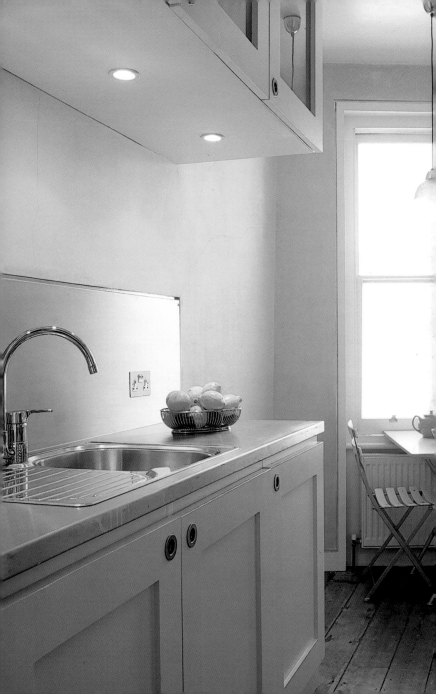

Flat in Gloucester

Elise Ovanesoff / Stephen Quinn

Photos: © **Jordi Miralles** Completion date: **2001** stephenquinn@btinternet.co.uk

This original space was once a grand first-floor drawing room of a four-story Georgian house that was later poorly remodeled. It now houses a refurbished modern household. The architects restored the large front room and added a kitchen to form a living/dining area. The bedroom at the rear features a lowered adjoining bathroom and a walk-in wardrobe with a lively green-patterned sliding door on concealed sliding gear. Whites, grays, and dark woods create a mostly monochrome palette that accentuates the light and space afforded by tall windows and high ceilings. This modern, small space is effectively organized.

Einst war es ein großer Salon in der ersten Etage eines vierstöckigen Georgianischen Hauses, der zunächst notdürftig umgebaut und schließlich in einen modernen Haushalt umgestaltet wurde. Die Architekten renovierten den großen vorderen Raum und bauten eine Küche ein, um einen Wohn-/Essraum zu schaffen. Das Schlafzimmer im hinteren Teil hat einen begehbaren Kleiderschrank mit einer leuchtend grün gemusterten Lamellenfalttür auf verdeckt eingebauten Laufschienen und ein angeschlossenes Badezimmer. Weiß, Grautöne und dunkles Holz bilden eine überwiegend monochrome Farbpalette und akzentuieren Raum und Licht in diesem modernen kleinen Apartment, das optimal gestaltet ist.

L'espace originel était jadis le superbe salon au premier d'une demeure Georgienne de quatre étages, mal restaurée par la suite. Il accueille désormais un foyer moderne remis à neuf. Les architectes ont réhabilité la grande pièce de façade, lui ajoutant une cuisine pour créer une aire séjour/salle à manger. La chambre, sur l'arrière, dispose d'une salle de bain en renfoncement et d'une large penderie, doté d'une porte coulissante, sur un mécanisme escamoté, égayée par des motifs verts. Blancs, gris et bois sombres créent une palette essentiellement monochrome accentuant la lumière et l'espace, procurés par les grandes fenêtres et le haut plafond. Cet espace petit mais moderne est organisé efficacement.

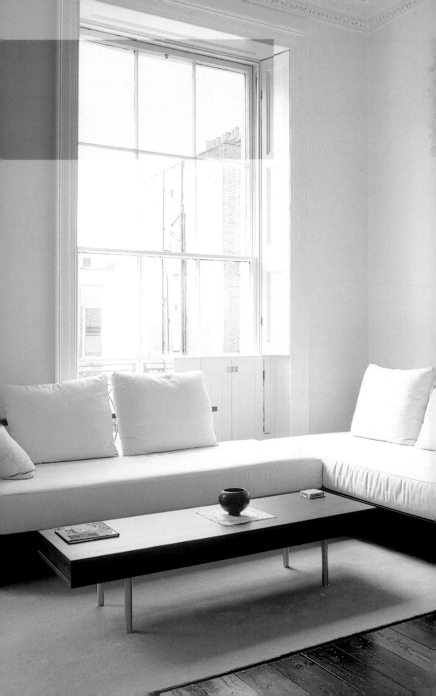

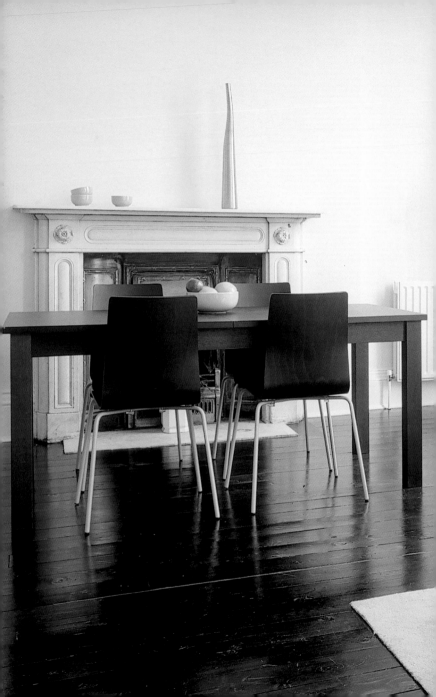

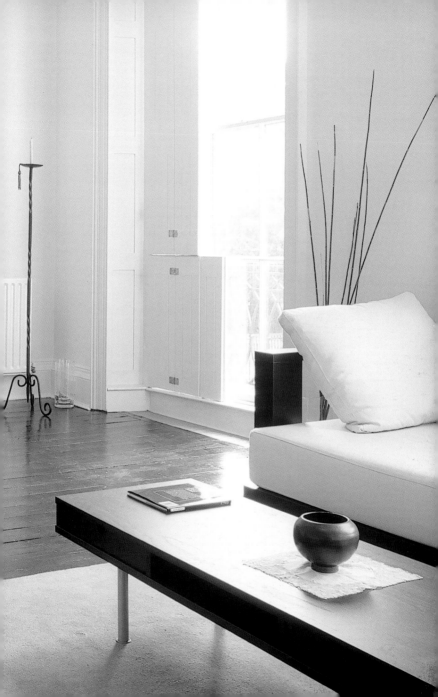

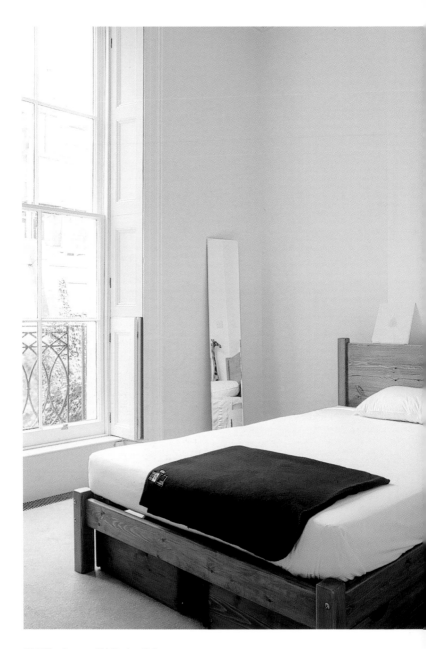

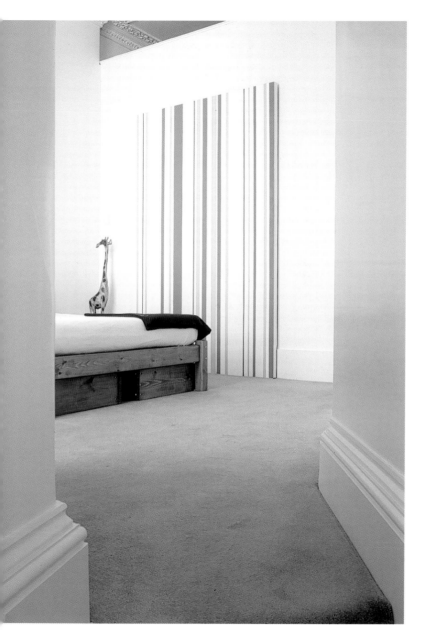

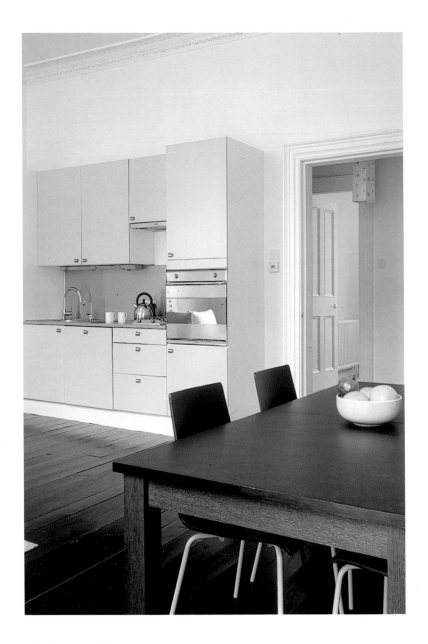

Elise Ovanessoff / Stephen Quinn

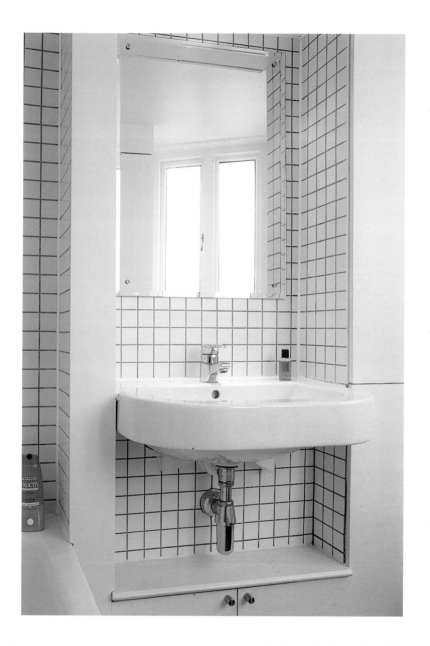